€17.95

DIGITAL PHOTOGRAPHY EXPERT

Close-Up
Photography

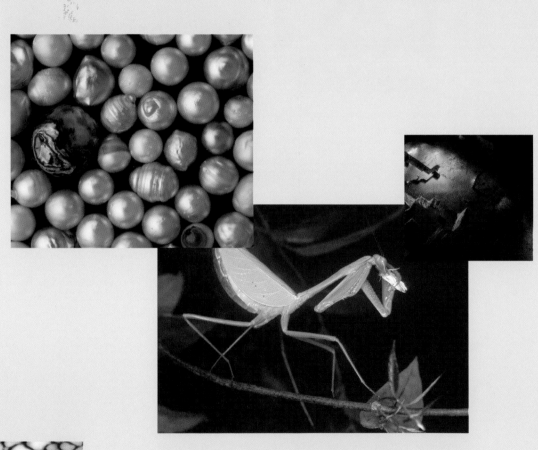

DIGITAL PHOTOGRAPHY EXPERT

Close-Up
Photography

MICHAEL FREEMAN

ILEX

First published in the United Kingdom in 2004 by
I L E X
The Old Candlemakers
West Street
Lewes
East Sussex BN7 2NZ
www.ilex-press.com.

Text © The Ilex Press Limited 2004
Images © Michael Freeman

This book was conceived by
I L E X
Cambridge
England

Publisher: Alastair Campbell
Executive Publisher: Sophie Collins
Creative Director: Peter Bridgewater
Editorial Director: Steve Luck
Design Manager: Tony Seddon
Editor: Adam Juniper
Designer: Hugh Schermuly
Artwork Assistant: Joanna Clinch
Development Art Director: Graham Davis
Technical Art Editor: Nicholas Rowland

British Library Cataloguing-in-Publication Data
A catalogue record for this book is available from
the British Library

ISBN 1-904705-25-1

Printed and bound in China

For more information on this title please visit:
www.mfxduk.web-linked.com

Contents

Introduction

When the poet and painter William Blake wrote about seeing a world in a grain of sand and a heaven in a wild flower, he was expressing both the connection between the microcosm and the macrocosm, and the miracle of creation as viewed through detail. The opening stanza of the poem Auguries of Innocence, written between 1800 and 1803, has become a mantra for lovers of nature as well as for those who share Blake's mystical vision, not only because they are inspired lines, but because he goes on to point out our responsibility for taking care of the small things of existence. And this is driven by the sense of wonder that comes from peering closely at the very small. Most of the time we don't bother to do this. Our eyes focus most easily on things at a distance, and when we do make the effort to focus closely, it's more likely to be at a book than in examination of a tiny object for its own sake.

Well, we get used to what we see, and if that naturally falls into the scale of a few metres and beyond, then the surprise of exploring how things appear at just a few centimetres or less is all the greater. By convention, close-up photography is divided, approximately, into three zones of magnification. Close-up per se goes as far as life-size reproduction, a significant point in terms of the way lenses behave. More magnified than this is the macro realm, where the human eye needs the help of lenses to see clearly, and this takes us to the point at which things are invisible to the naked eye, where the special optics of the microscope are needed.

Optics play an important part in these definitions, except at the lower limit of magnification – where close-up takes over from 'normal'. There is no precise point, it is just the point at which we say we are looking closely at something. For the sake of argument it must lie somewhere around a metre from the camera. This is a hazy start to the world of close-up, but it is also the area for one of photography's classic genres – still life, which merits the considerable attention given to it in this book. Still-life photography is commanded by attention to detail, and full control. The photographer chooses the subjects and constructs the image.

But the world of close-up imaging is also inextricably bound up in a study of nature, which in many ways is the opposite of still-life image-making. We may react in awe at some of nature's large-scale productions – like the Grand Canyon – but in fact most of life on earth goes on at a scale very much smaller than us. In terms of just documenting nature, we need close-up imaging, while the sheer wealth of subject material at these small distances makes exploration with a camera a delight. One of the themes of this book is that there are two purposes to close-up photography: revealing how things look and work, and exploring the aesthetic and graphic possibilities in what is largely an unfamiliar part of the world. It might seem at first that these are very different aims, but one only has to look at some of the results to see how close-up photography has the ability to marry science and art.

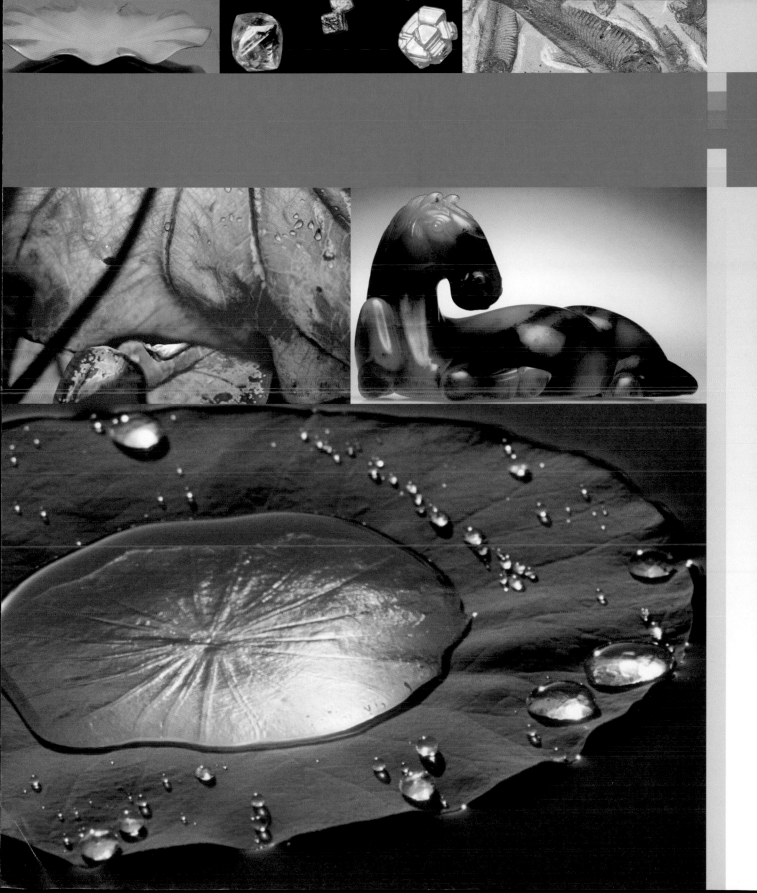

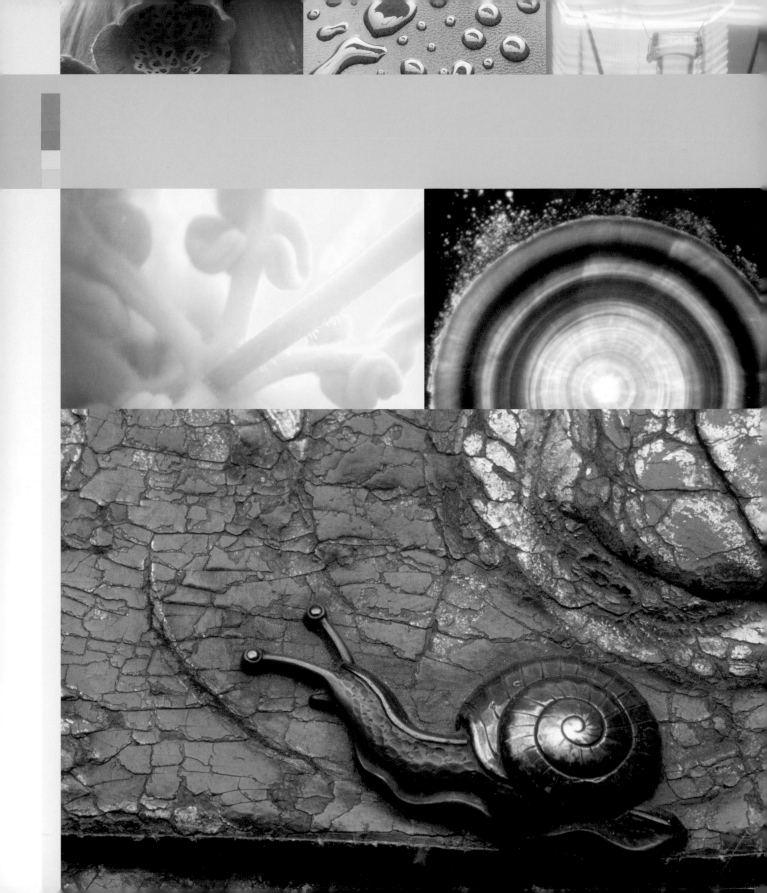

Another **World**

What surprises many photographers coming fresh to close-up imagery is that things really do work differently, in optics and perception. Close-up work may sound like photography that simply gets closer than usual, but in fact it calls for some very real adjustments to the ways in which we use a camera, both practical and creative.

First come the practical differences. Camera lenses are designed to work best at the distances that most people use them, but the corollary is that they underperform at close distances. There is no such thing as a perfect lens, and all are plagued to some degree by one or more aberrations. Correcting these involves a certain amount of compromise and, until fairly recently, close-up optics were a specialized area of photography. The manufacturers' solution to the problem of not being able to make lenses perform at short distances was to offer 'macro' lenses to those who really wanted them.

SLR cameras, which accept interchangeable lenses, made this practical, and it still applies in the digital world. If you use a digital SLR, a macro lens will guarantee you the best image quality for most of the distances and magnifications that we are dealing with here. A bonus for the owners of digital SLRs that use a sensor smaller than 35mm film is that the imaging makes use only of the centre of the lens, which is relatively free of many aberrations, including spherical aberration, which is worse at close distances. The good news for people who use a fixed-lens non-SLR is that most camera manufacturers have finally realised that macro is popular, and have applied sophisticated lens design to the already complex zoom lenses now widely used in digital cameras. In all but the simplest cameras there is a close-focusing option.

Close-up is one field of photography in which some technical knowledge is unavoidable – at least if you intend to explore this different world fully. Digital cameras make this much easier than in the days of film, because you can see what you are doing and judge your success on the spot. Nevertheless, it helps to know what to expect, and for that reason, I begin the book with the technical facts. Much of this is to do with sharpness – choosing which parts of the scene should have it, how to maximize it and how and why to limit it.

In photography in general, the technical can inspire the creative, and this is even more the case with close-up. Shallow focus is one of the banners hanging over close-up photography, meaning that depth of field is always more limited than at 'normal' distances. It is easy to see this as a limitation for making pictures, and there are occasions when overall sharpness is a priority. More often, however, this is simply a fact of imaging in a miniature world, offering a whole new arena for composition and abstraction. In normal vision, we are aware of things out of the direct line of sight and think of them as focused. The camera, however, sees only a soft blur, a characteristic of close-up.

All of this argues for using a camera in close-up interactively and in an experimental way. The closer you delve into this world, the more you will come to rely on the camera and lens to let you know what is happening.

Degrees of magnification

For convenience, the photography of small things is divided into three ranges of magnification, each making particular demands on the lens and on technique.

From normal to macro

Shown opposite is a sequence of three images, closing in progressively on the head of a flower. This illustrates the normal range of macro focusing, from the distance and magnification at which close-up begins, to life-size. Higher magnifications than this call for special techniques and, usually, an SLR camera.

We all have an idea of what we mean by 'close', but it's usually an imprecise one. For most people, it means approximately the distance at which you could hold something by hand, or nearer. If you pay special attention to how your eye focuses, you can sense a difference at such close distances (and as we get older, this close-focusing ability is exactly the one that is hit hardest). Camera lenses, too, have to perform a little differently, as we'll see. Because of this there are good reasons for subdividing 'close' photography into close-up; photomacrography (macro); and photomicrography.

First, however, there is the language of close imaging. The two standard ways of describing the degree of close-range imaging are 'magnification' and 'reproduction ratio', and these terms are interchangeable. These are written in different ways, but here I use the most common notations: magnification as in '2X', and reproduction ratio as in '2:1'. There's no agreement on the perfect starting point for close-up photography, but most manufacturers and photographers have it in the region of 0.1 magnification (1:10 reproduction ratio) and 0.15 magnification (1:7). Less than this is just normal photography.

Close-up photography runs from, let's say, 0.1X to 1.0X; in other words, from the point at which the image is one tenth the size of the object to when it is life-size (1:10 to 1:1). In practice, the reproduction ratio of 1:7 is the point at which the minimum significant exposure adjustment (1/3 stop) becomes necessary to compensate for the increasing distance between the lens and the film plane. In the old days, this calculation was important, but now, with auto-exposure and digital previews, the issue of less light reaching the sensor is generally taken care of by the camera. Photomacrography, commonly known as macro, extends from 1.0X to 20X (a 1:1 reproduction ratio to about 20:1), at which point optical conditions demand the use of a microscope. Note: because the word macro is so widely used and understood (and from now on I'll be using it in this book), you'll sometimes see the word macrophotography used ignorantly to mean the same thing. It doesn't; it means the opposite – photography on a large scale, which is so normal that the word isn't worth using. Photomicrography is simply photography using a microscope which is, at a basic level, surprisingly uncomplicated.

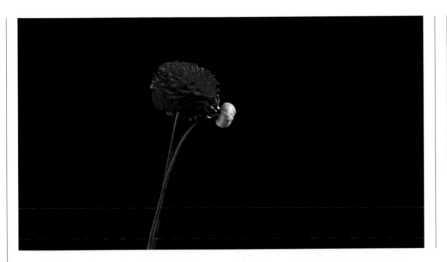

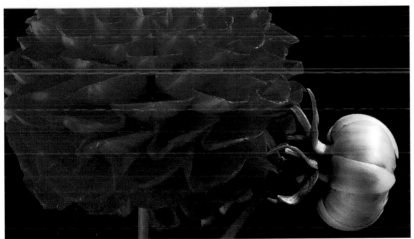

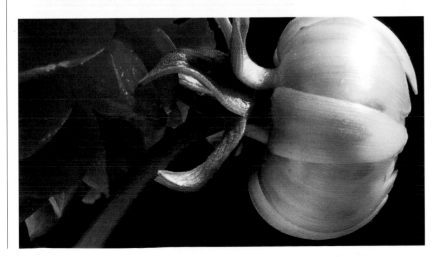

Close-up terminology

Reproduction ratio is the relationship between the size of the image and the size of the subject. For instance, if an object 32mm high appears 8mm high on the sensor, the reproduction ratio is 1:4 (i.e. 32mm divided by 8mm). Magnification is another way of expressing the same thing. It is the size of the subject divided by the size of the image. For the same example, the magnification would be 0.25X or, expressed as a fraction, ¼.

Basic close-up
 The top image has a magnification of 0.1X, reproduction ratio 1:10. For this moderate close-up, any normal lens will focus without needing any attachments or special capability.

Almost macro
Magnification 0.5X, reproduction ratio 1:2. This level of magnification, with the image half the size of the real subject, is as far as most macro lenses will go without supplementary lenses or extensions.

Life-size
Magnification 1.0X, reproduction ratio 1:1. To reach life-size reproduction, as here, a fixed camera lens will normally need to have a supplementary close-up fitted, while an extension ring can be used with an SLR.

The optics of close-up

Camera lenses, normally designed to work with large-scale subjects, behave differently in several important ways when used at close range.

There most efficient method of magnifying an image is to extend the lens forward, away from the sensor. This, in fact, is the way that most lenses are focused for normal picture-taking. However, the lens elements do not usually have to travel far in order to focus anywhere between about a metre and infinity. For close focusing, they need to move much further. The reason for this is the relationship between the two conjugates, which are the distances between the lens (to be precise, the principal point inside) and the object on one side and the sensor on the other (*see box*). When the subject is more than about ten times the focal length away, the image conjugate hardly changes. Any closer than this, however, and the image conjugate gets noticeably larger. When the two conjugates are equal, you have 1:1 magnification, with the sensor image the same size as the object.

This causes some problems for manufacturers, because most lenses perform best when subjects are at a distance (a long object conjugate) but

Depth of field

Depth of field is the range of distance from the camera, on either side of whatever the lens is focused on, that appears to be sharp. The emphasis is on 'appears', because depth of field is not a completely objective measurement. In front of the focused object, and behind it, there is a transition zone between distinctly sharp and definitely out of focus. In order to be able to put a figure to this range, there first needs to be a measurement of how the human eye distinguishes sharpness. This is the circle of confusion, meaning the largest size of circle that the eye perceives as a point. Even a point has dimension, which is why it makes sense to treat it as a tiny circle. In fact, a small highlight, such as the reflection of the sun in a raindrop, will appear as a distinct circle in an out-of-focus background.

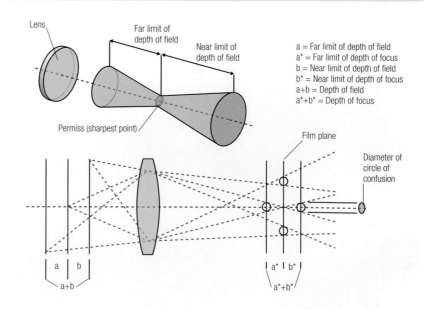

a = Far limit of depth of field
a* = Far limit of depth of focus
b = Near limit of depth of field
b* = Near limit of depth of focus
a+b = Depth of field
a*+b* = Depth of focus

less well when they are close. Apart from the mechanics of moving the glass elements inside the lens barrel, sharpness suffers and aberrations increase. Modern lens design has worked wonders in solving these problems, but not completely at very close distances. On a fixed-lens digital camera, the lens may have a 'macro focusing' capability or 'close-up mode', meaning that, at the least, the lens will actually focus down to a short distance. The quality of the image at close distances, however, depends on the lens design. Don't assume that just because the manufacturer uses the magic word 'macro' the lens performance matches the description. True macro lenses do exist, but, for obvious reasons, they are made for cameras that take interchangeable lenses – in other words, SLRs.

For fixed-lens cameras, there is a simple method for achieving limited magnification – supplementary close-up lenses. These simple meniscus lenses are fitted in front of the camera lens in the same way as a filter and can be used to give reproduction ratios up to about 1:5. Beyond this, image quality suffers. Their advantage is simplicity, and they are available in different strengths, measured in diopters. A + 1 diopter lens has a focal length of 1 metre, and will shift the point of focus from infinity to 1 metre. A + 2 diopter lens has a focal length of 0.5 metre, and shifts the point of focus from infinity to 0.5 metre and so on. Supplementary lenses can be combined, and the effect is additive (a + 1 diopter and a + 2 diopter act as a + 3 diopter), although image quality begins to suffer noticeably when more than two are used together. When combining, put the stronger diopter next to the camera lens. Split-diopter lenses cover only half of the mount and can be used to bring a close foreground into focus at the same time as a distant background, without having to stop the aperture down.

Conjugates

A camera lens focuses a point on the subject to an equally sharp point on the sensor, which sits on the image plane. In normal photography, as in the view shown below left of foxgloves photographed from 4 metres with a 105mm efl lens, the object conjugate is much larger than the image conjugate, which changes very little as you focus. But when the subject is quite close, as in the diagram and the tight shot of the flowers below right, the two conjugates become more similar in length.

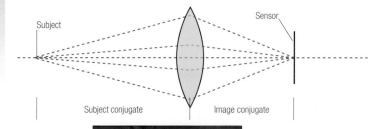

Subject

Sensor

Subject conjugate

Image conjugate

SLR techniques

Interchangeable lenses bring the full range of close-up to SLRs, while digital capture removes at a stroke the traditional difficulties of macro.

Because close-range shooting is a field of photography that is driven by optics, the ability to change lenses and to add extensions and other accessories gives digital SLRs a special advantage when it comes to high magnifications. As we saw, the chief mechanism is extending the lens – or at least some of the lens elements. This makes a macro lens the first choice of equipment if you have an SLR camera and are thinking about trying out close-up photography. A macro lens is one that has been designed from scratch to work best at close range, with an additional ability to focus up to infinity. In practice, there is no trade-off to using one other than the extra cost of the lens, because its resolution at distance will be visually just as good as a normal lens.

◢ Extension rings

Close-up magnification can be achieved by increasing the lens to film distance. The simplest and sturdiest method is to fit a ring or tube between the lens and the camera body. The focal length is the distance between the lens and the film when focused at infinity. Increasing this distance by half gives a reproduction ratio of 1:2. Doubling the distance gives 1:1, and so on (*see table*). Most good extension rings and tubes have linkages that connect the aperture diaphragm to the shutter and TTL meter, allowing the fully automatic diaphragm (FAD), where it exists, to remain in operation. Several can be combined for even greater extensions.

Reference table

Lens extensions, reproduction ratios and magnification

Extension (mm)	50mm lens		100mm lens		200mm lens	
	Reproduction ratio	Magnification	Reproduction ratio	Magnification	Reproduction ratio	Magnification
5	1:10	0.1x	1:20	0.05x	1:40	0.025x
10	1:5	0.2x	1:10	0.1x	1:20	0.05x
15	1:3.3	0.3x	1:7	0.15x	1:13	0.075x
20	1:2.6	0.4x	1:5	0.2x	1:10	0.1x
25	1:2	0.5x	1:4	0.25x	1:8	0.125x
30	1:1.7	0.6x	1:3.3	0.3x	1:7	0.15x
35	1:14	0.7x	1:2.8	0.35x	1:6	0.175x
40	1:12	0.8x	1:2.5	0.4x	1:5	0.2x
45	1:11	0.9x	1:2.2	0.45x	1:4.4	0.225x
50	1:1	1x	1:2	0.5x	1:4	0.25x
55	1.1:1	1.1x	1:1.8	0.55x	1:3.6	0.275x
60	1.2:1	1.2x	1:1.7	0.6x	1:3.3	0.3x
70	1.4:1	1.4x	1:1.4	0.7x	1:2.8	0.35x
80	1.6:1	1.6x	1:1.2	0.8x	1:2.5	0.4x
90	1.8:1	1.8x	1:1.1	0.9x	1:2.2	0.45x
100	2:1	2x	1:1	1x	1:2	0.5x
110	2.2:1	2.2x	1.1:1	1.1x	1:1.8	0.55x
120	2.4:1	2.4x	1.2:1	1.2x	1:1.7	0.6x
130	2.6:1	2.6x	1.3:1	1.3x	1:1.5	0.65x
140	2.8:1	2.8x	1.4:1	1.4x	1:1.4	0.7x
150	3:1	3x	1.5:1	1.5x	1:1.3	0.75x

Some SLR manufacturers offer macro lenses in different focal lengths, from standard to long. The advantage of a longer focal length is that the working distance is greater. You can shoot at the same magnification from further away. In photographing insects and other small creatures, this makes it possible to shoot quietly without disturbing them. When you cannot approach a subject like this to within a few inches, a longer focal length is the only answer. Set against this, if you also intend to use the lens on a bellows extension, the magnification will be less than usual.

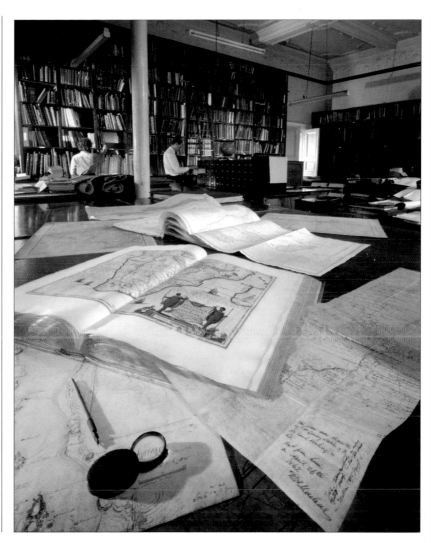

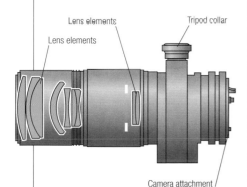

Lens elements

Lens elements

Tripod collar

Camera attachment

▲ Telephoto macro lens

Lenses designed specifically for macro work feature a lens construction in which the focusing mechanism suppresses aberrations; here, by moving just the first two groups of elements.

▶ Tilt lens

A highly specialized solution to getting a close foreground and distance sharp is a tilt lens. By tilting lens elements downwards, as shown in the illustration, the plane of focus itself is tilted. Normally vertical (perpendicular to the lens axis), it can be aligned with the important parts of a scene. The depth of field remains unchanged.

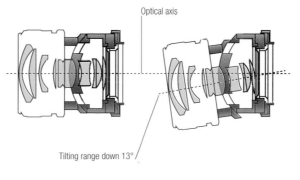

Optical axis

Tilting range down 13°

▲ Depth of field

Taken with a tilt lens, this image retains sharpness not only at the nearby cartographical texts, but also at the far side of the room.

True macro

The range of magnification greater than life-size is the realm of digital SLRs and various extenders, and brings with it the technical issues of sharpness and lens aberrations.

Loss of light

At macro magnifications, the lens elements are further from the sensor, projecting a larger image and reducing the amount of light that reaches the sensor. The *f*-stop is no longer accurate, necessitating a calculation of the reduction of the effective aperture. Metering and the camera's screen help, but it's good to know what will happen.

The table shows the loss of light at different magnifications:
R = reproduction ratio
M = magnification
E = exposure increase
F = exposure increase in
　 f-stops
X = decrease in flash to
　 subject distance.
X is an alternative to F.

R	M	E	F	X
1:10	0.1x	1.2	⅓	1.1
1:5	0.2x	1.4	½	1.2
1:3.3	0.3x	1.7	⅔	1.3
1:2.5	0.4x	2	1	1.4
1:2	0.5x	2.3	1⅓	1.5
1:1.7	0.6x	2.6	1⅓	1.6
1:1.4	0.7x	2.9	1½	1.7
1:1.2	0.8x	3.2	1⅔	1.8
1:1.1	0.9x	3.6	1⅔	1.9
1:1	1x	4	2	2
1.2:1	1.2x	4.8	2⅓	2.2
1.4:1	1.4x	5.8	2⅓	2.5
1.6:1	1.6x	6.8	2⅔	2.7
1.8:1	1.8x	7.8	3	2.8
2:1	2x	9	3⅓	3
2.2:1	2.2x	10.2	3⅓	3.2
2.4:1	2.4x	11.6	3½	3.5
2.6:1	2.6x	13	3½	3.7
2.8:1	2.8x	14.4	3⅔	3.8
3:1	3x	16	4	4

Most so-called 'macro' lenses magnify up to life-size – that is, 1X or a reproduction ratio of 1:1 – and this is more than enough for most people's close-up demands. However, as we saw on pages 10–11, true macro begins around about this magnification, and covers the range up to the point at which a microscope becomes necessary. This is a fairly specialized area, for which the lens needs to be extended considerably, and this inevitably makes it the province of SLRs. This said, digital SLRs are wonderfully equipped to deal with true macro, because the on-board processing of the image can take care of the otherwise tricky problems of contrast, colour, and even sharpness. Also, digital SLRs are equipped with ports that allow direct connection to a computer, and at these great magnifications a computer screen is your best window on the scene.

Sharpness is one of the major issues. At macro distances, where the image conjugate (*see pages 12–13*) is always greater than the subject conjugate, it is affected by a number of phenomena. One of them, more relevant to macro than to normal photography, is diffraction. This is what happens when a hard solid edge (and so opaque) obstructs the path of the light. It causes the light to deviate from its straight path, with a very slight spreading, and this in turn causes unsharpness. This, unavoidably, is what the aperture blades in the diaphragm inside a lens do. The worst part of this for close-up photography is that diffraction increases with smaller apertures, which are needed for good depth of field, and also increases with magnification.

A complication on top of this is that stopping down the aperture of a lens reduces most of the other lens aberrations, including spherical, chromatic, astigmatism, coma and field curvature. This is mainly because a

smaller area in the centre of the lens is being used to form the image. As the graph shows, there is a crossover between the two effects, so that at some point between wide open and fully stopped down there is an optimum f-stop. Exactly which f-stop delivers the best performance depends on the actual lens; how well the various aberrations have been corrected by the kind of glass used and the design; and also on how you, the photographer, judge it. In close-up work, the hazy softening from diffraction is likely to be prominent.

Another aberration that is more obvious in close-up photography is spherical aberration, which is caused by the surface curve of most lenses. Light rays through the outer zones of a lens, where the angles of the glass are greater than at the centre, focus closer than do the rays passing through the lens axis, as the diagram shows. Stopping down improves this aberration because the smaller aperture allows only the centre of the lens to be used. However, it also becomes more noticeable when the object is closer and the distance between the lens and the sensor is greater – which is what happens with increasing magnification.

Optimum aperture

Diffraction is the one lens aberration that increases as the aperture gets smaller, as the graph shows, comparing it with other common lens failings. Unfortunately, this effect is easily noticeable, and therefore merits serious attention.

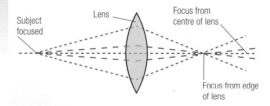

Increasing image quality

optimum aperture

- - - - Diffraction

- - - - Spherical and chromatic aberrations, astigmatism, coma and field curvature

Spherical aberration

The shape of a typical lens means that the angles at which the light rays are refracted are slightly different near the edges of the glass compared to how they are in the centre. The result is that the image from any sharp point tends to be spread slightly, reducing sharpness. Stopping down helps to reduce the problem.

Subject focused

Lens

Focus from centre of lens

Focus from edge of lens

◁ Diffraction

These images show the visible loss of sharpness caused by diffraction at 4X magnification, between an aperture of *f*11 (left) and *f*27 (right).

Depth of field strategies

Use not just aperture but also imagination to get the most out of the limited depth of field in close-up settings.

The closer the camera is to a subject, the more shallow the depth of field, and this is very characteristic of close-up photography, as we saw on pages 12–13. With some subjects, such as insects, front-to-back sharpness is usually the ideal, which means making the most of what depth of field is possible. Other subjects, particularly those, such as wild flowers, that have complicated backgrounds, may benefit from having little depth of field as this isolates them graphically from their surroundings.

There are three ways of improving depth of field in a close-up shot; two straightforward, and one highly specialized. Perhaps the most obvious is to use a small aperture. Even though some slight image quality is lost at very small apertures, the general effect is a sharper image overall. However, exposures are likely to need to be long to compensate, so camera shake and movement of the subject (leaves in even a slight breeze, for example) could become new problems. Also, simply stopping right down to the minimum aperture is not very good technique, because you may not want everything to be sharp. One of the values of shallow focus is that it helps to isolate subjects visually (*see the following pages*). If you are trying to maximize depth of field, do it just to the point that you need, and no further.

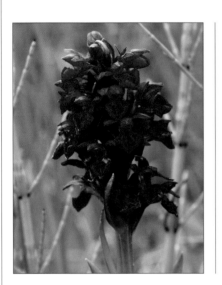

◢ Just deep enough

Standing a little apart from the surrounding grasses, this Scottish marsh orchid needed a depth of field that just included the leaves and stalk, and no more. In a case like this, experiment with different aperture settings to find the one that renders the subject sharply but the background soft.

▷ Side-on

One way of living without depth of field is to tackle a subject from a position that shows it at its shallowest. At a distance of 76cm, the depth of field with this 200mm macro lens at f11 was only 5mm, but enough for this damsel fly at rest. As the insect seemed undisturbed by the camera (tripod-mounted due to the 1/4 sec shutter speed), it was possible to move around until the camera was exactly side-on to the fly.

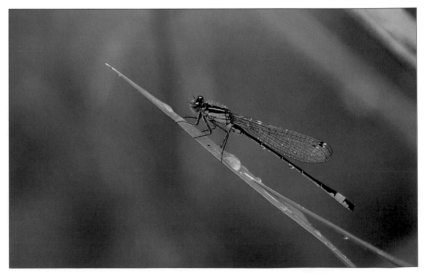

The alternative is to change your viewpoint to make the most of whatever differences there are in the shape of the subject. Most things are shorter in one direction than another, and if you photograph a long subject side-on rather than head-on, it presents less depth to the camera. Obviously, this can't work with all objects. If the situation allows, and provided that it will not spoil the image, make sure that the distance between the nearest and farthest parts of the subject are as shallow as possible. Try moving the camera or − if it's amenable to being repositioned − rearranging the subject, for instance, by gently twisting a flower stem.

The specialized solution, at macro magnifications, is to use a bellows with a swivelling front. A good bellows unit will usually have a lens mount that can be tilted slightly, and what this does is to tilt the plane of sharp focus, just as in the specialist tilt lens shown on page 15. So, if a leaf slopes diagonally towards the camera, the lens mount can be tilted so that the focus coincides with the leaf. This solution is really a way of managing without great depth of field than by increasing it.

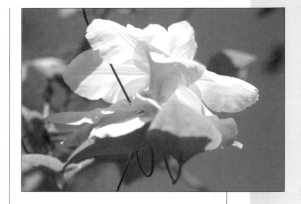

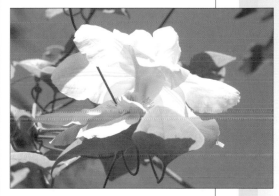

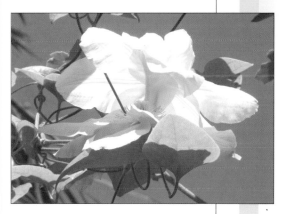

The Scheimpflug principle

This technique is a mainstay in large-format view-camera photography (and at the macro scale, a bellows extension is a very close equivalent of the large studio cameras). The diagram shows how it works. Tilting the lens tilts the plane of focus (which is normally perpendicular). The subject plane and the lens plane will then intersect somewhere, and if the lens is then focused so that the image plane also intersects at this point, then the entire subject plane will be sharply imaged − whatever its angle.

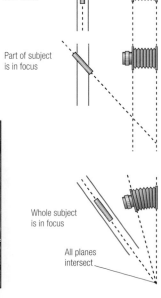

Range of focus Camera

Whole subject
is in focus

Part of subject
is in focus

Whole subject
is in focus

All planes
intersect

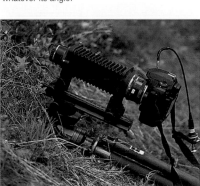

Depth of field control
Altering shutter speed and aperture gives three different depths of field in this view of a white clematis. The shallow depth of field given by a wide aperture (f3.2) isolates the flower but loses sharpness in the petals. At f11, there is a balance between having most of the clematis sharp and a blurred, separated background. At the smallest aperture of f36, the background is too sharp and distracting.

Making shallow focus work

The interplay of sharp and soft focus is one of the characteristics of close-up imaging – a feature to be explored and enjoyed.

Rather than thinking of the limited depth of field as a problem in close-up photography, treat it as one of the inevitable facts of life. In a normal three-dimensional scene on a small scale, something will always be out of focus. This is the case even when you look at these distances with the naked eye. We're not usually aware of this because the eye–brain combination works in a way that builds up the memory of a scene, and because the eye adjusts its focus very quickly as we scan our eyes over that scene. Look at one close detail and you may be aware of the other parts of the scene being hazy, but glance at one of these and they spring into focus. In a photograph we have the opportunity to appreciate the soft, out-of-focus areas – in fact, it is the only occasion. In this respect, as a photographer you are able to add your interpretation of a scene rather than simply making a factual record.

In photography in general, as well as in close-up, there is a natural tendency to want to get everything sharp and all the detail recorded. However, this is not the only approach to making an interesting image, because unsharpness has its own appealing qualities. It brings an abstraction to photography, allowing the photographer to experiment with pure graphic elements divorced from their sources. Chief among these is colour, which by being blurred and softened can be merged and blended, as if spray-painted. These colour washes can create an image in themselves, or be made to form a background for the focused detail.

In either case, close-up scales are ideal for this kind of creative experimentation, for two reasons. The first is that blur is very easy to achieve with the optics of close conjugates, as we saw on pages 12–13. A small focusing movement of the lens barrel at a reproduction ratio of 1:4 (0.25X magnification) can make a focused detail completely unintelligible. The other reason is that very small movements for photographer and camera create significant effects for the image.

In playing with the abstract qualities of colour and tone, the basic technique is to move the camera forwards, backwards, or to one side, and watch the effects through the viewfinder or on the LCD screen, while altering the lens aperture to change the depth of field.

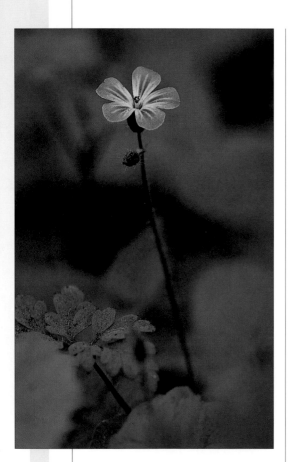

Contrast through focus

A small pink geranium in shaded woodland. What was interesting here was the contrast between the pale petals and the dark background, and shallow focus helped to accentuate the difference. The flower stands out not only because of the colour contrast but also because of the distinction in sharpness.

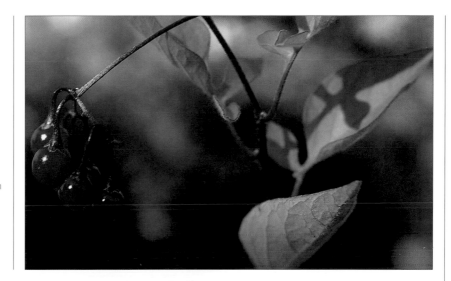

Caladium

Caladium leaves after an afternoon tropical downpour in Guyana. The attraction here was the variation in the shades of magenta, accentuated by the back-lighting, so the pale tones blend with dark. The point of focus was less important than filling the frame with an arrangement of colour. The sinuous lines of leaf ribs and the out-of-focus stalk in the foreground helped to organize the composition.

Background separation

The berries, just caught by the sun and sparkling with highlights, were the natural point of focus, and the arrangement of twigs and leaves made a natural composition in which they would be on the left. Shallow focus was essential to separate this arrangement from the green background, and careful positioning of the camera ensured that the berries were placed neatly against a darker shaded area behind.

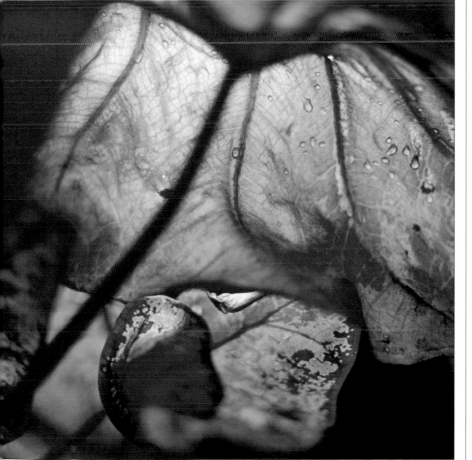

Where to focus

The shallower the depth of field, the more critical the choice in the exact point on which to focus – and this may not always be obvious.

The creative use of soft focus is one of the key techniques, and pleasures, of close-up photography. As we just saw, it allows the photographer to take an abstract approach to colour, blending it across the frame. But in addition to this graphic contribution to the image, it also enhances the impact of whatever is sharply focused. The contrast between blur and detail draws a viewer's attention compellingly towards the point of focus. Except in the rare instance of a photograph that is purely an abstraction of colour – with everything out of focus – unsharpness is a counterpoint to the in-focus subject.

There remains the matter of exactly where to focus. This may seem to be too obvious to mention – as the subject has probably already been decided – but when the depth of field is measured in millimetres, there is bound to be a

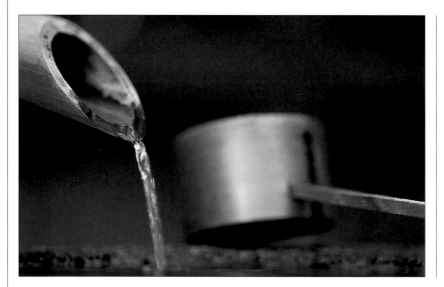

△ Water basin

At a Shinto shrine in Japan, the traditional elements of a stone water basin are the bamboo spout and a wooden dipper. The point of focus chosen was the stream of water as it emerged, and the depth of field was deliberately left shallow to allow for the highest shutter speed possible in order to catch the water flow with minimum motion blur.

Depth of field table (mm)

Reproduction ratio	Magnification	f5.6	f8	f11	f16	f22	f32
1:10	0.1x	41	59	81	117	160	232
1:5	0.2x	14	16	22	32	45	64
1:3	0.33x	4.5	6.4	8.8	12.8	17.6	26
1:2	0.5x	2.2	3.2	4.4	6.4	8.8	12.8
1:1.5	0.66x	1.7	2	3.3	4	6.6	8
1:1	1x	0.8	1.1	1.5	2.1	3	4.2
1.5:1	1.5x	0.41	0.6	0.8	1.2	1.6	2.4
2:1	2x	0.28	0.4	0.55	0.8	1.1	1.6
3:1	3x	0.16	0.75	0.32	0.47	0.64	0.94

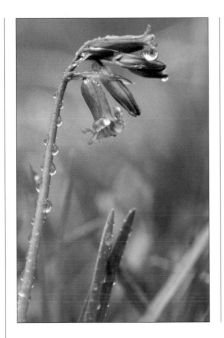

Raindrops

In this shallow-focus shot of a bluebell in rain, the points chosen for focusing were the raindrops, because of their highlights and because the largest, acting as a lens, contains an inverted miniature landscape.

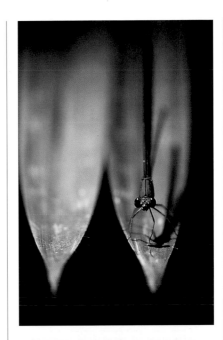

considerable choice. Consider a flower in the rain, which is the subject of the bluebell photograph shown on this page. Ordinarily, part of the flower, such as the edge of the petals or the pistils, would be the obvious place to focus, but in this weather the water drops are also an attractive detail. Moving the camera slightly catches a brighter refraction of the light in one drop, so this now becomes a contender for focus. In practice, several techniques come into play, including increasing the depth of field slightly and adjusting the viewpoint so that two different details become sharp. If you use a digital SLR, focusing and viewing is always done at full aperture, and with close-up photography this is a good starting point – provided that you remember to check the true distribution of sharpness and blur by depressing the preview button. Depth of field will always play an essential part.

While it is more common for the softness to be in the background, a slightly different effect can be created by shooting through parts of the scene that are closer to the camera. In nature photography, for instance, if you are shooting wild flowers, it is often unavoidable to have blades of grass between the camera and the subject. However, if they are strongly blurred they hardly interfere with the view, appearing only as a softly transparent overlay. This can be made use of in subtle ways, by constricting the sharply focused detail. Imagine, for example, that you have your subject, a small flower, perfectly focused and separated from its background by sufficient distance so that everything beyond is blurred. However, part of a nearby twig is unavoidably in focus and distracting. Moving the camera a fraction to one side brings a foreground blade of grass into view, so blurred that it is just a wash of green, but it conveniently hides the twig. Situations like this are quite common in close-up shooting.

Dragonfly

The movements of the dragonfly and leaf made a high shutter speed necessary, and so a wide aperture. Sunlight filtering through the trees formed catchlights on the insect's eyes. I tried a high camera position, but the lower makes more of the eye, and the head-on shot seemed more interesting than a side-on view.

Composite focus

One of the benefits of digital photography, layered images, can be turned into a spectacular solution to extending depth of field as far as you need with even the smallest objects.

Racking the focus backwards and forwards to find the perfect position, as in the previous pages, suggests a wonderful digital method of improving depth of field. If you could take a sequence of focus positions and combine them, you could in theory have total front-to-back sharpness. It would not actually be better depth of field, which is a purely optical effect, but the appearance would be similar. And indeed, it is a completely practical means of achieving a totally sharp image that would be impossible in any other way. At macro distances, depth of field becomes shallower, and so deep objects are impossible to photograph with front-to-back sharpness at the minimum aperture of a camera lens.

The technique involves taking a series of shots, each focused on a different part of the object. In an image-editing program they are then assembled in layers, and the out-of-focus areas of each layer removed with a soft erasing brush. If the sequence of shots was planned and executed properly, what is left in the composite image is a set of sharp zones that fit together seamlessly. This is not too complicated, but it does take a considerable amount of work. For the sharpest result, you should not stop down completely, because of diffraction effects (*see pages 16–17*). Ideally, find

Tibetan rings
These two gold rings were photographed at four different focus points from front to back. Three of the images were then resized to match the first, and the softly focused areas of each were airbrushed away using a soft large brush. Here the image is shown alone for clarity, but in practice the erasing is done with the lower layer showing through.

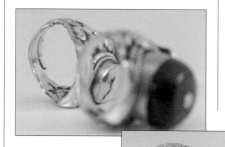

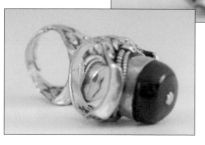

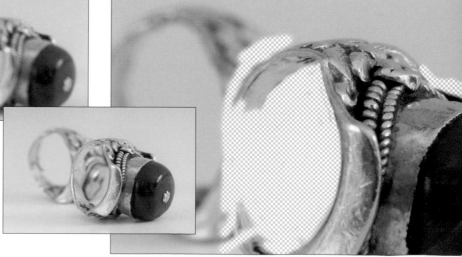

the f-stop for your lens that gives the optimum sharpness (*see page 22*); this is likely to be about 2 or 3 f-stops less than maximum. The depth of field for each shot will then be very shallow, meaning more layers. How many are necessary will depend on the depth of the object and the degree of magnification: 20 separate exposures and layers would not be unusual.

You can shoot the sequence either by adjusting the focus of the lens (set the camera focus to manual for this), or by leaving the focus in one fixed position while moving the camera or the object forward or backward. If you are shooting with a bellows attachment on an SLR, as in the example of the 19 here, this is easy – simply use the rack-and-pinion tracking rail at the base. In either case, however, you will need to resize one or more of the layers.

Success is all in the planning, because you cannot afford to have gaps in the sequence, and it is safer to overshoot than risk having a zone that is unsharp. Practise first on a small section, altering the focus very slightly. Take two or three shots and then open them in an image-editing program that allows layers. All should be in perfect register. Examine each layer to see where each sharp zone ends, and brush out the soft areas of the top layer. As you do this, slowly, you will see the sharp zone of the underlying layer appear. This is a purely manual and visual operation; there is no way of automating it, because other image qualities affect the sharpness. For example, a smooth area may be in focus but show no detail. Do the erasing one stroke at a time, continuing until the brush stroke reveals a softer rather than a sharper result.

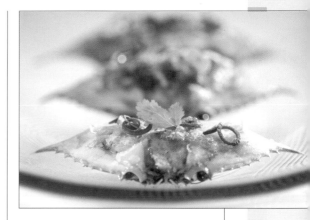

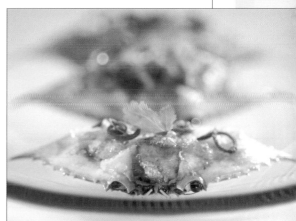

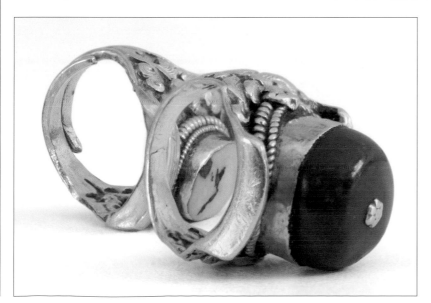

◄ Final rings
The final composite version, with the image flattened. Only the parts needed are sharp. Not shown here is the slight resizing necessary to compensate for the scale differences caused by refocusing – keep the layers in register.

▲ Crab meat
In this photograph of a Thai crab dish, selective focus was the style. The natural points of focus were the eyes, but it felt necessary to include the sprig of coriander. Doing this by increasing the depth of field would have spoiled the feeling of selective focus, so the two shots were combined. The camera was on a tripod and unmoved for both shots. The difficulty lies in the slight change of scale caused by focusing the lens, calling for rescaling of one layer by eye.

Case study: **closing in**

To highlight the way in which a simple change of scale alters both subject matter and perception, each of these pairs of images moves from a 'normal' view – the first thing you might see when approaching – to a small but significant detail within it. This is a special procedure for close-up photographers: scanning the scene not so much for its possibilities to make an image in itself, but rather for completely different images within it.

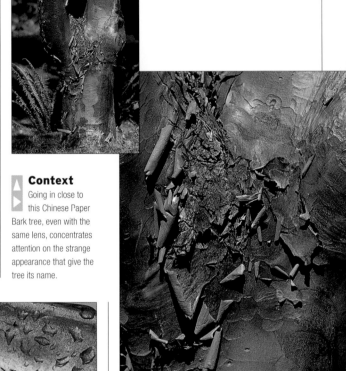

Context

Going in close to this Chinese Paper Bark tree, even with the same lens, concentrates attention on the strange appearance that give the tree its name.

History in detail

In the barracks of the famous Scottish regiment, the Black Watch, is the regimental gong. Not obvious from the distance necessary to capture the action is the origin of this bronze piece, captured during the Indian Mutiny. Water drops from a shower add texture to the gong's polished surface.

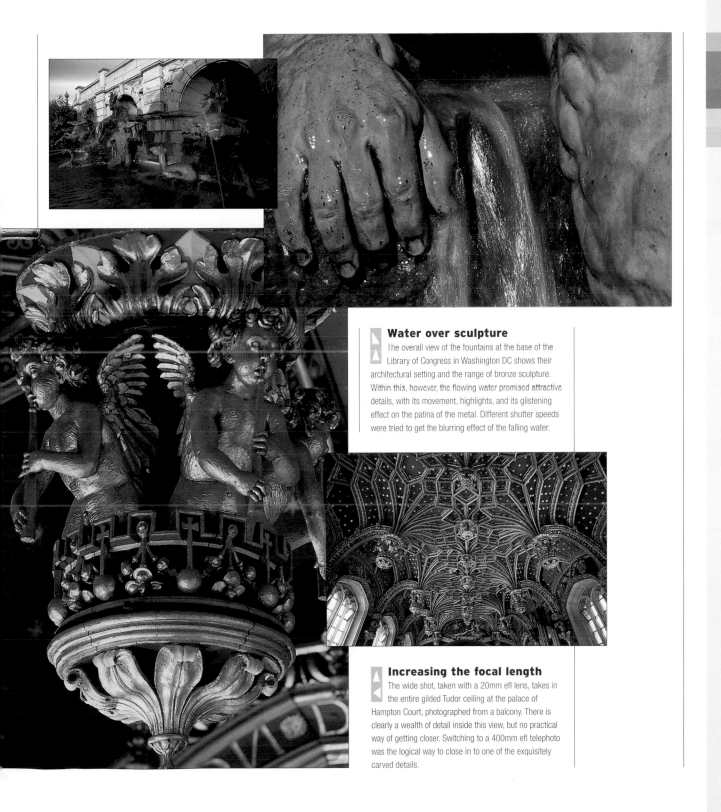

Water over sculpture

The overall view of the fountains at the base of the Library of Congress in Washington DC shows their architectural setting and the range of bronze sculpture. Within this, however, the flowing water promised attractive details, with its movement, highlights, and its glistening effect on the patina of the metal. Different shutter speeds were tried to get the blurring effect of the falling water.

Increasing the focal length

The wide shot, taken with a 20mm efl lens, takes in the entire gilded Tudor ceiling at the palace of Hampton Court, photographed from a balcony. There is clearly a wealth of detail inside this view, but no practical way of getting closer. Switching to a 400mm efl telephoto was the logical way to close in to one of the exquisitely carved details.

Case study: **closer still**

Increasing the scale difference from the last case study on the previous pages pushes the limits of perception even further. Here we go even deeper into the scene, to the magnifications that people rarely pay attention to in daily life – except when they are in the mood to examine something with special care. In many cases, it helps to have some prior knowledge of what to expect – for example, being aware of the possibility of mantids and other insects inhabiting rice stalks in a field.

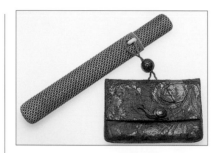

Pouch
The difference between these two images of a nineteenth-century Japanese tobacco pouch is not great. The longer shot is a standard documentary still life, but the clasp dominates the close-up.

Crystalline landscape
A large amethyst crystal, measuring about 7cm along each axis, makes a fine mineralogical specimen when seen whole, growing from a small section of its rock matrix. Closing in to a magnification of 1X and focusing on one plane of the interlocked crystals, with light aimed through the amethyst, reveals a landscape that could be at any scale imaginable.

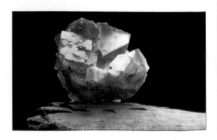

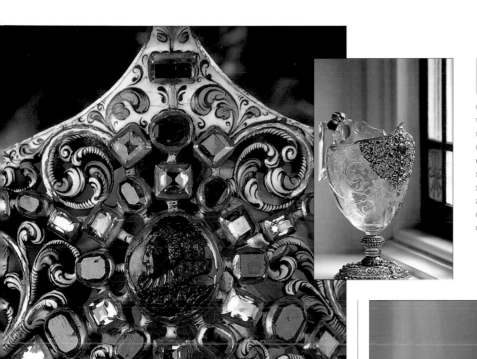

Ruby cameo

This Elizabethan crystal ewer, encrusted with gems, is a magnificent work in its own right, but on close examination it can be seen to contain something even rarer – a large cabochon ruby carved with the profile of Queen Elizabeth I.

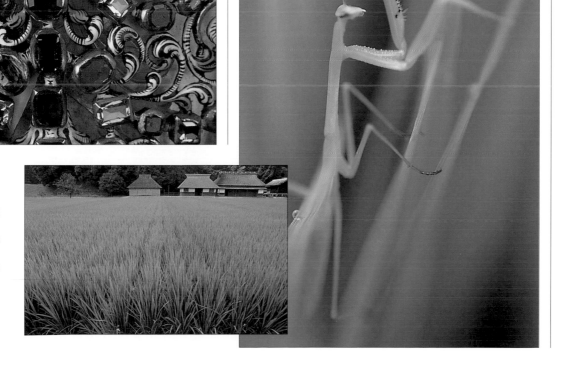

Hidden predator

An immaculately tended rice field in its full summer green at the Imperial Japanese Shrine at Isé seems to harbour no imperfections. Moving in with a macro lens, however, reveals another life below the surface, including a camouflaged mantid waiting patiently for its prey.

Found objects

There is much beauty to be found in the commonplace if you use the camera to isolate objects and details from their larger settings.

Part of the ethos of close-up photography is to direct attention onto something that we might ordinarily overlook. As we just saw on the previous four pages, these 'hidden' details can surprise by their beauty and unexpectedness. The only reason we missed seeing them in the first place was because they fell under the threshold of our normal scale of view. But the fundamental close-up technique of searching things out and exploring detail raises a larger question – what is a worthwhile subject for a photograph? This issue of fit subjects for display and investigation is common to all the arts, from painting to literature, but it has an especially prominent place in close-up imagery. The reason for this is that close-up implies selectivity from the very beginning, and much of the detail of life consists of things we would rather not see (consider garbage in its various forms, for example).

Now, because closing in with the camera involves divorcing objects from their context, it offers a wonderful opportunity to look afresh at objects that are normally considered worthless and not fit for photography. In 1972, the American Irving Penn, one of the most highly regarded still-life photographers of his generation, made a series of exquisite and beautifully crafted images – as platinum prints – of cigarette butts collected from the streets. By applying the techniques normally reserved for objects of value to the detritus of life, he simultaneously questioned our normal received values and celebrated the physical qualities of the ordinary.

Cigarette butts are an admittedly extreme example of the commonplace, and creative exercises like this can easily fall flat in the hands of someone less rigorous in his craft than Penn, but

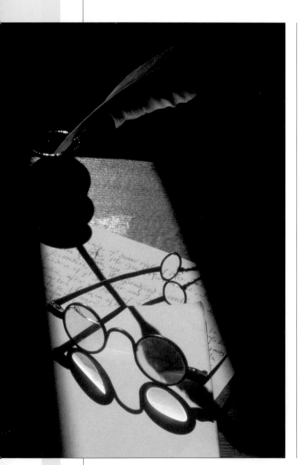

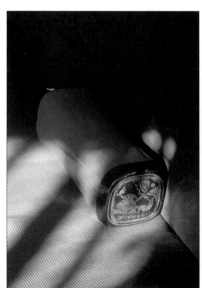

 Spectacles
This desk had just caught the morning sun, and the spectacle lenses cast an interesting play of shadow and light.

▷ **Pillow**
Another case of timing, as light through a partially shut window falls on a sofa with a Chinese opium pillow.

the principle of isolating very ordinary things that we would normally consider 'beneath' our attention is potent and valid. The essence of these images is that the photographer says to the viewer, 'look at this without your usual preconceptions'. The object may be without normal social or commercial value, but by selecting it, and shooting it with skill in composition and lighting, you are presenting your personal creative judgement.

Interiors are a sub-category of location for this kind of exploration. They offer a wealth of 'semi-found' objects and details, in small arrangements that form an important element in interior design. These objects are at least partly intentional in their choice and placement, and are rarely commonplace. The photographic techniques, however, are similar – pulling them out of the wider setting and choosing a viewpoint that allows you to create elegant in situ scenes. Indeed, entire books of interior design have been created from details like these. Visually, there is added value in images that appear to have been discovered than built up from scratch.

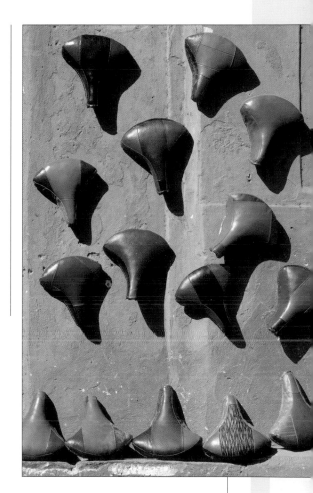

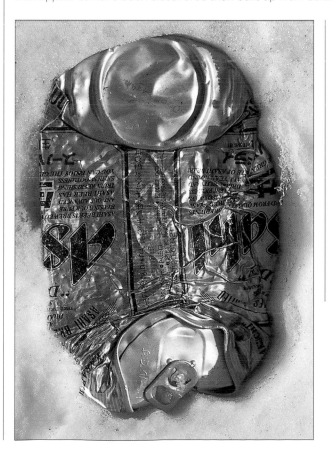

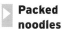 **Bicycle saddles**

Brightly coloured restored bicycle saddles are displayed on a red stone wall in the northern Indian city of Jaipur.

Packed noodles

Newly unwrapped, a rectangular block of Japanese udon noodles has a glowing textural beauty when backlit on a lightbox in the studio.

Beer can
Discarded on the pavement and flattened by passers-by, a bright aluminium beer can nestling in the snow becomes a sculptural object rather than a container.

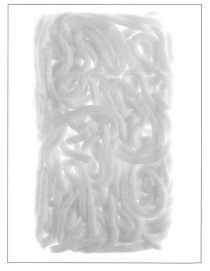

Reflections and shadows

In close-up work, use the secondary effects cast by objects to create more interesting and less obvious images.

Another feature specific to close-up is that reflections and shadows are more prominent than at normal scales. The reason is a subtle one, not immediately apparent in everyday life. As the scale becomes smaller, the variation in the size of things becomes greater. Take, for instance, a landscape viewed from an overlook. Even in hilly country, the texture of the scene is quite consistent. The strongest shadows will always occur early and late in the day when the sun is shining, and, even then, the largest shadows are likely to be cast by a promontory such as a rocky crag, or by trees. In other words, the further back you stand, the less the individual features stand out. A similar thing happens with reflections. The largest surfaces that reflect are bodies of water – lakes or the sea – and even these are only occasionally effective as mirrors, when there is a dead calm.

At close-up distances, all this changes. Shadows loom relatively larger, and reflections, if you choose to include them in the shot, can take over the picture. With imagination, this can provide excellent opportunities to make both the composition and the content of a photograph more intriguing. Both reflections and shadows share a common quality – they are by-products of

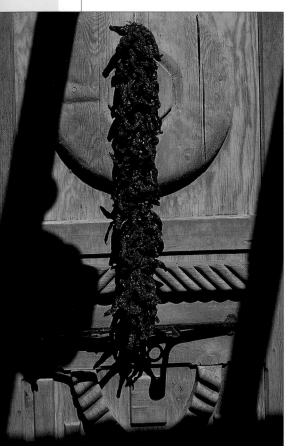

▲ **Drying chilies**
Red-hot chillies drying in the bright New Mexico sun. Intense sunlight in clear air created the ideal conditions for casting strong and definite shadows.

▶ **Yak horn**
The horn of a yak skull, wedged among prayer stones in Tibet, casts an elegantly curved shadow across incised text from a Buddhist scripture.

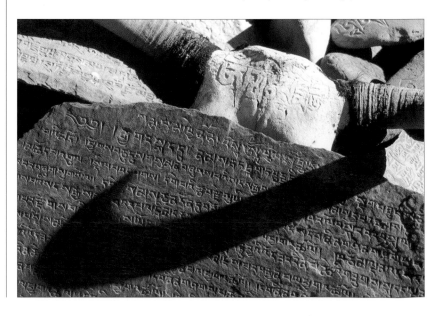

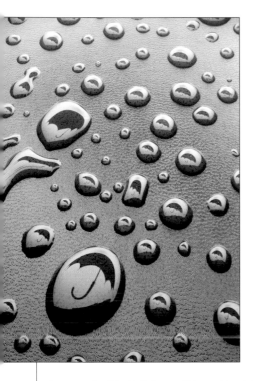

Umbrella raindrops

To catch the silhouette of an umbrella in raindrops would have been impractical with a real umbrella. Instead, a small window light was suspended close overhead, and a black paper cut-out taped to its front surface. Rather than water, which evaporates quickly, glycerine was placed on the background (a book) with a dropper.

Shadow of a bird

A Victorian display of a stuffed bird in a glass case reads perfectly well when seen only through its shadow on the wall of an old country house in England – and makes a more interesting image than a straight view of the object itself.

the way that light falls on things. Used in an image, they refer to objects rather than showing them directly, and this obliqueness of vision can be both subtle and graphic. As with all visual references, using them successfully depends on treading a line between the obvious and the obscure. Shadows are at their most interesting when they add some new quality to the object casting them, as in the image here of a Victorian stuffed bird in a glass case. In this instance, the distortions introduced by the glass bring extra visual interest to an otherwise straightforward outline. At the same time, if you decide to concentrate solely on the shadow, the exercise will fail if it is completely unrecognisable, or, worse still, vague. In the photograph shown here of carved Tibetan prayer stones, inscribed with Buddhist texts, one component of the pile of sacred objects was the skull of a yak. Interesting in itself, it made an even more intriguing image through the elegant and unexpected curved shadow that it cast so precisely.

Reflections in water and shiny surfaces, though they work in an optically different way, have similar possibilities in an image. They are less obvious than the real thing, and so bring a touch of the unexpected. Also, as with shadows, they can work as a second visual layer, allowing subjects to be juxtaposed neatly, as in the still life close-up of an umbrella in drops of water.

Case study: **strange encounters**

Closing in – tight framing, in other words – is one form of editing. By concentrating on a particular visual detail, the photographer is deliberately excluding other parts. And when these excluded elements of the scene are essential to the full information about the subject, the result is a kind of puzzle. The sheer unfamiliarity of how things look at these scales makes this easy. Factor in an unusual choice of subject and you have the classic guessing game of 'what is it?', playing on the element of surprise that is never far away in close-up photography. Each of these images relies on a slightly different combination of cropping, unfamiliarity and the confusion of scale to present a strange view.

Ice mammoth

This window was carved in the shape of a tusked woolly mammoth by an ice sculptor in one of the suites in Sweden's famous Ice Hotel.

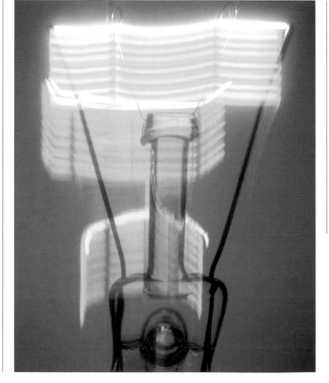

Lamp filament

The filament of an ordinary household lamp, greatly enlarged, becomes an abstract image, further altered by a second exposure during which the camera was deliberately moved.

Petri dishes
These shallow glass dishes are a standard laboratory item for growing cultures, but arranged and backlit against a perforated metal sheet they achieve a beauty that goes beyond their practical purpose.

Polaroid
A damaged sheet of instant print film seen at macro scale (2X magnification) turns into a peculiar landscape of ravines and riverbeds.

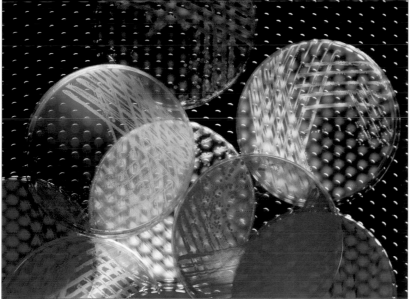

Gold bars
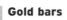 At a gold refinery, ten-kilo bars are being smelted, shot from above in their fiery crucible. The green fluorescent overhead lighting and molten gold below create a striking colour contrast.

Case study: **pearl harvest**

The images shown here formed part of a larger assignment on the pearl business, focusing on the seasonal harvest of pearls from the largest species of oyster off the eastern coast of Thailand. While there was plenty of photography undertaken, one important part was to show the pearls in close-up. However, this was a magazine story, not a catalogue, and simply lining them up in rows would not do. I looked at all the ways in which the pearls were gathered and grouped, whether for sorting and grading or for packing and labelling – that is, natural arrangements with minimal interference from me. I also looked for my own ways of presenting pearls, in one instance using a studio light and reflectors to bring out the special nacreous lustre that gives them their appeal as jewellery, in another relying on natural sunlight. The aim of all this different kind of shooting was not to find a single best close-up treatment, but to offer the picture editor variety.

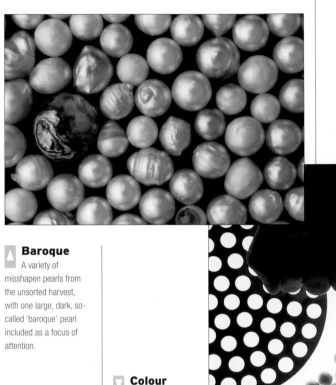

Baroque

A variety of misshapen pearls from the unsorted harvest, with one large, dark, so-called 'baroque' pearl included as a focus of attention.

Colour variety

A small selection of very fine pearls displays their range of colour. This was emphasized by shooting against black velvet.

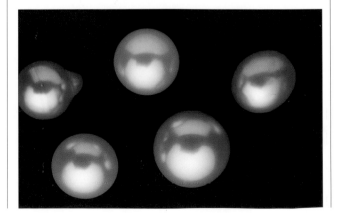

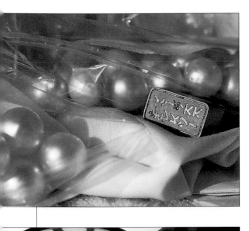

Plastic bags

The pearls themsleves complement the colour of the weight holding the bags in place.

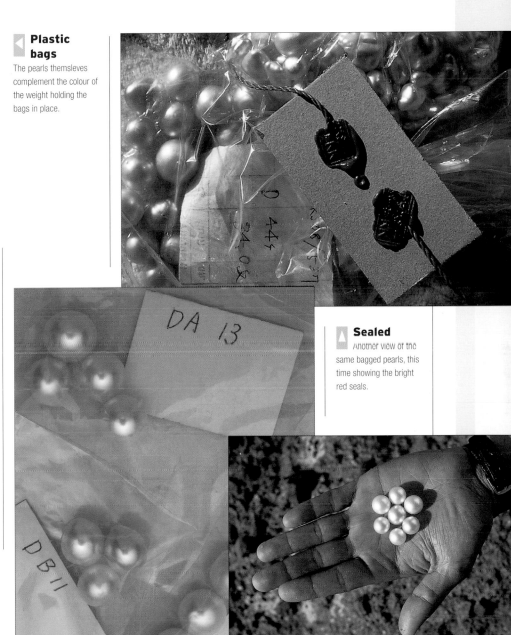

Sealed

Another view of the same bagged pearls, this time showing the bright red seals.

Grading

Special metal grading trays are used to divide the harvest into different size groups. They made an obvious graphic composition when strongly backlit.

Labelled packets

The soft blue skylight and reflections from the plastic gives another variation on the theme of wrapped parcels of pearls.

In hand

One tried and tested way of showing the scale of small objects is to place them in the palm of a hand. In this shot, afternoon sunlight creates a strong contrast.

Flash

Flash can help solve the lighting difficulties of small-scale scenes, but the built-in flash on some cameras may not reach very close subjects.

For several reasons, close-up shooting frequently calls for more light than usual. One is simply that small objects are often shaded by other things, including the camera if it is only a few centimetres distant. Another is that, as the lens is extended, less of the light passing through it reaches the sensor (*see page 16*). Thirdly, when you magnify the image, you also magnify the apparent speed of movement, so that what looks like an almost imperceptible swaying of a blade of grass becomes, through the viewfinder at macro distances, a violent gale. The alternative to raising the ISO sensitivity, which increases noise in the image, is to add flash.

Flash lighting has a special relevance to close-up photography, because at these scales the scene that you are shooting is usually small enough to be lit fully. At normal scales, such as when photographing a group of people in a room, the output from a flash mounted on the camera will usually light the subject but not the background. Shooting close-up, however, is like having a larger light. The normally harsh lighting from the small tube of a portable flash unit is actually improved at close distances with small subjects. The reflector and window of even a small unit is at least as large as most insects, for example, so that at magnifications in the order of 0.5X and 1X, the light will appear to be moderately well diffused.

Ringflash
A type of flash unit specifically designed for close-up photography is ringflash, a circular flash tube that surrounds the front of the lens, and creates shadowless illumination.

However, a camera's built-in flash unit may not be in the best position for very close shooting. It points forward, which is perfect for normal shooting distances, but if the subject is only a few centimetres in front of the lens, it may catch only the lower edge of the beam of light. Automatic exposure will compensate for this either by increasing the aperture or the flash output, but it means that you are losing flash efficiency. Worse still

Calculations

Under normal circumstances, automatic exposure mode will take care of everything, but as a back-up, in case you want to shoot in manual mode or are using off-camera flash, the following are the ways of calculating exposure increase and flash position:

1. Exposure increase = $\dfrac{(\text{Lens focal length} + \text{extension})^2}{(\text{Lens focal length})}$

2. Exposure increase = $(1 + \text{magnification})^2$

3. Flash-to-subject distance = $\dfrac{\text{guide number}}{\text{aperture} \times (\text{magnification} + 1)}$

4. Aperture = $\dfrac{\text{guide number}}{\text{flash-to-subject distance} \times (\text{magnification} + 1)}$

with some cameras, the extended lens in macro mode may actually cut off some of the light, leaving a strange semi-circular black shadow in the lower part of the image. It's as well to check the flash performance of a new camera at the closest distance that you expect to use it.

Most fixed-lens digital cameras have no provision for synchronization with another flash unit held separately. SLRs, however, do allow this, and in this case it is worth experimenting. The solution to flash cut-off from the lens barrel is to position a detached flash unit to one side, connecting it to the camera's sync terminal with a sync cord (some flash units have these built in). And it's not necessary to spend a lot of money on a sophisticated flash. A small manual unit positioned close to the subject should be quite powerful enough (a guide number of 40 is more than adequate), and you can easily arrive at the best combination of aperture, position and output by simple trial and error, using the LCD screen to check results. For more on special flash set-ups for close-up, see pages 134–135. For variety, an off-camera flash position can simulate, at least partly, natural lighting, particularly if the flash is softened. For this effect use either a proprietary diffuser (a small sheet of plastic) or a handkerchief.

Simulating sunlight

In some situations, it is possible to use a portable flash unit to mimic sunlight, either because the natural lighting is not satisfactory, or because a breeze creates a risk of blurring at slow shutter speeds. Because the illumination from a small flash unit falls off rapidly, lighting from the front always looks unnatural. The most effective method is the one shown here, where the flash is used to introduce a certain amount of back-lighting as well as overhead illumination. In the photograph [1], a shaft of midday sunlight isolates the head of a dandelion in a forest clearing. In the right-hand [2] photograph, a flash unit held above and slightly behind the same flower gives a passable imitation. Use a small stand for the flash if it's too awkward to hold yourself while shooting. Alternatively, place the camera in position on a tripod and hold the flash.

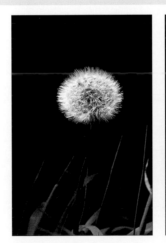

[1] Sunlight, 1/60 sec at f11

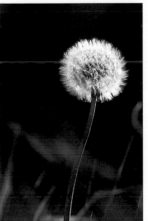

[2] Flash, f27 with ISO 80 guide number and the flash at 1 metre (3 feet).

◢ Freezing motion

Things appear to move faster in close-up. Freezing the image of bubbles rising in a bottle called for flash, in this case a separate unit fired through a sheet of translucent plastic behind the bottle, and attached by a sync lead to the sync terminal of an SLR.

Photographing with a scanner

With built-in near-shadowless lighting and excellent resolution, even an ordinary desktop scanner can be used to photograph objects to an extraordinarily high quality.

Think of a desktop flatbed scanner, now as common a fixture in offices and homes as a fax machine used to be, as if it were a copy camera. It's fixed, bulky and points upwards, but if you already have one, you will find that it can knock the socks off any digital camera when it comes to certain types of close-up subject. Scanners have some exceptional qualities, not least of which is the resolution. Even a modest design will deliver high resolution by the standards of photography, for the simple reason that scanners are intended for 1:1 reproduction, whereas camera images are always meant to be enlarged.

By analogy with film photography, the scanner is the ultra-large format device, equivalent to a 8 x 10-inch or 11 x 14-inch plate camera – exactly what was once used for the highest quality still lifes and copyshots. If your subject conforms to a few basic specifications, consider scanning it rather than photographing it – the results may well be superior. The requirements are: first, that the object is more or less within the size range of the scanner's bed; second, that it stays still; and third, that it is moderately flat (or can be slightly flattened without damage). A large leaf from the garden is what comes easily to mind, and I chose that for one of the examples shown here. Actually, the flatness is not compulsory, any more than it is for close-up photography in general, but scanners have shallow depth of focus, being intended for documents and images. And, significantly, you cannot choose where to focus – it will be whatever is nearest the glass. Naturally, take care with the glass surface to avoid scratching it.

The quality of the lighting is non-adjustable, but is surprisingly pleasing for three-dimensional objects, being frontal without the harshness associated with on-camera flash. In essence, it is rather more like a ringlight (*see page 132*) – an enveloping illumination with very gently modulated shadows. As the scan of the white orchids demonstrates, a gentle fading away towards the background produces an unusual and delicate effect. You can control the exposure and colour through the scanning software controls. This may mean finding the advanced options and turning them on, depending on the sophistication of the software supplied with the scanner.

A basic scan

Using the standard document set-up in which light is reflected from the object, a withered brown leaf is simply laid on the glass and the platen with its bright white under-surface lowered gently onto it. The scanning software – unsophisticated in the case of this Canon scanner – is used at its auto setting. At this high resolution and 48-bit colour depth, any colour and tonal adjustments can be made later, in image editing.

▶ Against black

A similar document set-up to the leaf scan was used for these White Phalaenopsis orchids, the difference being that I wanted a contrasting black background. To get this, I raised the platen and substituted a piece of black cloth, which did not damage the delicate blooms.

▼ Slide scan

Thin, translucent specimens like this green leaf can be treated as if they were slides, if the scanner has a slide-scanning head. In this arrangement, the lights in the head were used to shine through the object for a backlit effect.

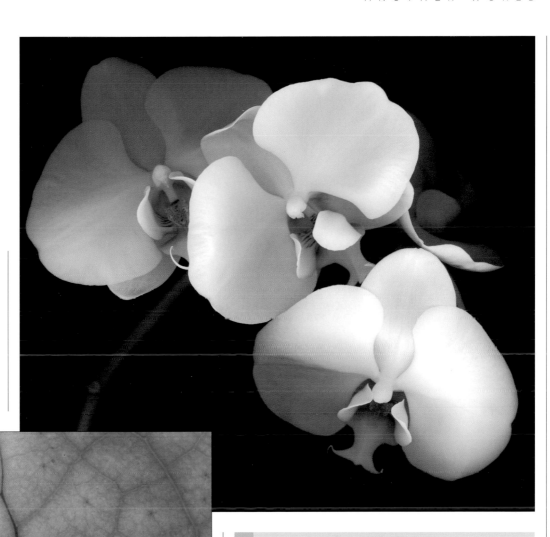

Pros and cons of a scanner-as-camera

Pros
High resolution for platen-sized objects
(that is, approximately A4 or A3)
Built-in low-shadow lighting
Works directly with the computer
Good range of image adjustment controls

Cons
Limited depth of field, best with flattish subjects
Scans need some kind of cover
Non-transportable
Long exposure

Micro

Although photomicrography is in general a specialized field, at entry level it is inexpensive and is now fully geared for digital cameras, which offer you instant results.

For the nature and close-up photographer, the huge variety of interest and life-forms that can be found at the microscopic level offer some very exciting possibilities for creative photography. Ideally, in photomicrography it is the microscope alone that should form the image, because it is far better equipped than any part of the camera system to do so, and it is important not to degrade a carefully enlarged image by using an additional camera lens.

A digital SLR is the best choice of camera to use for photomicrography. These models are light enough and compact enough to be supported directly on the eyepiece of the microscope, by using a special adapter tube. Some stereo microscopes even have an additional vertical tube to allow a camera to be attached. These models are known as trinocular microscopes, and they can switch the image into either the viewing or photographic tubes by means of a prism.

Most digital cameras have a fixed lens, which is less than ideal, but there is sufficient demand within the field of microscopy for taking pictures that a number of adapters are available. These are enough to cope with any camera, however basic. The first issue is of physically fixing the camera to the microscope. Some fixed-lens cameras, such as the Nikon Coolpix series, have a screw thread at the front of the lens that can be used to attach the camera directly to the microscope with a coupling ring. If you do not have a camera that allows this, there are two alternatives. One solution, which can be homemade, is a tube attachment that fits like a sleeve over the camera lens at one end, and over the microscope eyepiece at the opposite end. The other solution is to use an adjustable mount that attaches to the underside of the camera via its tripod bush.

The second issue is focusing the image. With a fixed-lens camera, in addition to a mount that enables the camera to 'look down' the eyepiece, a secondary relay lens is needed to focus the microscope image, and this is incorporated into the adapter. There are many companies specializing in microscopes and accessory equipment, and probably the best approach is to visit their websites.

▽ Plug in
Using this adaptor (from a range by Brunel Microscopes), a digital camera can be attached to the eyepiece of an ordinary microscope.

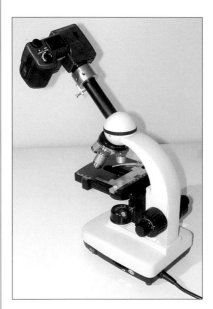

Choice of microscope

When it comes to choosing a microscope, what counts first is the application for which you need it. If you are a researcher with a particular field of study, you will already know this, but if you simply want to explore the photographic possibilities with no scientific requirements, you will probably be better off looking for a low-powered monocular instrument.

Typical professional compound microscopes have a range of magnification between 40x and 1000x. However, magnifications of between 20x and 40x are easier to manage and are better for such recognisable specimens as insect details. You can mount a camera on either a monocular or a binocular microscope, but for maximum convenience (albeit at a price) there are also trinocular microscopes, in which the third lens is dedicated to the camera. Stereo microscopes deliver an upright and unreversed three-dimensional image (unlike the normal inverted and reversed image). This is useful if you have to manipulate the specimen, but it also adds to the expense.

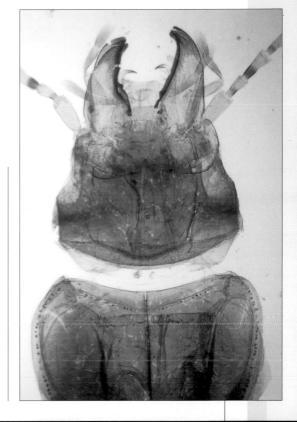

Insect

Standard brightfield illumination (*see page 45*) was used for this photomicrograph of the head of an insect – basically, back-lighting, but there was sufficient density in the insect's exoskeleton to show structural detail.

Pearl section

Measuring 3.2mm at its widest, this thinly sliced section of an unusually shaped natural pearl is here seen under darkfield illumination, explained on the following pages.

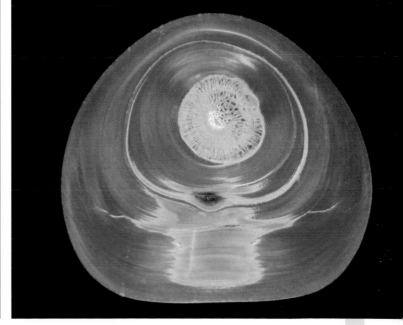

Digital camera settings – checklist

1 Turn the flash off.
2 Set metering to matrix metering if available, not spot.
3 Set white balance to incandescent if the light source is tungsten, or auto.
4 Set macro mode if there is one.
5 Set maximum aperture, by choosing either aperture priority mode or manual.
6 Use the LCD screen to frame and focus.*
7 Zoom lens forward until you see the least vignetting (shading at corners).*
8 Set continuous autofocus.
9 Use a cable release if there is a fitting for one, or the timer.
10 Do not touch the camera or microscope during exposure.

* for fixed-lens non-SLR digitals

The microscope

Microscopes are available at all levels of sophistication, from school classroom models to highly specialized instruments, and all can be used for photography

Not surprisingly, the best microscope equipment is expensive, and the final choice is often a compromise between optical quality and price. For photomicrography, certain microscope components are particularly important. These are the objective, the eyepiece, condenser and mechanical stage.

The principal lens in a microscope is called the objective. Its magnifying power is engraved on its mount, and is usually between 5x and 100x. The most important quality in an objective is its ability to resolve detail. The usual measure of this is known as 'numerical aperture', or NA, a figure calculated from the angle of a cone of light needed to fill the aperture of the lens. The higher the NA, the better the resolution. In air, the maximum NA is 1.0, but some objectives are designed to be immersed in a film of oil, which allows an NA of up to 1.40. The most common, and least expensive, objectives are known as achromats, and only partly correct the most common optical aberrations. Coloured fringes are usual at the edges of the image. The finest quality objective is the apochromat, which is highly corrected.

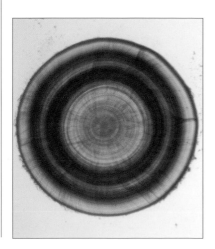

Brightfield/ darkfield

This pair of photographs, of a thin section from the middle of a natural pearl, illustrates the difference between the two most basic kinds of microscopy illumination, brightfield (left) and darkfield (right). Note that in this case, with a surrounding featureless area, brightfield lighting is prone to flare – corrected (lower) by close adjustment of the black point and white point.

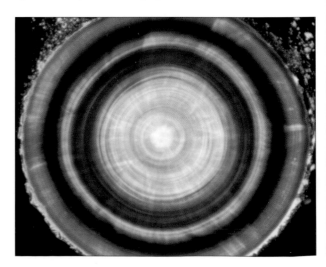

The secondary lens in a microscope is the eyepiece. It magnifies the primary image and projects it either to the eye or the film in a camera. For photomicrography, a 'compensating' eyepiece is needed – this corrects some of the defects in the objective. A matched pair of objective and eyepiece gives the highest quality image. Another important part of the optics is the condenser, a lens situated below the stage, which collects the light from the lamp and converges it on the specimen. There are three types of condenser: Abbé; aplanatic; and achromatic, and the latter is the most corrected for optical aberrations. It is thus best for photomicrography. The final essential component is the mechanical stage, for precise control of the position of the specimen and the composition of the image. These are either manual or the much more precise micrometer drives.

In basic operation, the simplest method of lighting a specimen is brightfield illumination, which, as its name implies, displays the specimen against a brightly lit background. The light is, in fact, passed through the specimen, which is thin enough to be translucent. Standard microscopes have a mirror beneath the subject, and this can be angled to project light upwards from a separate lamp. Some advanced models, however, have built-in light sources. The principle of brightfield illumination is to focus an image of the lamp in the plane of the specimen, and in such a way that it falls on the centre of the field of view and covers the whole field evenly. The lamp, therefore, is an essential part of the optical system. The standard light source in photomicrography is a tungsten filament lamp, fitted with a condenser lens and diaphragm that can both be adjusted. A tungsten-halogen lamp is the best for colour photomicrography, as the glass envelope does not darken and discolour with age. The disadvantage occurs when photographing live, moving organisms that need greater illumination to avoid blurring. An answer is electronic flash, using a pocket flash unit. An auxiliary tungsten lamp must be placed in the same position for viewing and focusing prior to photography, however.

Exposure and colour balance

Because microscope optics do not allow the use of an aperture diaphragm, exposure must be controlled by other methods. Altering the shutter speed on the camera gives one stop adjustments, but for finer control either the lamp position may be changed or neutral density filters may be used. As an approximate guide, shutter speeds for a typical brightfield arrangement at ISO 200 sensitivity, might run from 1/15 second to 1/250 second.

Microscope lamps are generally balanced at around either 3,200 Kelvins for tungsten light or 5,500K for daylight use, so you can adjust the white balance in-camera. Additonally a 2B filter may be needed over the lens to absorb unwanted ultraviolet radiation.

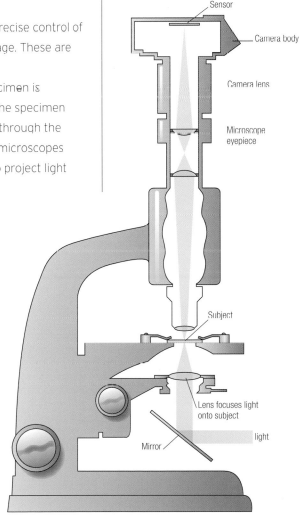

Sensor

Camera body

Camera lens

Microscope eyepiece

Subject

Lens focuses light onto subject

light

Mirror

Photomicrography lighting

Because most microscope specimens are so thin that they are largely transparent, one of the greatest problems is to light them in such a way that they are clearly visible.

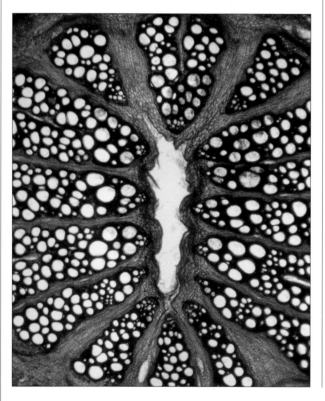

Apart from a few specialized types of microscope, such as metallurgical models that use reflected light, the normal procedure in photomicrography is to shine light through a specimen in one way or another. Many specimens such as cells, amoeba and other minute organisms, are naturally very thin and transparent, so this presents no particular difficulty. Other specimens, however, have to be prepared as extremely thin sections to display their structure, using a slicing instrument such as a microtome. The difficulty with such delicate structures is usually in achieving sufficient contrast to record an image. Staining, as you can see in the photograph shown left here, is one standard technique for achieving contrast.

The basic illumination for photomicrography is brightfield (*see page 45*), in which the light shines through the specimen, and its precision affects the sharpness of the photograph. For a precisely focused and evenly lit image, the beam of light from the lamp requires some careful adjustment.

On a simple model of microscope, a mirror at the base is angled to direct the beam from a separate lamp straight up towards the sub-stage condenser. This is a simple lens that focuses the light on the specimen, which is placed on the microscope's stage. It is essential that the lamp's beam is centred on the condenser and that it just covers its circumference. More advanced microscopes have built-in lighting. The light then passes through the microscope's primary lens – the objective – positioned just above the specimen. At the top of the tube, the eyepiece lens further increases the magnification, and is used in preference to the camera's ordinary lens to focus the final image on the film.

For microscopes that do not have light sources built into the base, the standard light source is a tungsten filament lamp, equipped with its own

◢ Staining
As thin transparent sections are necessary for brightfield photomicrography, many specimens would be invisible if not prepared specially. An integral part of much microscope work, therefore, is staining. Biological stains are available in all colours, and the choice depends on the specimen. Typically – on a tissue section, for example – two contrasting stains are used for different parts of the specimen. Trial and error are necessary to fine-tune the white-balance setting to suit the staining.

adjustable diaphragm and condenser. However, when photographing active specimens, a portable electronic flash unit may be needed. To overcome the difficulty of positioning a small flash unit correctly, adjust it so that is at the same angle and height as the tungsten lamp used to set up the shot, and then carefully slide it into the same position. Fortunately, the instant feedback from a digital camera makes this easy to check.

Darkfield lighting

By arranging the lighting so that the background is dark rather than light, transparent specimens can be seen much more clearly, with enhanced contrast. To achieve this effect, a 'darkfield stop' is placed in the centre of the beam of light, below the condenser, forming the light into a hollow cone. When a specimen is placed on the stage, it scatters light up to the objective lens. Because so much of the light from the lamp is lost with this method at high magnifications, for photography it is often necessary to use either a higher sensitivity, longer exposure, or electronic flash. At low magnifications, however, it is ideal for marine organisms, such as plankton.

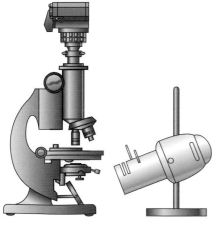

Using light

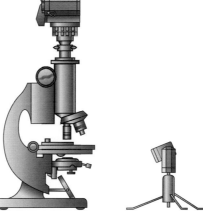

Using flash

▲ Lighting polished sections

A polished metal section like this Roman tool fragment needs reflective lighting, being opaque. In a metallographic microscope, as here, the vertical reflective illumination is provided by using a beam splitter above the objective. Light is introduced from the side into the main optical system, and the 45° beam splitter redirects this down the axis.

Special techniques

The delicacy and transparency of many subjects, particularly if they are moving, living ones, calls for an even greater boost to contrast.

Basic brightfield or darkfield lighting, combined with staining, can cope with a wide range of specimens, but by no means all. Live subjects that move need more light, and very shallow, transparent specimens need much more contrast to be clearly visible. For these cases, several advanced techniques have been developed, needing accessory equipment or even dedicated microscopes.

Phase-contrast

A more sophisticated lighting technique that can reveal internal details of completely transparent objects is the phase-contrast method. This uses an effect in which the edges and fine detail in the specimen diffract the light passing through it – the specimen passes a portion of the light directly without modifying it, but scatters the remainder. In a phase-contrast microscope, a special coating behind the objective slows down the direct beam of light by one quarter of a wave-length. When the two beams – one direct, the other scattered – are drawn together again, they are no longer in phase, meaning that the peaks and troughs in the light waves are in slightly different positions. The light reaching the eyepiece is therefore less intense, but the small differences in the structure of the specimen have been enhanced.

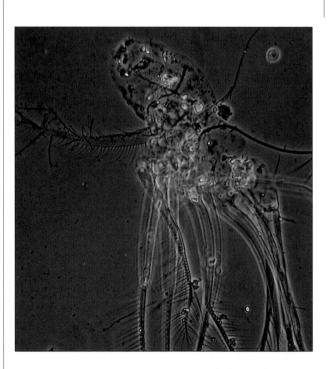

Phase-contrast
This tiny decomposing mosquito lava has clearly visible edges thanks to the phase-contrast method. Otherwise it would appear only as slight variations in a clear image.

Interference-contrast

In the phase-contrast system, detail is made visible because two beams of light create interference patterns that correspond with differences in the specimen. Other interference-contrast methods produce a similar result, but the light is split not by the specimen but by the microscope's optical system. The Nomarski system, for example, uses prisms to split the light, one beam of which is directed through the specimen, the other bypassing it. The first is called the 'object beam'; the second, the 'reference beam'.

good because of the small size of the imaging lens. As most endoscope photography is conducted in small, restricted spaces, such as the internal organs of the human body, lighting is usually carried alongside the lens system, down a second fibre-optic bundle. Image quality is poorer than that from a normal camera lens, but at least some kind of picture is possible in spaces inaccessible by any other means. It also makes it possible to give the kind of view that a small creature would have.

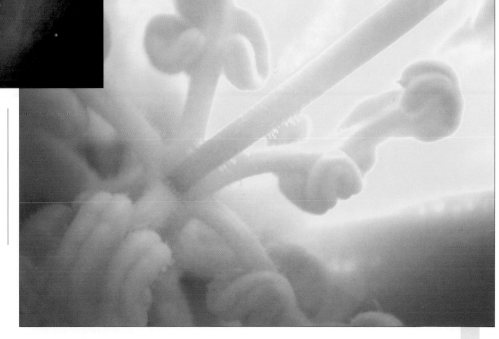

Depth of field
A by-product of the tiny lenses used in endoscopes is great depth of field, similar to that of a pinhole camera, as demonstrated here close to the tip of a burning cigarette. Image quality, however, is not high.

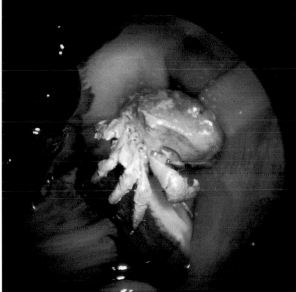

The view from 5mm
Photographed with the borescope, this minute parasitic crab inside an oyster would have been an otherwise impossible shot. Low light transmission down the fibre-optic cable and back up the channel called for the highest sensitivity setting, which resulted in some loss of quality.

California Glory
Used in the garden, an endoscope is a useful tool for exploration, giving an insect's eye view of plants, as with this interior view of the yellow pistils of a California Glory (*Fremontodendron californicum*).

The Art of **Still Life**

The still life is a genre of image that pre-dates photography by at least three centuries, and yet is one to which the camera brings a distinct and original approach. It is bound up in the idea of things selected and seen closely, with a strong element of the display of the image-maker's skill. Indeed, this inevitable emphasis on creative technique – primarily composition and lighting – held the still-life back from consideration as a worthy form of art. In painting, it was long considered as a kind of exercise in which the artist honed skills that would later be employed in subjects of real importance – religious allegories or portraits. Collections of mere objects were simply not considered worthy of art, except in a supporting role for grander scenes.

It took painters like the Spanish Juan Sánchez Cotán (1561–1637) and the French Jean Chardin (1699–1769) to elevate still life to respectability, and photography has inherited this – though with qualifications. Chardin, in particular, was highly influential, and widely praised even at the time for his insight into the nature of things and his ability to breathe life into the mundane. Chardin painted one of the most famous of all still-life paintings. Called *The Skate*, it features a dead and bloody fish hanging with its face towards the viewer. Diderot, Chardin's contemporary, wrote, 'The subject is disgusting, but it is the very flesh of the fish, its skin and its blood; seeing the thing itself would affect you in the same way.'

As Chardin demonstrated so convincingly, the choice of subject is not only important, but completely open. Subjects vary enormously – indeed, there's no a priori definition of what constitutes the focus of this close attention, as we'll see in some of the examples that follow in this section.

Photography, especially, has allowed a wide range of subject material as it takes much less time than painting or drawing, and so much less is riding on the choice of objects. Even less is at stake with a digital camera, because the completed image is immediately available for assessment. In the days of film, an important set-up would be left untouched while the film was processed. With digital capture, the process is complete as soon as it looks right and the image has been checked on the computer. As well as having practical benefits, this gives even more freedom to experiment. Shooting direct to the computer, as is possible with more advanced cameras, is by far the most convenient method.

Because the still-life is a tightly controlled form, it inhabits, for the most part, the studio. Here, I'm using the term 'studio' in a broad sense as a space in which everything, and in particular lighting, can be manipulated at will. Still-life photography is probably the most demanding of all studio work, and its standards, set largely by magazine and poster advertising, are extremely high. Professional studios are typically well-equipped and are dedicated to the purpose, but for occasional use the two features that you need are control of the light and a lack of clutter. Given these, you can call any space your studio. Just remember that improvisation certainly does not mean unprofessional. Instead, it lies close to the heart of creativity.

Composing a still life

Follow a plan of action in building up a still life from scratch, so that the composition steadily improves – but stay open to unexpected possibilities.

A still life of your own choosing begins with an empty space waiting to be filled – in much the same way that a blank canvas faces a painter. For photographers who are accustomed to shooting real life and real nature outdoors, this is an unexpected freedom – so much so that it can be a little daunting. There are no guidelines other than your own imagination, and the choice of subject. At least at the start, it may help to ease yourself into the process of arranging the still life by taking a deliberate step-by-step approach, as summarized here. As you gain experience and confidence, this will all start to come naturally.

The first decision, though it may seem too obvious to mention, is to choose the subject – which may be one object or a group. Behind this choice, of course, lies an idea or a theme. You may choose something simply because you like its shape. Fine. In that case, keep in mind that shape is what you want to show, by positioning, camera angle, lighting, and other objects. The theme may be more complex than this, or less obvious, but as you go through the process of arrangement, keep it in sight.

Even when a subject has been selected, the choices of setting, composition, camera angle and lighting are so open that it may be difficult to know how to proceed. For this reason, many still-life photographers follow a sequence, gradually refining down the possibilities until the entire set, arrangement and lighting have been perfected. There is a very strong element of the constructed image in still-life shooting in which there is a path that progresses from the raw ingredients and slowly develops into the final result. The order of doing this varies according to the personality and style of the particular photographer.

Consider the background, because this will need to be in position before you start placing objects. Backgrounds range from the non-existent – white – to the complex and eye-catching, and over several pages in this section we look at the various alternatives. If you have no immediate idea, look through these examples to see if any stimulate your imagination. At this stage, you may want to put a rough lighting plan into position, and it helps to have an approximate idea of the effect. Again, however, if you have no strong opinion

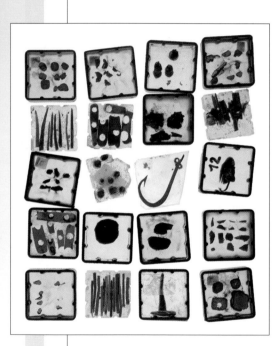

Like objects
Small archaeological artefacts embedded in blocks of resin were arranged in a back-lit still-life to emphasize their similarity – but with a few of them deliberately angled for compositional interest.

about this at the start, consider the simple arrangement illustrated on pages 64–65. You can always change the lights later – and you will almost certainly want to make some refinements once you have completed the composition. Lighting quality, as we'll see, is critical to the success of a still life, to the extent that you could almost think of it as part of the object.

Possibly the most entertaining, and occasionally frustrating, part of still-life photography is the detailed arrangement of the parts of the composition. Moving objects slightly in relation to each other, and constantly checking the effect that this has through the viewfinder or on the camera's LCD screen, is a process that can go on forever. Once you have the idea of where, more or less, things should be, pay close attention to the detail – whether the corner of one object interferes with the edge of another, for example; if there is an awkward gap; or if some detail is lost against the background. As you work on this, you will probably find that the parts of the composition gradually seem to interlock, until finally there seems to be no room for improvement – at least, to your original idea.

▶ Avoiding regularity

In unplanned outdoor photography, one of the most eye-catching occasions is the unexpected alignment of objects and lines – order suddenly appearing out of the chaos of everyday scenes. In studio photography, however, there is a reverse problem, of avoiding the obvious in an arrangement of objects. In this shot of jade gems on large blocks composed of rough jade matrix, it is clear that the stones have been arranged and not simply found. Yet the style of the composition is loose, not geometric. Arranging nine virtually identical objects so that they do not lock together into an obvious shape took several minutes of experimentation.

◀ Informal grouping

The purpose of this food shot, taken in an authentic Shaker kitchen in Kentucky, was to show the kind of produce grown on the home farm, in juxtaposition with nineteenth-century utensils. The potatoes in the iron pan key the composition and are off-centred so that the eye can move down along the pan's handle and also up to the crowded baskets of vegetables lit gently by a window at top right. There is deliberately little empty space, yet the arrangement looks comfortable rather than chaotic.

Starting from scratch

Here is one example of a procedure for constructing a still-life image:

1 Examine the subject (or subjects) and decide what they need in terms of camera angle, focal length and lighting, as well as the kind and colour of background and props that might help to set them off.
2 Assemble the props to go with the subject.
3 Choose the background or setting.
4 Make a first, casual arrangement, with the main subject prominent.
5 Try different lighting combinations until you find one that best suits the set.
6 Position the camera.
7 Refine the composition.
8 Make final adjustments to the camera angle.
9 Refine the lighting.

Minimalism

Reducing a composition to the bare essentials can sometimes make a more powerful image than the more usual process of building up a still life with props and additions.

The ability to arrange objects in front of the camera in any way you care means that you have complete freedom of composition. It can be interesting to exercise this in the opposite manner to normal, by limiting what you show and concentrating on the 'pure' qualities of shape, form, texture, colour and space. This is minimalism. Minimal art emerged in the 1960s and 1970s, and was characterized by its extreme simplicity of content and arrangement, which was often geometrical. It became a mainstay of design, and also enters the world of still life. The reasons for its popularity as a style among studio photographers are not hard to find. First, still-life shooting is all about constructing an image, and an almost-inevitable result is that things tend to get discarded from compositions as the photographer exercises an increasingly refined sense of design. One of the tenets of minimalism is to say more with less, and the still-life arrangement as translated through the camera viewfinder is an ideal medium for this.

A second, related reason is that photographers, like any artists, generally like to make their own mark on a picture. Yet normal photography makes this harder to achieve than drawing or painting, because it can only deal with what is in front of the camera (digital manipulation aside). Reducing the scene, or at least its components, is one of the few reliable methods of making a dent in the predictably photographic nature of the image. It calls for a rigorous approach to both the selection of objects for the composition, and to the graphic design of the whole image. When you have only a few items in the frame, their placement takes considerably more effort and attention. Minimalist composition presents the viewer with little alternative, and the response is likely to be all the more critical for that. Backgrounds of empty space must be either meticulously clean or convincingly natural.

Least detail
A composition that deliberately looks sideways and a severely restricted palette of colours and tones conveys the essence of the strict simplicity of Shaker life. This nineteenth-century linen shirt was hanging close to a window in a Kentucky meeting house of the utopian religious sect. Absence of decoration was part of the Shaker lifestyle. The obvious framing – the whole shirt, centred – would have been just a record shot, but something more interesting was wanted. Shifting the view to the left loses no essential information (we can already see what a sleeve looks like), but emphasizes the bareness of the setting. The shadow on the left balances the composition.

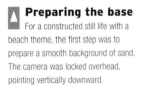

Assembling
The raw ingredients for the scene were shells of many different kinds. These were grouped in trays, then placed in position with tweezers.

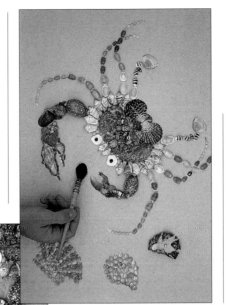

Final cleaning
After more than an hour of assembly, the sand was brushed down to appear flat, and stray grains removed.

A styled shot
The finished design, worked meticulously in a variety of shells, is lit very diffusely to minimize shadows and emphasize the individual shells.

Preparing the base
For a constructed still life with a beach theme, the first step was to prepare a smooth background of sand. The camera was locked overhead, pointing vertically downward.

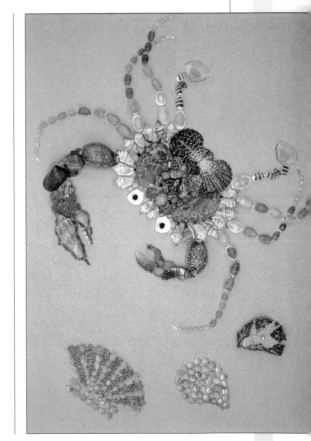

Other sources of props are antique dealers and street markets. By offering a deposit on the full value of the item, you can usually find a dealer who is willing to hire, even if it is not normal practice. Many props are inexpensive enough to buy outright, and most still-life photographers have a small stock of interesting or useful props. A slab of marble and a butcher's chopping board, for instance, have obvious value to a food photographer, as do glasses, decanters and tableware for food presentation. With other areas of still life, it's difficult to generalize, and much depends on whether you have a particular style. Even so, most homes have a surprisingly useful range of items, from heirlooms to interior accessories – and that applies to friends' homes also. When you are looking around for anything appropriate, it is important to remember that you can always try different combinations.

Continuous lighting

Tungsten lamps are the traditional type of continuous light source – uncomplicated though hot – but they are now being challenged by colour-corrected, flicker-free fluorescent.

As in any kind of lit photography, on location or in a studio, there are the usual arguments in preference for flash or continuous light. If anything, however, the cases for and against each are more definite with close-up shooting. The major advantage of continuous light is that you can see precisely what you are doing, and at close range, where it may be a little difficult to organize the view in the first place, this is a compelling argument.

The competing case for flash, of course, is its movement-stopping power, very relevant on a small scale; we deal with that on the following pages.

Tungsten used to be the only contender for a continuous light source, but since the introduction of high-performance fluorescent lights, the choice has expanded. With a digital camera, the colour balance is not an issue (set the white balance to suit), except in situations where you are mixing different types of light sources. For precision and normal shooting, it's best to keep the lighting consistent, although a mixture of colour, such as a tungsten spot added to daylight, can enrich the scene. As always, test and review the result on the LCD screen before continuing. In a studio setting, it's relatively easy to check the results immediately on a computer screen, which will show a larger image and more accurate colour. If your camera allows direct shooting to the computer, even better.

▼ Fresnel spot
These tungsten lights can be directed and controlled with barn doors, but give off a lot of heat.

▼ Bowens 9lite
Designed specifically for digital photography, the 9Lite offers cool continuous light that can be placed close to the subject for maximum efficiency. It consists of nine 30w flicker-free fluorescent lamps mounted together in a single lamp housing and placed in a square intensifier to produce an efficient, square light source.

▶ Highlights
These lights, here from the Photo Bear range, give a wide spread of light, ideal for soft continuous lighting.

There is a wide selection of lighting available for studio photography, almost all of it professional, and design standards for equipment and fittings are high. Because of the heat generated by tungsten lamps, they are not a good choice for diffusing attachments that enclose the head. For this kind of area or 'window' light, high-performance fluorescent or flash are better (*see following pages*). The standard tungsten head uses a Fresnel lens and adjustable lamp position to control the beam

Precision lighting

The Dedolight system, designed originally for cinematography by a director of photography (and sold by Dedotec USA, Inc.), is extremely compact and fitted with precise beam control by means of two meniscus lenses. The second lens pre-collects the light, directing it to the front lens and minimizing light loss. As a result, there is virtually no 'spread', or stray light. Shadow edges can be crisp from a distance, and their position and shape adjusted exactly by means of barndoors or projection attachments with adjustable framing blades.

Often, the small scale of close-up sets calls for lighting that works on a similarly small scale. If you want diffused or enveloping light, you have the advantage that lights built for normal-scale shooting give even more of this because they are larger in relation to the object, but the same lights are less effective at delivering crisp, precise, hard-edged illumination. One problem is simply the size of the lamp. Most high-intensity quartz-halogen lamps are considerably smaller than the palm of your hand, and for a normal subject, such as a person, they are virtually a point source. At high magnification, however, the same lamp may be the same size, or even larger, than the subject. Hard lighting at close range needs one of two things: either a tiny lamp (which will then be less bright), or a focusing lens. You can experiment with simple lenses; or you could try using a magnifying glass – the principle is the same as for concentrating the sun's rays with a handheld glass to set fire to a piece of paper. Alternatively, you could invest in a professional lensed light (*see box*).

▲ Visual control
► For this shot of a perfume distillation flask in action with petals added to boiling water, a particular spotlit effect was needed, with carefully judged highlights. A lensed tungsten head was used so that the precise effect could be seen through the viewfinder; it would have been less exact with flash.

Studio flash

Measured doses of daylight-balanced
illumination; motion-stopping pulses;
and absence of heat build-up have
made mains flash the choice for most
studio shooting for decades.

A world away from pop-up flash on a camera,
studio flash units are larger, more powerful, and can
be fitted with any of a range of attachments to diffuse,
concentrate or modify the quality of the light.

The easy ability of digital cameras to adapt to the
colour of any light source, through the white balance
settings, gives studio flash somewhat less of an edge
than it enjoyed in the days of film, but it retains its other
advantages, namely speed and coolness. The term 'still
life' belies the movement that often happens in front of
the camera, from bubbles rising in a champagne flute to
steam from a just-cooked dish. In close-up, all movement
is magnified, and continuous lighting sources such as
tungsten capture this kind of motion at best as a blur.
Flash will freeze it, even though the larger studio units
arc at a slower speed than a typical built-in camera flash.
A word of warning, however. Independently powered
flash units may not sync with cameras that are designed
to work only with their own built-in pop-up units. This
might well be a factor when you come to purchase either
a camera or the lighting.

Lighting quality is the issue here, and flash has an
advantage in being much cooler than tungsten lamps.

▲ Monobloc with diffuser
This is a basic configuration using studio flash for a
small still-life set-up, with an enclosed windowlight (also
known as a softlight) attached to a self-contained 750-
joule unit. Enclosed diffusion like this is impractical with
hot tungsten lamps.

◄ Set-up
Another set-up for
still-life photography. As
with the jars arrangement
to the left, a large
diffused monobloc, set to
an angle is used to
illuminate the subject.
Here, however, the
camera is looking down
on the subject,
eliminating the need for
reflectors and picking up
some shadow.

Not only does this reduce the temperature of the still-life set, but it allows all kinds of enclosing attachments to be fitted to the flash head. The most commonly used of these in still-life photography is the area or window light, for precision often fronted with a translucent plastic of some kind. This precision is needed more often in close-up still-life shooting than in other kinds of photography simply because reflections of the light itself often appear in shot – as in reflectively lit background surfaces (*see page 67*). Fabric and spun front surfaces have a texture which can spoil such shots.

Cool light for delicate subjects

In close-up photography, everything is close together – not just the camera, but usually the light source also. In these situations, heat can be damaging to many still-life subjects, from flowers, which wilt quickly, to ice-cream in a food shot. Not only that, but high temperatures on the set dry up moisture, a distinct problem in shots that call for drops of water or liquids like sauces. A studio flash generates some heat, both through the flash discharge and the low-wattage modelling lamp, but much less than tungsten lights.

Flash meters

The instant feedback from a digital camera might seem to have sounded the death knell for handheld light meters, but when it comes to studio flash they save a great deal of time. The alternative, particularly with a complicated lighting set-up that uses diffusing panels, reflectors and even added continuous lighting, is tedious – a series of exposures that start with guesswork. A flash meter, which will also measure continuous light, is still standard studio equipment. The case for it is even stronger with close-up photography – the tinier the set and higher the magnification, the more difficult the calculations. As the lens is extended, the light reaching the sensor is reduced, as explained on page 16. The camera can work that out for you, but constructing the balance of light from more than one source still needs to be worked out in advance. If you go to the trouble and expense of buying studio flash, you might consider investing in a meter as well.

▶ Controlling flare

Any significant amount of white background will contribute to image degradation. If you know that the object will be presented as a cut-out, as in this case, use black paper, cloth or card to reduce flare – and also to control any reflections in the object.

▶ Stopping motion

Flash comes into its own in the studio when it is essential to freeze movement, as in this close-up of mescal being poured into a shot glass – together with the famous worm in each bottle.

A basic set-up

A basic still-life set-up requires a simple and reliable type of lighting that needs just one light source, and that delivers attractive and legible images for a wide range of objects.

Successful still-life photography hinges on precise control of lighting, and the most basic method of manipulating the light is to diffuse it. The raw light source, whether the head of a portable flash gun; a normal tungsten bulb; or the coiled tube of a studio flash unit, is virtually a single point, and without modification will give high contrast and deep, hard-edged shadows. Using a diffuser and reflectors, as shown here, the quality of this light can be altered in infinitely fine stages. Adjusting the degree of diffusion to suit the subject depends partly on your own personal taste, and partly on the material qualities of the subject you are photographing. It is the size of the light source in relation to the size of the subject that determines how diffused the lighting will appear. This can be easily controlled in two ways: by using a bigger or smaller light source; and by altering the distance at which you position it from the subject.

The other principal control that you have over a light, after deciding the amount of diffusion, is direction. Of course, a light can be placed at any position in relation to the camera, through 360 degrees. Some of the more unusual lighting positions are shown on the following pages. Here, however, the more subtle variations of a basic arrangement are illustrated. A single diffused windowlight over a curved sheet of white Formica or flexible plastic, known as a scoop, is one standard arrangement for photographing single objects. What this lacks in originality and excitement is compensated for by simplicity and a generally pleasing distribution of tones. The shape of the scoop gives an impression of great depth, uncomplicated by edges or horizon lines. If a directional light, such as the window diffuser shown here, is used overhead, there is an even gradation of tone from light to dark, which enhances the impression of depth and can contrast with the lighting on the subject, as the first two photographs show. Notice that the white base acts as a natural reflector to an overhead light, relieving the shadows at the base of the subject. Paper or card can be used, although wrinkles may interfere with the image.

▼ Basic diffused light
There is no standard amount of diffusion; it depends on personal taste as much as the steadily changing fashions in still-life imagery. This is moderate-to-full diffusion, with a metre-square windowlight illuminating a similar-sized area from a distance of about one metre. To preserve a balance between contrast and colour in the set, the light was positioned directly overhead (back-lighting would have desaturated the colours).

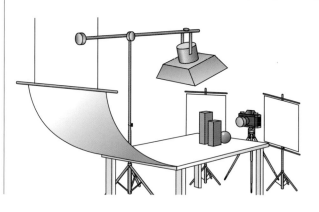

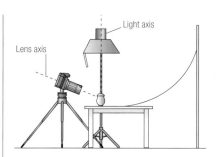

Slightly elevated camera

With a windowlight directly overhead, this standard camera position gives a slight angle between the lens and light axes. The combination of directional windowlight and white scoop gives a tonal gradation from white foreground to very dark background. From this camera position, the gradation falls near the top of the picture frame and is quite gradual. This tends to set off the subject quite well.

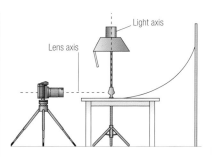

Horizontal camera

With identical lighting, still directly overhead, a camera aimed horizontally from table level gives a different tonal distribution. The highlights in the subject are more localized, and the gradation of the scoop much more abrupt and lower in the picture frame. Most of the subject is against a dark background.

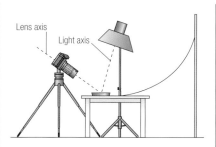

High camera

A high camera position from right next to the light results in more frontal illumination, showing detail more effectively.

Pooled light

With the light smaller or further away there is less diffusion. Shadows are denser and more definite, and contrast higher. Nevertheless, if the light is fitted with a diffusing head, there is still a marked difference between this and spotlighting, where the illumination is hard and focused. In this case, the lighting was used deliberately to emphasize contrast by not using fill-in lights or reflectors, and by setting the camera's tone compensation to 'higher contrast'.

▶ Quill and cards

Taken using a high camera position, as described above, the detail on the nearby subjects is apparent while the diffused light gently fades away in the background.

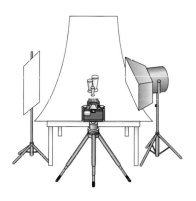

Side-lighting

For vertical subjects, such as bottles or vases, a side-light is usually most effective. Without the reflection from the white surface given by an overhead light, contrast is higher, and a reflector may have to be placed opposite the light.

Lighting style

Clarity is not the only purpose
of lighting in still-life photography.
Beyond efficiency are the possibilities
for creating atmosphere and putting
your own point of view.

Although certain principles are technically unavoidable, there is no such thing as a correct method of lighting. The basic set-up just described is a starting point, and is very useful to master. It is the kind of lighting that you know will work; it will show objects clearly and well, with no surprises. A great deal of still-life work is focused on showing how things are, and for this the contribution of lighting is first and foremost to be efficient, keeping highlights and deep shadows to a minimum. However, there are many other instances when you will want to go beyond this to make images that are in some way striking or unexpected. Even on a technical level of lighting, different treatments will emphasize different qualities of an object, as in the series of three images of a glass and a bottle.

Soft-focus spotlighting

This intense and slightly luxurious style of lighting relies on a low-angled focusing spot (with an adjustable lens to concentrate the beam and sharpen the shadows), and a soft-focus lens attached to the camera lens. The soft-focus lens brings diffusion to the highlights alone, made prominent by the concentrated beam.

Studio lighting equipment is designed for variety, particularly in the many attachments that modify the quality of illumination from the lamp. For a professional still-life photographer, all this is a justifiable but not inconsiderable investment. Much, however, can be put together on the spot and with simple and accessible materials such as card and paper – a low-cost if less convenient alternative.

Concentrating a beam of light rather than diffusing creates a completely different effect to the soft, clear treatments that we saw on the previous pages. Diffuse lighting tends by its nature to be unassuming. It doesn't make itself strongly felt. A spotlight, on the other hand, as in the image shown

here of a pre-Columbian gold necklace, is naturally dramatic. It makes a statement and is a more insistent part of the image, particularly if used from a low, raking angle that casts long shadows and reveals texture sharply.

There are infinite ways of designing lighting, and one of the pleasures of a still-life set in which you install the lights according to your own ideas is that you can experiment with the interplay of shadows and highlights, adding light sources, subtracting them, altering their colour and diffusion. Beyond plain product photography is a world of imagery in which lighting can play a highly creative role.

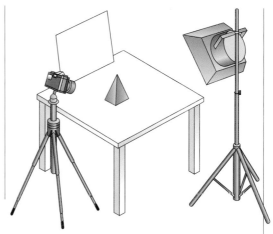

Side-lighting
The set-up for the large shot to the left, with the card opposite the diffused light and the subject in the centre.

Naked lamp
With all diffusing screens removed, a naked flash tube throws strong shadows and creates specular highlights, resulting in a composition of strong shapes.

Back-lighting
Using the same lighting but moving the camera and rearranging the objects, back-lighting reveals the glass's colour.

Side-lighting
Here, a single diffused light, with a white card reflector opposite, stresses the surface textures of this glass and the bottle lying next to it.

Case study: **jade horse**

This beautiful Qing dynasty reclining horse, carved in nephrite jade in the late 17th or early 18th century, was chosen for the front cover of a *Smithsonian* magazine feature – and not only that, but a wrap-around cover as well. This meant a considerable enlargement, which was no problem technically but did require absolute precision and attention to detail to bring the best out of the item. It was shot with a portable still-life rig at the dealers handling the sale of this piece. Back-lighting through seamless curved plastic was filtered separately to give a soft, yellowish colour shading to a darker tone. In fact, several background colours were shot, with the option of later making adjustments in image editing.

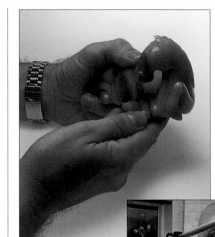

1 Miniature
Measuring 20cm in length, the horse at this scale of view is a pleasing miniature, but one of the aims was to make it look imposing.

2 Set-up
The set-up featured a sheet of opalescent plastic with a frosted upper surface, bent and held into an S-shaped curve. This gave a horizonless background, with a light underneath and behind (just visible here) controlling the gradation of light.

3 Metering
A flexible probe attachment to the light meter ensures an accurate measurement of the illumination from the overhead area light.

5 Mirror
A small mirror was positioned, just out of frame, to lift up the foreground shadows that are inevitable with a main overhead light.

7 Catchlight
The working end of the fibre-optic cable is positioned with another clamp just out of frame, and aimed at the eye of the horse. This solves the problem of how to produce a catchlight without casting an overall hard frontal light.

4 Cleaning
The 2x enlargement that was to be published made the removal of dust and fingerprints critical. Folds and crevices like the ears needed special attention, using compressed air, brushes and tiny probes.

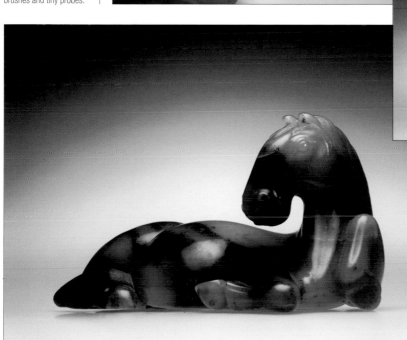

6 Flash
The secret weapon for this shot is a fibre-optic cable used to deliver a highly concentrated dose of light. One end is attached to a sealed flash unit underneath the table.

8 End result
The finished shot was taken from a low angle to help give presence. The position was carefully chosen to reveal the most attractive curve to the neck, jaw and mouth – a part of the outline that would attract immediate attention because of the back-lighting. The catchlight in the eye also helps to bring the miniature sculpture to life.

Shadowless white

For true absence of background, featureless white is the ultimate. This can be created at the time of shooting by introducing some degree of back-lighting.

There are some occasions when only the subject is wanted in the shot, without any hint of background. In order to obtain this, the answer is white: pure and simple. A regular white surface, although it is basic and useful, will not really do the job adequately. However bright and reflective it seems, a surface like paper, card or Formica will always pick up some shadows, and these can sometimes be surprisingly dense, particularly underneath an object with a light overhead.

White without shadows calls for back-lighting, and this is a key technique in still-life photography. The principle is that the background should be translucent or transparent, with at least one light placed behind, shining onto it in the direction of the camera and subject. It may take some effort to perfect such a set-up, because you need to be able to light the background brightly and evenly. This makes the quality of the background material important, as it must be smooth, free from any visible defects, and thick enough to diffuse the light strongly. Milky, translucent Perspex/plexiglass is the standard, and it should be at least 3mm in thickness. For strong diffusion, which spreads the light out more evenly across the surface when it is backlit, the thicker the better – up to, say, 8mm – but this will also reduce the amount of light drastically.

Another method of spreading the light evenly is to move the light source further back. This also, of course, reduces the amount of light. Using more than one light is also a solution, and if you use fluorescent striplights, placing two or three

Digital whitening

Even when the background appears completely white when shot, it may need some adjustment later. There are two main digital methods: setting the white point on the background, and selecting the almost-white background before removing any tonal value.

Furoshiki
Here, back-lighting using a background table as illustrated not only serves to isolate the subject, but also displays the colour and translucency of a furoshiki, or Japanese gift-wrapping cloth.

parallel to each other and close will give an even output. This, in fact, is the construction of most lightboxes used for examining slides. If you have one left over from your film photography days, it will make an ideal back-lighting set-up.

Shooting vertically down solves the problem of supporting the subject, although it makes it more difficult to position the camera (the legs get in the way). Here, a useful accessory is a horizontal arm that attaches to the platform of a tripod. Better still, though expensive, is a background table, which consists of a large sheet of white, translucent Perspex/plexiglass, bent into an S-shaped curve and held in position on a frame. It looks similar to the basic set-up shown on pages 64–65, except that it allows one or more lights to be placed underneath and behind. The rear upward curve provides a seamless background for an object sitting on the flat central section, while the downward curve falling away in front allows the camera to be lower but still, if needed, horizontal. An extra detail is a sandblasted matt top surface to the Perspex/plexiglass, to reduce reflections.

Near-white as shot
As the histogram shows, the background for this old wooden toy is still about 5% less than absolute white.

White point
Using the white point dropper, the value of the background is easily set to white. However, in this case, to preserve a minimum printable dot, the white point is first set to a level of 250.

Select and delete
An alternative treatment, which works well with distinct edges to an object, is to use the auto selector (Magic Wand) to choose the background – shown here in mask form for clarity – and then hit the Delete button.

Case study: **clipping paths**

Objects with clean, definite edges lend themselves to cut-outs, and in the commercial world of websites, magazines and brochures, there is great demand for cut-out images. From the publisher's perspective it makes for a clearer layout. If you know in advance that this is what will happen to the image, you can and should prepare for the photography appropriately. This means you can ignore the background, because it will simply not appear. However, you will need to consider reflections of colours and other things in the object, particularly if it has reflective surfaces and especially along edges at an acute angle to the camera. Also, make life easy for yourself later by ensuring a clearly visible outline; in most cases, white is best.

In the main example here, a set of Chinese furniture was to be printed in a brochure and also displayed on a website. Of the several methods, a clipping path seemed most appropriate.

Walking Buddha
Even without the ability to set up lighting and reflectors at the time of shooting, a path, converted to a selection so that the background can be deleted, can turn a messy image into a clean and useful one, as in the case of this famous Thai walking Buddha, photographed from two angles in a Bangkok monastery.

1 Photo set-up

The lighting set-up uses large sheets of polystyrene to give even illumination across the surfaces of the furniture from the sides, with a white umbrella as additional frontal lighting. The angle of the furniture and the position of the main polystyrene sheet are critical.

5 Check against black

The inverted selection is temporarily filled with black (or any other colour) to see how the edges behave. If the path had been more open, some of the original background would have been included.

6 Clipping path

Finally, the working path is converted into a clipping path that the PostScript interpreter in a page layout program can read. The flatness value determines the margin of error when printed, and the precise value depends on the printer.

2 Cabinet

At a slight angle to the camera to give a conventional and informative view, a cabinet like this presents two flat surfaces. For effective modelling, one must be slightly lighter than the other, and in this arrangement the front gets the most illumination, from the white polystyrene sheet to the left.

4 Make selection

As part of the procedure for checking accuracy, the path, when complete, is converted into a selection. This is then inverted.

3 Drawing path

Working at 200% magnification for accuracy, the Pen tool is used to draw a path around the cabinet, working fractionally inside the edges so that the final clipped image can be used against any colour of background.

7 Cabinet

The final clipped image is now ready for delivery and use in any application.

Drop-out black

Deep black is more than just an inverted alternative to featureless white: it provides a rich, strong contrast for light-toned objects.

Black backgrounds give punch to photographs of objects, particularly if these are bright in tone or colour. Like white, as we just saw, this is a solution for treating objects in isolation, placed firmly within the frame, with nothing around to distract attention.

Objects emerge from black. In the psychology of perception, light tones advance and dark ones recede, which makes black a perfect background for enhancing the three-dimensional impression of a still life.

Image editing can help, as always, but it's important to take pains over getting the density of the background to its maximum at the time of shooting. There are two ways, used together, of assuring this. The first is to choose the least reflective material; the second to illuminate the object so that as little light as possible spills onto the background. Both, of course, have to do with light. The material that absorbs the most light – and one that is readily available – is black velvet. Among the different types and qualities of velvet, good cotton velvet appears blacker than synthetic. If this type of background is one that you think you will make use of more than once, it's well worth buying a couple of metres of it. Keep it unwrinkled by storing it rolled, not folded, and before each shot check the fabric for small pieces of lint and dust. The easiest way to remove this is with a small length of sticky tape dabbed lightly on the velvet.

As an extra precaution to keep the density of the black deep, try to avoid light spilling onto it. This may be impossible to avoid simply because of the angle of the light and the way the object sits on the velvet, but if the light is from one side, use a barndoor or a piece of black card to shade the background just up to the edges of the object. Even more effective when the situation allows is to separate the object from the velvet. One way of doing

Isolating the subject
The most obvious ways of photographing a lobster would be either in a setting that suggested its habitat, such as rocks or the sea, or one that suggested food, perhaps a marble slab. In this case, however, the intention was to treat the lobster as a still-life object, without any associations. For a simple, strongly lit photograph, a single overhead flash, diffused with a square window attachment, was used with a background of black velvet to absorb all light. For additional simplicity, the arrangement was symmetrical, and no reflectors were used, so that it emerges seamlessly from the background.

this is to shoot vertically downwards while supporting the object on a rod, as in the example of the shell shown here. After all of this, it should be easy to tweak the final image during image editing by using the black point dropper on the background area.

Note that black, like any background, reflects in the edges of many objects. The extent to which it does this depends on how shiny the surface of the object is, and its angle to the camera. This is why edges pick up so much of their surroundings, because the very shallow angle of a curving edge, such as the sides of a bowl, are the most reflective. So, while objects can always be cut out digitally and placed against new backgrounds, realism often suffers. Look, for example, at screenshot 5 on page 73, where a black background is being used as a quick check for outlining accuracy, and notice how unconvincing it looks. For black to work properly as a background, you need to shoot against black.

▲ Background separation
One way of improving the density of the background, and to avoid specks of dust and lint appearing, is to elevate the object to separate it from the black velvet. By adjusting the light, as shown in the illustration, there will be less spill onto the background.

▼ Select and fill
The alternative is to select the background, here with an auto selector, and apply a black fill to this.

Settings and textures

Selecting the right background for a still life shot can be as important as choosing other props or even the subject itself.

Where the main subject is a single item or a small group of objects, the background may take up the largest area of the photograph. There are three categories of background: plain, complementary and setting. Plain backgrounds explain themselves. They are intended to be as unobtrusive as possible, simply providing a colour or tone that shows off the subject clearly. Complementary backgrounds can enhance certain features of the subject and become an integral part of the shot, consisting of either matching or contrasting tones, textures, shapes or colours. Finally, settings are used to put a still-life subject in its context, and can give a more natural impression than shots very obviously taken in a studio. Many existing interiors make good settings, but their style and the objects they contain should reflect the nature of the subject itself.

A catalogue of backgrounds

The list is endless, but most of the possibilities are either settings, like desks or tables, or fall into one of the following categories:-

PLAIN

White For the least texture, use a slightly shiny surface, such as white Formica, or a non-reflecting surface, such as white velvet.
Black For a completely black background, use a high-quality cotton velvet. See pages 74–75.
Graduated A smooth white curved sheet of Formica, card or paper, lit by an overhead diffused light. See example on page 64.
Solid colour One method is simply to use coloured paper, card or Formica. However, you can avoid the expense by adding colour either through filters, or digitally later.
Digitally Either composite a second exposure of just the background with the shot, or else extract the subject in image editing.
Graduated colour See Solid colour above.
Bicolour Why stop at a single colour? Apply the methods in Solid colour above using two different colours. See page 109.

Glass The glass shot is an old standby. Place the object on a flat sheet of glass, itself raised over a background colour on the floor (far enough below to be out of focus and so textureless). Arrange the light or lights to illuminate the subject and the background (either together or separately), taking special care to keep the light at a raking angle to prevent reflections in the glass.
Perspex/plexiglass Opaque coloured Perspex/plexiglass can give a variety of backgrounds. When lit frontally, colour saturation is good, and light-toned subjects have subtle reflections. Lighting reflectively (as with the pistol, right), reduces saturation but increases contrast and reflections.
Mylar This thin, flexible material, with a mirror-like finish, can give unusual distortions of colour and shape.

COMPLEMENTARY

Cloth fabrics Cloth offers a very wide range of textures. Try crumpling and folding for even more character.

Textured paper Papers are available in a wide range of not only patterns and colours, but textures also, including embossing. To show off texture, light reflectively or backlight.
Textured plastic Like textured paper, but more durable, flexes more smoothly, and has a less fibrous texture.
Stone Slate, sandstone, marble and other stones have a tactile quality which can contrast with delicate or elegant objects (such as jewellery) or complement rougher, rustic subjects (a great standby in food photography).
Wood Similar in its possibilities to stone. Varies from smooth to natural. Sources are wooden flooring, bread boards and cutting boards, driftwood.
Leather Strong natural texture, sometimes with connotations of luxury and the antique.
Water Either as a continuous sheet in a container or as droplets. In either case, it is an addition to another background. Its visual effect depends very much on lighting.
Aggregates Large quantities of sand or gravel and pebbles are easy to spread out.

Flexible colour

Shooting digitally makes it possible to capture the background separately from the subject and use this second image to apply a wide variety of colours, patterns or textures. The set-up and lighting play an important part, and call for the background to be lit independently, as in this example. In addition to the full image, take a second shot with just the background light, without moving the camera. The two should then be in perfect register. In image editing, combine as layers, and apply any colour you like to the background shot, compositing it in any appropriate mode: in this case, Multiply.

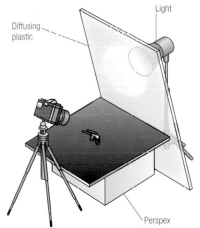

▲ Reflective plastic for precision

Black Perpex/plexiglass produces a clean effect when used as a background and lit for reflectivity. The tonal range is muted and neutral, and by shooting at an angle that shows the light source in reflection, the shading can be controlled. In this example, the light was placed close to a large sheet of translucent diffusing plastic for a 'pooled' effect.

Diffusing plastic — Light

Perspex

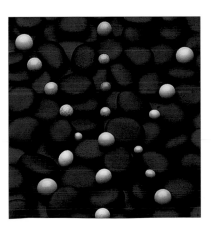

◄ Multiples

Large quantities of similar or identical objects can make an unusual but very controllable background. Ball-bearings are one high-tech possibility, another is illustrated here as a setting for rare, orange pearls.

Backgrounds with purpose

Make backgrounds work harder by selecting them for what they can add to the idea behind the image.

Too often, backgrounds are treated as space to be filled; inconvenient areas of the frame that just happen to be there and need to be dealt with somehow. In that case, you might as well go for featureless white or black. However, the considered choice of background can enhance an image, as these examples illustrate. In each, the background has become a valuable, contributing part of the image.

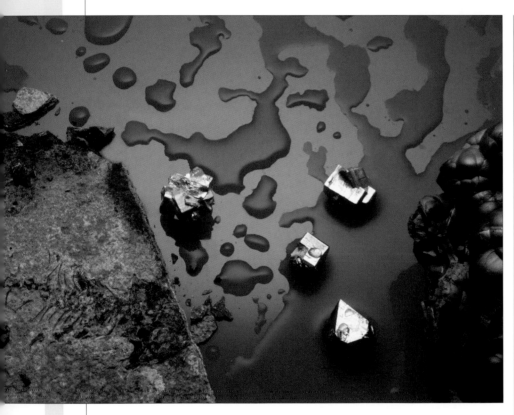

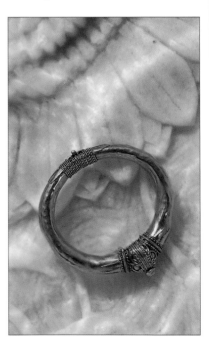

◢ Marble pond

As part of a magazine feature on the Indian city of Jaipur as a tourist destination, some images were needed of antique gold jewellery, including this ring. The shot was not intended to run large on the page, but rather was to be one of a series of details. For this reason, it was important to keep the image simple and easy to read when small. At the same time, a location background was wanted, and a good choice was a decorative marble pond at the entrance to a luxury resort. The marble and its carved design are typical of the area. The water added a deliberately unexpected note, as if the ring had been dropped accidentally. Ripples were created by splashing the water by hand, to make it more obvious.

◢ Water and red

This was a book cover and for part of a series of three dictionaries of science. Each had to be in a similar and distinctive style for the sake of continuity, so it was decided to have a strong colour taking up about two-thirds of the image (and so leaving room for the typography); a small selection of relevant objects entering from the lower edges and corners; and the same near-vertical camera viewpoint. For the Life Sciences volume, the colour chosen was the obvious green; for Physical Sciences, blue (with its connotations of sky and a cool clinical approach), which left this shot for Earth Sciences. Red would be neat (an RGB set), and fortunately was justified through its connotations of fire, lava and magma. The elements chosen were rock (deliberately crumbled), minerals (here, pyrites) and water, which was sprinkled to become a part of the background.

Coloured diamonds

Although the brief called for these coloured, uncut diamonds to be arranged in a casual group, it was important to show their depth and colour. I or refraction, a bright background was necessary. Back-lighting, by placing the stones on translucent Perspex/plexiglass and aiming a light from underneath, would have given the strongest effect, but at the same time the flare would have degraded the colours and contrast. Also, a soft texture would make a good contrasting background for the hard diamonds. White velvet was used, with the dense texture of the fibres softening and absorbing much of the shadows. For the reflections, a diffused window-light was positioned almost overhead, illuminating the stones from the top left corner. Each large stone was angled to catch the reflection in one interesting face, and a silver foil and white card reflector were arranged opposite the light; the first to add secondary highlights, the second to balance the illumination.

Illustration as background

Occasionally, artwork can be used to convey one of the elements in a shot, or simply to establish a particular atmosphere. Historical prints and paintings work very well in this way. The purpose of this photograph was to symbolize the beginnings of merchant banking. In common with many illustrative shots, it uses the juxtaposition of two subjects. The small gold bar was naturally attractive, and to achieve a simple image, a print showing an early merchant ship in a tropical harbour was chosen. The lighting chosen had to reflect off the gold, and be even over the surface of the print. A single diffused window-light was used, with curved white paper reflectors added to define the edges of the bar and balance the illumination. In addition, because of the brightness difference between gold and print, the background was later selected and digitally lightened.

Digital backgrounds

With the ability to outline objects and separate them from their settings, completely new backgrounds can be added, and even generated, digitally.

Replacing one background with another has become one of the signature techniques of digital imaging. It relies primarily on making an efficient, believable selection of the main subject. In still-life photography, you might question why this should be necessary, given that all is under control and the real background has to be chosen and put into position in any case. The answer is that some backgrounds involving a certain range of colour or type of texture are just simpler to do digitally.

One of the simplest and most effective is a gradient, for which the gradient tool in an image-editing program is tailor-made. The most basic in still-life photography goes from a light foreground to a dark background, mimicking the natural distribution of light and shadow on a curved white surface lit by an overhead diffused light – in other words, the lighting set-up shown on page 64. Performed digitally, this is a straightforward linear ramp from almost white at the bottom to nearly black at the top. One method is to create this background first on a plain canvas and then drop in the selected object.

Textural variety
These five differently generated digital textures illustrate the kind of choice available through image-editing applications such as Photoshop, and through third-party filter suites such as Xaos Tools' Terrazzo and DreamSuite. Incorporating them realistically into an apparently photographic image relies on simple illusion techniques that include drop shadows and three-dimensional shading.

Alternatively, load the selection already created around the object, invert it and apply the gradient. To complete the effect, you will then need to add a drop shadow underneath, either by airbrushing into the inverted selection or by creating a shadow from a copy of the object. To do this, create a new layer underneath the object, load the selection of the object's outline, fill it with a dark tone, and move this shape down so that its lower edge appears below the object. Then deselect and apply a strong amount of blur to this shadow layer, adjusting its brightness or opacity as necessary. There are also third-party filters that will create drop shadows instantly.

One of the issues with digital backgrounds is maintaining photographic believability. Artificially created tones and gradients too often look like illustrations rather than real space. One artefact is banding, in which a gradient appears visibly divided into steps. The answer to this is to apply a

small amount of noise. This has the added advantage of creating the subliminal effect of grain, which is still strongly associated with the reality of a photographic image. Never mind that grain itself is an artefact of film – the effect works perceptually.

More complex background textures can be created digitally, and there is an almost limitless choice, depending on the effort you are prepared to put in. There are many third-party filter suites that will create textures to order – Auto fx DreamSuite, Alien Skin Eye Candy, furbo filters, and Xaos Tools Paint Alchemy and Terrazzo, to mention just a few. Going a step further, even more convincing textures in depth can be customised with a 3-D modelling program.

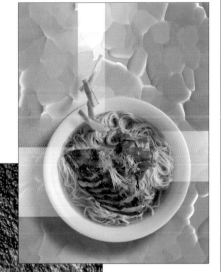

Generator

Filters that generate textures digitally employ randomization effects and bump-mapping to appear three-dimensional and not repetitive. The blending mode 'bars' were placed on top, after the dish was placed.

Digital gradient and noise

A simple gradient can quickly be drawn using most image editing software. It is a straightforward process of selecting the colors and drawing. Here some noise was also added to give the background some texture, though there are numberous other filters available. You will find many in your imaging software's Filter menu.

Digital vegetation

This pre-created moss-like texture, which has a strangely special quality, is one of a set of organic textures available from Xaos Tools in a collection called Fresco.

Tools of the trade

Working with small objects in a precise manner often calls for an esoteric collection of specialized equipment, drawn from fields as far apart as watch-making and surgery.

Precision is the by-word of still-life photography, and calls for extraordinary control over everything, from lighting to the condition of the surface and preparation of things to be photographed. Specialists in still-life studio work surround themselves with an arcana of bits and pieces, tools, and some of the oddest specializations, including imitation ice and bubbles.

Clamp and pole system, here shown with an arm and spring clip holding mirror.

Anti-static gun to reduce dust pick-up on surfaces.

Miniature blow-torch for food photography.

Compressed air for cleaning, and also for attaching to tubes for creating bubbles in liquids.

Assorted small mirrors and metal reflectors, including an inspection mirror with extendable arm and swivel head.

Spirit level for levelling surfaces (essential when photographing liquids in containers).

Bluetac adhesive – re-usable putty for sticking and supporting.

Magnets for supporting and propping up objects.

Brushes for cleaning and moving.

Jeweller's retractable claw for picking up single small objects.

Assorted sharp-nosed tweezers for moving and removing small objects.

Alligator clip.

Moulded and carved acrylic imitation ice cubes, for drinks shots.

Tiny glass spheres for imitation water-line bubbles, and glass hemisphere for a surface bubble seen from above, for drinks shots.

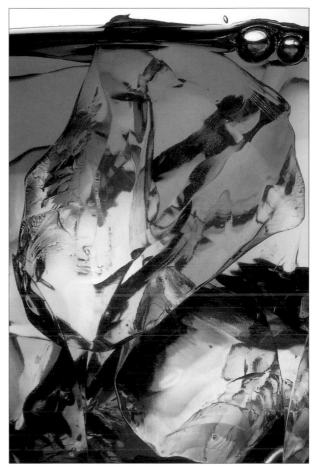

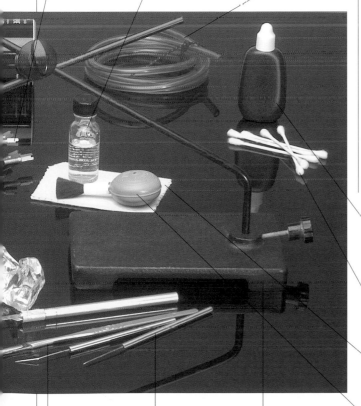

Assorted miniature G-clamps for holding mirrors and other things out of frame.

Anti-static liquid for preventing dust pick-up.

Plastic tubes to attach to compressed air for bubbles creation, for food photography.

De-natured alcohol for cleaning surfaces without leaving streaks.

Cotton buds for cleaning and wiping small areas.

Cloth for cleaning and wiping.

Scalpel and craft knife for trimming and cutting, particularly useful in food photography.

Straight and angled sharp probes for moving small objects on set.

Stand with adjustable arm and spring clamp for holding things just out of frame.

Hand-blower brush for cleaning delicate areas where compressed air would be too strong.

◢ Moulded ice

Here the tiny glass spheres and moulded and carved acrylic simulate an ice-cold drink perfectly. They have the advantage of not melting under camera lighting, as well as being infinitely positionable.

The minutiae of still life

The combination of still-life precision and magnified scale helps to create a shooting culture of almost obsessive attention to detail.

The whole style of still-life studio photography is directed towards an unblinking, close examination of objects. Not surprisingly, such examination reveals imperfections that few of us would ordinarily notice. Focusing closely on constructed still-life sets, there is no escaping the need for exactness and absolute cleanliness. It is easy to overlook the very tiny details when shooting, but they will all be exposed and very obvious in an enlarged photograph. This means, for instance, that if you aim for symmetry in the composition, then you must be absolutely symmetrical, not a couple of degrees off. And dust, dirt, and blemishes are intolerable – to borrow the jargon of digital imaging, they are the artefacts of still-life photography, intruders on an otherwise pristine arrangement.

These still lifes are in a sense miniatures, and demand the obsessive eye of a miniaturist to do them justice. In real-life shooting outside, with found objects, it's perfectly acceptable to include whatever happens to be lying around. This is realism. But when you, the photographer, are entirely responsible for everything in the image, from choice of objects to style of lighting and composition, as happens with a still life, you take the blame for imperfections – unless you can genuinely claim that they are deliberate. Crumbling the rock in the photograph on page 78 is just such an example of intentional untidiness, and is obvious as such at even a glance, but there would have been no excuse for just a couple of specks of chipped rock.

Although it will come as no surprise that digital retouching can rescue a shot from mistakes of detail, still the best time and place to deal with these issues is when shooting. Professional still-life photographers always and without exception make a complete, thorough check their last action before shooting. After what can be an hour or more of painstaking arrangement, rearrangement and lighting, it would be intolerable to find that a piece of lint had floated down into the middle of the set, or that a supposedly hidden

▼ Basic dust removal

Despite using a brush and compressed air on this Art Nouveau brooch made with pearls from conch shells, dust and ingrained dirt still remained highly visible at a close-up scale. The basic procedure is to use the cloning tool in image editing, with a brush size just larger than the particles, removing each at 100% magnification. The finished image is shown on page 96.

support was just visible. Hence the specialist array of tools and materials, many of them dedicated to cleaning, shown on the previous pages. One of the advantage of shooting direct to a computer is that you can enlarge the image immediately and perform a very close inspection at 100%.

But of course, digital retouching often does come to the rescue. The basic tool is the cloning brush, used at a small diameter, just large enough to cover the specks in view. This kind of retouching, however, runs risks when used on smooth, pristine surfaces, particularly if there is any gradation of colour and tone, as often in still-life lighting. It may be better to go for a procedural cleaning process, as shown here

Procedural removal

Across large smooth backgrounds, the most reliable method of dust removal is procedural; meaning the application of a filter to a pre-determined area.

Select

The Magic Wand auto selector is first used to choose the background (and so protect the detailed parts of the image).

Adjust the selection

To prevent the filter from affecting detailed areas, the selection is pulled back by contracting two pixels, and softened by feathering the same amount.

The clean final image

Perspex/plexiglass, as used here, is notorious for its static attraction for dust. The digital cleaning solves this problem very effectively.

Final check

Converting the selection to a mask gives a visible check of the selection edges, which can also be retouched with the brush tool if necessary.

Filters

Two filters are applied in succession: first 'Dust and Scratches', with an appropriate threshold to protect fine texture, then 'Median', which has a smoothing effect.

Improvised lighting

Use the freedom of digital shooting to experiment, alter and adapt any potentially interesting light source.

In practical terms, professionally designed lamps and attachments tend to dominate still-life lighting. This is fine for the majority of situations. After all, they are intended for just that specific purpose, and have evolved to solve various technical problems. There is, however, no law that says that once you have a studio light it must always be used conventionally. There are other kinds of light that can deliver interesting results, and a digital camera allows you to see immediately whether or not they can produce interesting results. Don't be afraid to experiment. There are, in addition, some neat digital solutions that take normal lighting as a starting point, such as the range of blending modes offered by many imaging applications.

Polarized hypodermic

The stresses created in certain plastics during manufacture are revealed in polarized light as interference patterns in rainbow-like colours. Photographic lighting is not normally polarized, so simply fitting a polarized filter in front of the lens had no effect, but by filtering the light source with a sheet of transparent polarizing material (visually grey) the effects can be startling. In the example here, back-lighting was used with the camera pointing vertically down, the needle being placed on a sheet of polarizing material. The polarizing filter fitted to the lens was then rotated until the background changed from white to deep blue.

Digitally enhanced shadows

The problem with this painted sculpture was the massive contrast range in the gold paint between the reflectively lit top and the shadowed area underneath. Nevertheless, the point of the piece was precisely this varied behaviour of a reflective surface, so it all had to be shown. Seen in real life there was no such problem, because of the eye's ability to accommodate rapidly from light to dark. The answer was to greatly extend the contrast range of the camera's sensor by taking two shots, one to cover the bright part of the range, the other to cover the darker part. The two shots were then combined by brushing in two layers, deleting the out-of-range zones in each layer.

▲ ◄ Catching lasers

This shot of an experimental laser apparatus was difficult to control. Like all light rays, a laser beam is only visible when it strikes particles in the air. A hazy atmosphere is ideal, and the most effective solution was to blow cigarette smoke over the entire set. As this would have been unsuitable for the standard lighting (it would just have created a foggy effect), two separate images were made without moving the camera. They were later combined as layers. A black velvet backing provided contrast, with a main side-light and a small effects light opposite, covered with a blue gelatin filter to add some variety of colour. For maximum depth of field, the smallest aperture was used. For the smoky exposure, the shutter was left open for a minute (this was a low-power laser).

▲ Sparkling laser highlights

A low-powered He-Ne (helium-neon) laser also shows its effect when reflected as a point source. One way of creating this was to place beads of mercury on a flat surface. Lit by a regular square area light, they also reflected the laser aimed from one side as a red starry burst. The speckled appearance of the light is typical, and caused by interference patterns.

Digital composites

When not all the objects for a still life can be assembled at the same time, or some need to be resized, do the arrangement later, on the computer.

One of the great advantages of digital photography is that some of the work can be performed later, using an image-editing program. This can be useful in assembling various objects when, for one reason or another, you can't do it all in front of the camera. For example, it may be impossible to gather all the objects together because some cannot be moved. Or, as in the case of the image opposite, you may want to re-size some of the objects so that they fit together better in the image.

The controlled conditions of a still-life set are ideal for planning this kind of operation, which simply needs preparation. Calculate first what will go where; ideally, make a sketch. Shoot the individual objects in such a way that you can isolate each for compositing. If the background is featureless, as here, you won't have to bother with outlines. Otherwise, make sure that the background against which you place the objects allows an easy cut-out. The normal selection tools can be used, such as paths (for clean outlines), auto selector (Magic Wand in Photoshop) or mask painting. When re-sizing, as a safety measure to keep image quality high, always work to the size of the smallest image. In other words, reduce rather than enlarge, and examine the final assembly of objects at 100% magnification to compare resolution between re-sized objects.

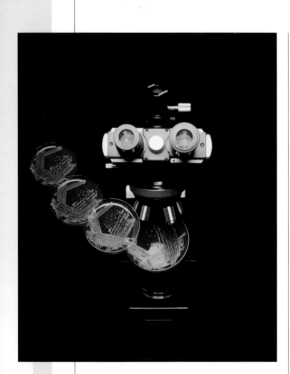

▲ Overlapping

Instead of a clean assembly, obvious superimposition was needed for this image, which was to illustrate a magazine article on cross-infection in laboratories. For this specialized concept, the idea was an overlapping series of culture dishes receding from a microscope. Again, black was used as the overall background to avoid complications. The first exposure was made of the microscope and culture dish. Then the microscope was removed, the camera lowered slightly but at the same angle, and the dish photographed separately, three times in slightly different positions. The lighting and exposure were exactly the same for all four exposures. The dishes were composited as layers in Screen mode.

▶ Compositing outlines

In this case, I wanted the flexibility of being able to arrange and rearrange gilded wooden lotus flowers from a Japanese temple. Each was shot against a white background, then outlined using paths, from which selections were made (Paths > Make Selection). With each lotus loaded into its own layer, they could then be moved at will.

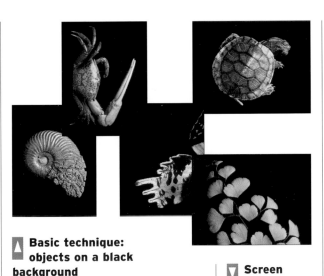

Basic technique: objects on a black background

With this nature collection, I needed to adjust the relative sizes exactly, so as to suit the composition, and the fern and the fossil ammonite were smaller than I wanted. A plain black background was chosen as an easy option for compositing; no outlining would be needed. For a dense black background, a good quality black velvet was used, which was much more effective than ordinary paper or card. To ensure that no light was reflected by the velvet, each object was raised from the cloth on a short rod. A barndoor prevented light from spilling onto the velvet. The lighting was set in the same position for each object.

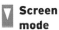

Screen mode

Screen mode is ideal for a black background. After final positioning, unwanted black edges can simply be erased.

Repetition

This mailed fist, superimposed against its own silhouette, was shot on black Perspex with an overhead window-light with black velvet hung behind. Then the velvet was replaced with white card and the light angled towards it, a barndoor cutting off direct light to the fist to create a silhouette. The lens was zoomed forward. In editing, the lit glove, as the top layer was blended in Lighten mode. A colour fill layer was included, and the sparkling highlight is a flare effect.

Downsizing

To maintain quality, the larger objects were reduced by using the Scaling tool, rather than enlarging the smaller images.

Shiny objects

Bright polished surfaces need special care in lighting; the key to handling them lies in realising that you will nearly always be photographing a reflection of the light source itself.

Without special precautions, reflective materials such as mirrors, polished metals and opaque glass often reproduce poorly in photographs. This is more than a pity, because these very reflective qualities can be used to make rich, striking images. It only takes an understanding of how light behaves in these conditions. The problem is that mirror-like surfaces are bound to reflect something, and at least part of the lighting will thus appear in the shot. The principle means of dealing with this is to control the shape of the light source. A broadly spread light with a simple square or rectangular shape and a completely even tone gives the least obtrusive reflection. Evenness of tone depends not only on how efficient the light's reflector is, but also on the thickness and structure of the diffusing sheet in front, as we saw on page 70. White translucent Perspex/plexiglass is always a good material, but a fresh, uncreased roll of heavy tracing paper can also be very precise, provided that it is supported properly.

A large area light source close to a small, flat surface gives the most complete reflection. The smaller the light, the further away it is, or the more curved the surface of the object, then the greater the risk of the light's edges showing. With strongly curved surfaces, such as cylinders or spheres, the light will inevitably appear as a reflection. In these cases, the light should be chosen to have as uncomplicated and unnoticeable a shape as possible. In extreme cases, bend diffusing sheets around the object and shine light through these from the outside. Taken to its logical conclusion, this treatment becomes a light tent, which we look at on the following pages.

For polished objects that have several surfaces facing in different directions, the solution is to arrange for each to reflect a slightly different amount of brightness. Thus, one or two of the planes might reflect the main diffused light, but others could reflect white card or aluminium foil reflectors positioned outside the frame to catch different degrees of light.

Every case needs to be assessed on its own merits, but the essential thing to remember is that you will be photographing reflections of other objects. It helps to have a varied selection of clean reflectors, which can be cut into specific sizes and shapes.

Scissors and glass
This still life was for a magazine cover illustrating a feature on bankruptcy. The flower was made of glass, and the scissors were new and highly reflective. The solution for revealing the essential qualities of both at the same time was a large, highly diffused light source (a sheet of milky Perspex/plexiglass) positioned very close so that it flooded the reflective surfaces.

Relief by reflection

Although the texturing of the gold surface of this Fabergé cigarette case gave it a matte finish that was less contrasty than if it were polished, the low relief of the elephant demanded careful positioning of the light to make it stand out clearly. A one-metre-square bank was placed above and in front of the camera, pointing at 45° to the case. In this way, the entire upper surface reflects the diffused light, but at sufficient an angle to show modelling.

Balancing light and shade

Two gold bars placed on ingots show a variety of texture and reflectivity. As in the image above, a diffused light has been placed above and in front, but at a shallower angle to deliberately allow a play of light and shade on the shiny surfaces. An alternative would have been to bring the light more overhead so that the entire upper surfaces would have been reflectively lit, but this treatment was felt to be more interesting.

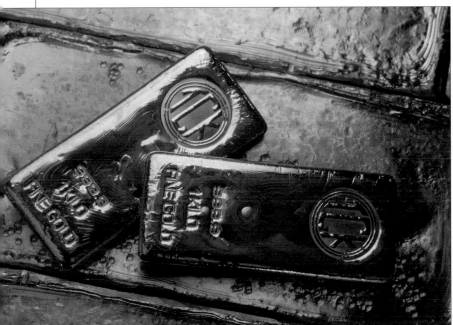

Cake stand

For this shot of a cake on an antique silver cake stand, the reflection problem lay in the stand's circular and scalloped shape, compounded by the upper surface, which was a mirror. The background chosen was a scooped sheet of white Formica, lit by an overhead light. A large sheet of white translucent Perspex/plexiglass was suspended horizontally over the set and under the light, and the camera angle adjusted so that the back half of this would be reflected in the mirror. To light the silver sides of the stand, a large sheet of tracing paper was curved around, as in the diagram, with a hole cut in the centre just large enough for the camera lens.

Light tents

Very shiny objects with curved shapes can reflect their entire surroundings, including the camera and lights. One solution to this is to enclose them in diffusing material.

With completely rounded reflective surfaces, it is impossible to remove all distracting reflections. However, if a simple reflective surface can be lit effectively with an evenly toned area light source, as we saw on pages 70–71, then the ultimate solution for reflective objects with complex shapes is to surround them with light on all sides. Curved, mirror-like surfaces are notoriously difficult, reflecting a wide view of the surrounding studio, and are best handled in this way. The ideal method would be to construct a seamless translucent dome around the subject and shine light into it from outside.

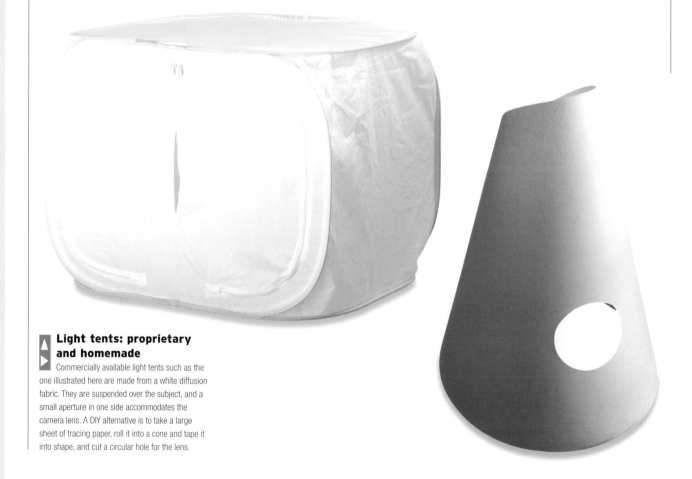

Light tents: proprietary and homemade

Commercially available light tents such as the one illustrated here are made from a white diffusion fabric. They are suspended over the subject, and a small aperture in one side accommodates the camera lens. A DIY alternative is to take a large sheet of tracing paper, roll it into a cone and tape it into shape, and cut a circular hole for the lens.

The practical alternative is almost as effective. To give an enveloping light, without shadows or bright highlights, a light tent is the most favoured technique. Basically a translucent cone, which acts as both diffuser and reflector, it can be made of any colourless milky material – paper, tracing paper or Perspex/plexiglass. Used in the way shown, it should surround but not intrude on the picture frame at the base, and enclose the lens at the apex. There are several commercially manufactured models available, but it is also perfectly feasible to construct a makeshift version yourself, from large sheets of tracing paper, thin white paper or even cotton bed sheets. One of the advantages of building your own light tent is that you can tailor it in size and shape to the subject. Set up the camera, subject and background first, and then construct the light tent to those specific dimensions. Check the view for any joins or gaps, and remember that it may be easier to remove these with a cloning brush in image editing than to perfect the set-up at the time of shooting.

One or more light sources can then be aimed through the aperture of the light tent. Experiment with different lights for effects in which the light shades in tone. Two or three evenly spaced lights will normally create a thoroughly diffuse light, while one light will give strong directional lighting.

One problem with this system is that, even with a perfect light tent, the camera lens itself may show up as a dark patch in the centre of the object. This is unavoidable, but it can be concealed by placing a non-reflective object to cover this up (while making sure that the arrangement looks natural and comfortable). Alternatively, this dark patch can be removed with a cloning brush later.

Silver service

Three versions of a highly reflective silver serving spoon, shot against black velvet with a single, moderately diffused light – a large window. In the first shot, no attempt as been made to deal with the reflections in the concave bowl of the spoon. In the second, a light tent has been made from a large sheet of tracing paper folded into a cone, its apex taped around the camera lens. In the third, a commercially available dulling spray has been used instead. This is for comparison only and is not recommended except in extreme situations. It gives the reflective surface a matt finish, but is rarely a good solution: it is sticky and difficult to remove, and in close-up introduces a noticeable texture to a smooth surface. It also completely alters the nature of the object.

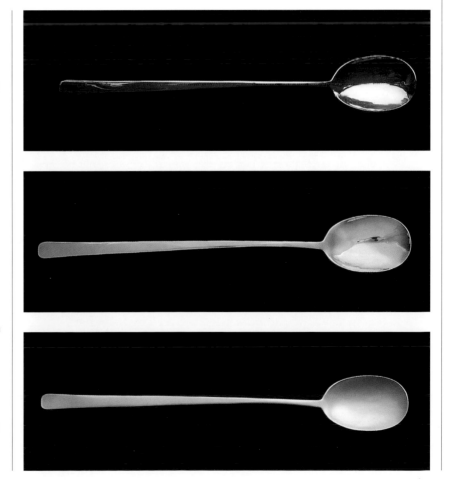

Glass, etcetera

Transparent materials show a fascinating interplay between reflection and distortion, which can be revealed and altered through lighting.

Glass, clear plastics and even some minerals, like quartz, make exciting subjects in close-up because of what they do to light. Indeed, lighting is completely the key to dealing with transparent materials. Most of them have smooth surfaces that reflect light in the same way as the shiny objects we just looked at, but their most important quality is that they transmit light. How well they do this depends on shape and thickness, but because you can see through them, they can almost disappear into a background if lit in a certain way. This is not what you would normally want in a still life, and the basic lighting technique involves shining light through a glass object.

These objects become interesting in close-up because of the variations in thickness and shape, which affect the refraction, or bending, of light. In appearance, this means some kind of distortion, and on a detail scale this is

◤ Cast glass
The precise details of a section of bamboo are faithfully recorded in a block of glass. The artist first made a ceramic cast of the bamboo, then placed it in a furnace with shards of glass. The block took more than a week to cool. The bubbles add textural interest, but the key task was to show the internal structure. Uneven back-lighting through a window was the answer, and the proximity of the dark window frame helped define the shadows.

▷ Machined quartz
This finely machined quartz assembly was intended for a space-shuttle experiment and needed extremely careful handling, with no possibility of suspending or clamping part of it. In order to photograph it opened up, two exposures were made, one of each half. These were combined digitally as layers in Screen mode, with one of them inverted. The mixture of smooth and ground surfaces in this exquisitely machined object, and the strong refraction in the quartz, spread the illumination from a single square area light above. The effect is a bright internal glow.

what helps to create a well-defined internal structure – different parts of the glass refract different areas of brightness around it, as happens in the close-up of a block of glass that has been cast in the form of a bamboo section. In this case, if the back-lighting had been total and broad, this cast shape would have been almost invisible, but because of differences in the light (natural daylight reflected from a snow scene through a window), it shows up clearly.

Starting with the principle that a large, but not necessarily even, area of light will reveal the structure and shape of glass, probably the best way to discover the effect you prefer is through trial and error. Simply experiment with the camera viewpoint, the angle of the object and the position of the light. Small changes can make significant differences to the appearance.

Back-lighting is certainly the standard technique, particularly in close-up, but there are other possibilities, as the photograph of the glass head illustrates. Placing shaped reflectors behind a piece of glass can be an effective way of redirecting the light. The best reflector will depend on the circumstances, but white card, paper, a small mirror or aluminium cooking foil are all possibilities. It's surprisingly easy to avoid giving the game away with this trick by making use of the natural distortion of glass (even stronger in the case of a bottle or glass filled with liquid). Cut or crumple the reflector to shape, and prop it behind the object, at a slight distance if necessary.

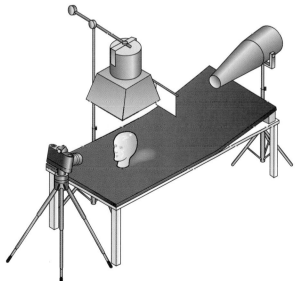

▶ Lighting glass by reflection

This glass head was partially painted for a magazine cover. Photographically, there were two problems: lighting the painted areas without flare and capturing the qualities of the glass below. The fairly high camera angle was determined by the design on the head, which was lit by a single diffused light. The top of the forehead was treated with dulling spray to reduce the highlight. For the glass, a second light and crumpled silver foil were used as a completely localized light source behind the head. The thin foil, matt side up, was cut to a shape that would be concealed from the camera position, and a narrow beam of light aimed at it. The reflection illuminated the transparent glass.

Jewellery

Necklaces, bracelets, brooches and rings are usually designed for first impressions, and so in photography they depend on impact, through lighting and through presentation.

There is tremendous variety in jewellery design, from baroque to modernist to playful, but all pieces have one thing in common – they aim for impact. The more eye-catching they are the better, while a piece that fails to be noticed is generally judged a failure. Strongly wedded to fashion, jewellery is more often than not about making statements, and is intended to draw attention to the wearer. It should, above all, stand out, and this naturally influences the way that jewellery is normally photographed. Subtlety may certainly be needed in the detail of a shot, but the overall effect of the image needs to be as striking as the piece itself.

There is a strong tradition of using expensive materials to make jewellery. Traditionally, this is one of the major uses of precious metals and gemstones, and the way they are used tends to emphasise reflection, refraction and colour. Diamonds, for instance, have such a commanding place in jewellery partly because of their rarity but also because they sparkle so strongly when cut. We'll deal with

◄ Enhancing the presentation
Two striking features of this Art Nouveau brooch are the use of unusual pink pearls from conch shells, and the exquisitely worked leaves and petals. Its open structure also required a background. Real leaves were chosen for this, as contrast for the pearls and to continue the theme of vegetation. The background leaves were placed at a slight distance below to avoid shadows, and backlit.

gemstones specifically on pages 154–155, and the techniques described there are all applicable to jewellery in general. One piece, however, may make use of a number of different precious materials, and all have particular needs for lighting, as in the 18th century hat clasp containing the famous Dresden Green diamond opposite. Ingenuity and compromise are often called for in lighting jewellery. With each of the pieces shown here, considerable care has been put into lighting that brings out the individual qualities of the item, whether that is the iridescent sheen that is the hallmark of electrolytically treated titanium, or the realistic leaves of an Art Nouveau brooch.

The need for impact also often dictates the way in which a piece of jewellery is presented, including the choice of background. Diamonds, for example, sparkle at their best when seen against a dark background, which makes a material such as black velvet one of the more obvious choices. Indeed, the presentation of the diamond hat clasp shown here was that of the museum in Dresden where it is housed. Another possibility in selecting backgrounds to enhance impact is to use the unlikely – something that contrasts through being rough, or ordinary, such as unworked stone, or cut fruit. And finally, of course, there is also the background against which much jewellery is ultimately intended to be seen – skin.

Thai pendant

This Thai antique gold pendant was set with a ruby. The complex embossed surface seemed best handled with uncomplicated diffuse lighting, and the lid of an old wicker basket was chosen as an appropriately ethnic background. It was dark enough to contrast with the gold.

Titanium brooch

The designer of this titanium brooch made use of one of the metal's lesser-known qualities. The surface colour changes when an electric current is passed across it, according to the charge – a kind of painting by electrolysis. A carefully-angled small diffuse light gave the best display of the range of colours.

Diamonds

This spectacular diamond confection encloses one of the world's most famous stones, the Dresden Green. A diffused light at left, together with white reflectors around, were used to model the different facets of the stones and provide a basic lighting, while the sparkle and coloured refractions were handled by a powerful focusing spotlight aimed from upper right.

Food

By convention, food photography is concerned mainly with making dishes look appetising, and the emphasis is on lighting, texture and impression.

Food photography has become one of the most specialized genres of still life. It is in great demand editorially in magazines and books, and commercially in advertising. Just as the function of jewellery, as we just saw, is to be beautiful and eye-catching, food has to look appetising. How mouth-watering a dish looks is the single most important gauge of success in food photography. Inherently, not all dishes share the same visual appeal, and this is where the skill and eye of the specialist food photographer are in greatest demand. As a general guide, food that has structure and colour usually photographs well, whereas amorphous dishes, like many stews, are difficult, however tasty they may be to eat. In commercial food photography, tinned and packaged foods are among the most challenging, and the job is often that of making a silk purse out of a sow's ear.

In common with all lifestyle subjects, the imagery of food follows fashions. These tend to change slowly, but if you compare a typical cookery book or magazine article from a decade ago with a modern version, the differences in presentation and lighting are noticeable. Nevertheless, the range is familiar: people are conservative in what they like to eat, and food photography tends to be conservative in style so that dishes are presented in a familiar and largely idealized way.

Then there is the matter of authenticity. There are a limited number of ways of presenting dishes so that they remain true to the recipe. For this reason, accuracy is important, and, in professional food photography, expert knowledge is provided by home economists or food stylists. Without this service, research the dish you are planning to photograph, using several authoritative sources, and buy the best ingredients available.

▲ Modern Japanese

The inherent simplicity of many Japanese dishes, such as sashimi (raw fish), lends itself to an emphasis on presentation. In this instance, a specially designed table containing a cast glass light, together with a modern ceramic dish, were the highlights, to which the chef added the seasonal touch of young maple leaves. The combination of built-in tungsten light from the table and blue twilight through the windows created a perfect colour contrast, unimprovable by photographic lighting.

Tricks of the trade

In order to make food look right in a photograph, it is often necessary to use a number of tricks that go beyond normal cooking. This may be because a dish suffers from the photographic process: frozen foods can melt, and fresh vegetables tend to wilt under studio lighting. Typically, many dishes are undercooked for photography so that they retain structure, while occasionally substitutes are used, such as glycerine instead of water so that the drops do not evaporate. With stews and curries, it may be necessary to raise the solid contents by placing a small upturned bowl inside, hidden from view.

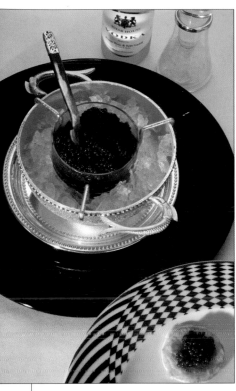

Caviar

Beluga caviar at its most luxurious, served traditionally with blinis and vodka. The authentic tableware was an important part of the photograph, and was provided by a specialist shop, The Caviar House in London. It clearly made sense in this case to approach a knowledgeable supplier and rely on it for authenticity.

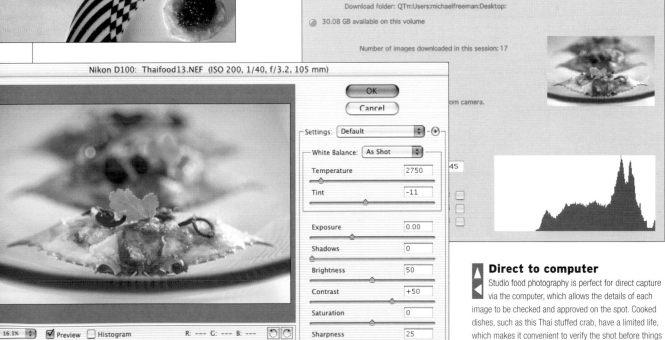

Direct to computer

Studio food photography is perfect for direct capture via the computer, which allows the details of each image to be checked and approved on the spot. Cooked dishes, such as this Thai stuffed crab, have a limited life, which makes it convenient to verify the shot before things wilt and congeal. The various control panels allow all the camera settings to be adjusted via mouse and keyboard.

Lighting food

The styles of lighting dishes for photography tend to follow fashion even more strongly than does the presentation itself.

At any one time, it seems that all the many published photographs of food in magazines and books follow the same formula. This is one of the inevitable features of a niche photography market that receives considerable editorial attention. Food lighting changes and evolves, partly because photographers, together with cooks and chefs, are trying to find real improvements in how food can be made to look. Nevertheless, there is no such thing as 'correct' lighting, and because food photography is bound up in matters of lifestyle, the way it looks is strongly dictated by fashion.

Right now the trend for a modern-looking presentation uses bright illumination (meaning an overall light and airy impression with few shadows) using shadow fill from secondary lights and at least one light placed behind and to one side, often with a concentrated beam. More importantly, this lighting is combined with close framing and very shallow depth of field, as in the Thai meal on page 25. Here, the high-key style of lighting makes the blurred areas glow. How long this style will last is anyone's guess.

Interestingly, this approach, tightly framed on the dish and from a low, diner's point of view, is ideal for digital shooting. It is intended to look immediate and direct, which is something that a digital camera, with its instant feedback, can handle extremely well. It also makes it possible to shoot in natural daylight – perhaps with one supplementary light. Colour temperature is, of course, no problem, and by checking through the white-balance options on the camera's menu, it is often possible to mix daylight and tungsten. On sunny days, look for a location that will receive direct sunlight late in the day, as in the photograph of the Thai dish.

Another style is to use a moderately diffused area light as in the basic still-life set-up on pages 64–65. The exact positioning of the light controls the relative importance of texture, detail and colour. Placing it slightly behind the food gives more pronounced highlights to liquids and shiny surfaces and tends to reveal texture strongly. Fill-in reflectors are essential with this kind of lighting to avoid large and deep shadows. Adding a spotlight from a low raking angle, as in the shot of the caviar on page 99, adds a slightly theatrical interest, particularly if the colour temperature is warmer.

Backlit oil
Olive oil, its hue enhanced by the addition of chillies and other ingredients, made a potentially colourful shot. A sheet of reflective Perspex/plexiglass was placed up against another sheet of the same material that was translucent, and this was lit from behind.

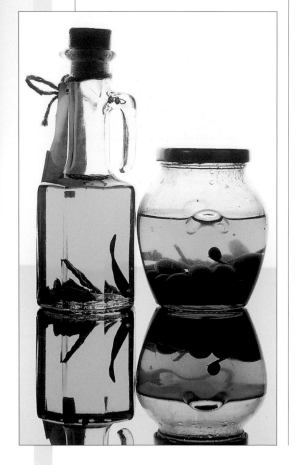

◀ **Tropical cocktail**

This image shows a cocktail served in the Grand Hotel near the Cambodian ruins of Angkor. Some sense of the building's old colonial atmosphere was called for: hence the addition of an old guide as a prop, and the careful placement of a palm leaf to cast graphic shadows across the tableau. Note the positioning of the shadows in relation to the shape of the glass.

Lighting and timing

Timing is important, as most foods look their best when freshly prepared, while warm studio lights speed up deterioration. An average dish will not normally survive the length of time needed to compose and light a shot, so position the camera and lighting in advance, using a substitute object for the food. With all the other props arranged, except for last-minute adjustments, it is a good idea to have two identical dishes, one prepared several minutes ahead of the other. Use the first dish to check composition and lighting, and then replace it with the second, fresher serving for the photography. Arrange for a short and clear line of delivery from the stove to the set, but do not have the camera so close to cooking food that it is in danger of being splashed with fat or other ingredients. For shots of food actually cooking, a portable gas burner can be useful. This can be positioned anywhere in the studio, and when the dish is almost ready it can be transferred to the smaller cooker or stove to keep it in good condition for the shot.

◀ **Natural light**

For this rustic Thai dish served in a northern Thai restaurant, the clarity of the evening light made it an easy choice, and it was unnecessary to use photographic lights. A reflector made of aluminium foil lightened the shadows at left. The dish was prepared and moved into different positions on a balcony as the sun set and the shadows changed.

▲ **Reflections and shadows**

A single window-light suspended overhead creates a more interesting lighting effect than you might imagine when combined with a gilded lacquer dish, the setting for a simple salt-grilled horse mackerel. Strong mirror reflectors in the foreground were needed to balance the bright reflections from the gold.

Case study: **market fish**

Food photography is by no means restricted to the final moment – the prepared dish as it arrives from the kitchen. Before that comes the raw ingredients. Here, we visit a market in Burma to shop for fish. The focus of the photography remains the same as for prepared dishes – to make the food look appetising – but the subjects are shot just as they are found, with no rearrangement and no added lighting. Shooting started as the sun rose. The lighting is attractive at this time of day, with warm sunlight grazing the food displays. We made a quick survey of this open-air small-town market to see what there was to shoot. Rustic naturalness and tradition was wanted, and one stall in particular caught the eye, principally because of the lovely old brass weighing scales, which would make an attractive textural contrast with the fish. The exercise here was one of refining composition with found objects.

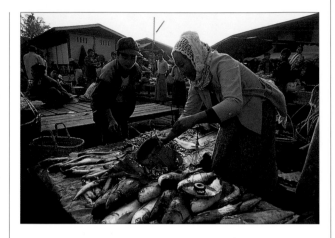

The setting
Sunrise. At this time of day, all the produce is open to the sky and light, but later, as it gets hot, awnings will be erected. This is definitely the best time for shooting. This stall stood out from the others because of the old brass weighing scales. The contrast of texture and colour with the freshly caught river fish would prove attractive.

Step one
The first attempt was a fairly predictable composition, with the pan of the scales centred and obvious. The light is good, and we can see the eyes of two fish, so it's an acceptable shot, but is there anything better? Perhaps the brass pan is too dominant…

Step two
Moving round slightly to the left, we see more of the fish and the pan is off-centred, which seems more balanced. But this introduces a new problem – the brightness of the fish at the top, which is distracting. Also, I really wanted a more graphic, geometrical design.

Step three
I moved around to the right this time, and angled the camera slightly. I lost part of the brass pan, but decided that this was not particularly important. The advantage is that there are now two sets of parallel lines, one overlapping the other. As a design, this is more organised and, at least to my eyes, a small but distinct improvement.

Liquids

Whether drinkable or not, liquids in close-up are all about refraction, colour and movement, with lighting as the key.

Clear liquids, such as beer, wine and olive oil, make interesting and attractive close-up subjects, but call for the same care in lighting as do the transparent materials that we looked at on pages 94–95. Generally, the same techniques apply, with diffused back-lighting always a standard option. Nevertheless, it is not a good idea to fall into a fixed pattern when shooting these subjects. Even though a broad back-light will nearly always give a successful, predictable result, it can easily become formulaic and even boring. The best way to keep ideas fresh is to experiment each time, and with liquids in containers (glass, flasks or bottles) there are countless subtle effects from refraction and distortion.

In any case, if the liquid is part of a larger set, with other objects or dishes to be lit in ways that suit them, back-lighting may not be an option. In this situation, one useful method of illuminating a liquid is to position a reflector, such as a small mirror, a sheet of silver foil, or a white card, behind the glass or bottle. Angle it to catch the light and reflect this through the liquid to the camera. If the reflector is approximately the same shape as the glass or bottle, its outline will not be noticeable when refracted by the liquid. You can see the same technique in use on page 95.

More than transparency, the special quality of a liquid is that it can move. Its appearance as it flows, trickles, or forms drops or bubbles, brings it to life. In close-up, this almost always calls for a high shutter speed or flash. While there are interesting slow-motion effects possible in nature, such as the misty appearance of a waterfall photographed with a slow shutter speed, in a still-life setting they tend to look confusing. Bubbles, splashes and ripples all need to be caught as if frozen. Flash is ideal, but only if it can be positioned wherever it looks best, and that, as you can see here, often means behind.

Substitute ice and bubbles

Two components that are often desirable in a still-life drink shot are ice cubes or bubbles. In both cases, the real thing is difficult to control and does not last. A solution sometimes employed in professional food photography is a handmade substitute. Ice cubes are available customized in acrylic, and bubbles in hand-blown glass. Because real bubbles burst and are difficult to position precisely, glass substitutes are a controllable alternative. Spherical bubbles are used for side-on shots of the surface of a liquid. Half-bubbles are used for shots looking down

Not all cameras allow synchronisation with a separate flash unit, and in this case the solution may be to use sunlight (modified with a diffuser if necessary) and a high shutter speed.

You may have to devise some way of creating motion, and this usually calls for close co-ordination. Pouring a liquid from a bottle into a glass is one of the classic problems, and you can expect many attempts before getting this right. The neck of the bottle needs to be in the correct position in the frame, and at the right distance for sharp focus. More tricky than this, it needs to be poured at the right speed and caught at the right moment. Too slow and it will look like a weak dribble, too fast and it will splash over. Too soon and the glass will look empty; too late and it will appear over-full. Fortunately, shooting digitally lets you know when you have the shot. The photograph of the mezcal on page 63 took about 20 attempts.

Manufactured bubbles
Creating bubbles in a liquid, sometimes needed in food photography either to imitate boiling without actually using a cooker, or to imitate an effervescent drink like champagne, demands some ingenuity. One method is to attach a flexible pipe to either a can of compressed air or an air compressor (this is easier than blowing with your mouth). The size of the bubbles can be altered by fitting a sponge or other diffuser to the other end of the pipe. To encourage bubbles to remain on the surface, a few drops of washing-up liquid can be added.

Decanter
Because the fruit pieces, rather than the liquid, are the interesting features in this shot, the lighting was selected to highlight their shape. Most of the light comes from the side, with just enough reflection to reveal the shape of the decanter.

Belgian beer
The aim here was to create a natural impression of a half-drunk glass of beer, deliberately avoiding the pristine perfection of a just-poured glass. One light was used from top left, with a small piece of silver foil placed behind the glass to reflect it up through the liquid.

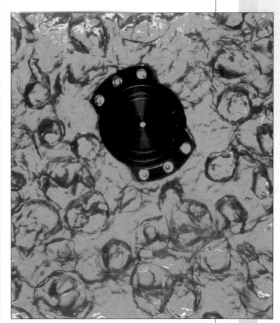

Turbulence
Boiling can create beautiful patterns in close-up, normally best revealed through back-lighting. In this case, the effect occurred naturally at room temperature, as the subject was liquid nitrogen. This was being used to super-cool a piece of scientific equipment in a glass dish suspended over a diffused flash.

Scale models and toys

Re-creations of large manmade constructions in miniature, scale models invite an equally detailed and precise treatment from the camera.

Scale models are something of a special case in still-life photography. For those who make them and collect them, they absorb a great deal of energy and attention. Sometimes functional (as in maquettes of building projects and in models for testing engineering principles), and sometimes a pleasurable exercise in exact miniature construction, scale models succeed or fail on their precision and the level of detail that they manage to contain.

Though it may seem too obvious to be worth mentioning, scale models are generally best seen, and photographed, from eye-level rather than from above. Remember that they are intended to be convincing reproductions of something much larger, and this argues strongly for a point of view that is also miniature – at scale, in other words. With this in mind, other elements of the photography should probably be in scale. The most important of these is depth of field. Ensuring sharpness throughout would not be an issue with the real full-scale object, but in miniature needs the care and techniques dealt with on pages 18–19. Lighting also deserves some thought. On the one hand,

▲ Shooting in context
Dolls and toys are designed for play, and this alone justifies a playful treatment. In addition to a more serious and straightforward documentary photograph, consider showing them as a child might see them.

▶ A considered casual grouping
These American nineteenth-century toy vehicles at a museum needed to be shown as a group, but a plain view against white was considered uninteresting. Well, the usual play area for cars and trucks is the living room floor, and fortunately there was an appropriate room set available in the same museum. And of course, toys get knocked over…

We would be happy to send you further information on ILEX books and updates on forthcoming titles.
Please indicate which subject area(s) interest you and return this card to us.

Subject categories:

☐ Digital Photography
☐ Graphic Design
☐ 3D Art and Design
☐ Game Design

☐ Digital Video and Audio
☐ Web Design
☐ Art and Imaging

As we will be sending details by email, please ensure that you enter your full email address clearly below.
All information is subject to the Data Protection Act:

Name: _____

Address: _____

Postcode: _____

Email: _____

Alternatively you can receive full details on ILEX books or join the online forum by registering on our website at **www.ilex-press.com**

POST CARD

ILEX
FREEPOST NAT10440
LEWES
BN7 2BR

◀ Shooting for scale

This beautiful scale-model synagogue in a Tel Aviv museum had realistic interior lighting. To shoot it as if it were full-size, a wide-angle lens was essential (20mm efl), and it was completely stopped down for full depth of field. This meant using a tripod and a long exposure.

▼ Two treatments

In the first (bottom) image, the model was shot side-on with a standard lens against a white background. The background was dropped out later in image-editing. The second shots (top) aimed for a scale view, moving in close and using a wide-angle lens at minimum aperture.

a diffused area light is good for clarity and avoids deep shadows, but using small light sources enhances the impression of scale. Equally, a normal or longer focal length is a natural choice in close-up, and helps to keep the background limited, but a wide-angle lens from very close is a more faithful treatment that lets the viewer feel the model is being seen as full scale.

Toys are rather different, although in the case of particularly well-built ones the dividing line between them and scale models can be hazy. Toys, by definition, are meant for play, but they are also, when old or valuable enough, collected. This suggests some alternative treatments for photography. One is the child's point of view, usually at ground level, where the props of everyday life – chair legs, carpets or the garden lawn, become different settings in the imagination. This was the idea behind the shot of nineteenth-century metal toys. At the point where toys become worth photographing, they are often antique and usually valuable, which gives an added interest to this apparently casual treatment. Much depends on the purpose of the photograph: if the idea is to document the details of a collection, a more conservative approach is probably appropriate. A purist collector will generally prefer to see a clear, expository view of the objects. And, as toys are often created in sets and sequences, the most useful treatment might be the photographically least interesting – an ordered arrangement of similar toys.

Built to order

Purpose-built models are an essential part of professional still-life work, particularly where photography is used to illustrate ideas and concepts that lack obvious visual elements.

Models are used in a number of ways in photography. Often they are made to a scale that allows the photographer to juxtapose them with another object that will appear life-size (the photograph of car and safe on page 65 is an example). The modelling technique itself can become an important part of the shot, as with the bricks and the mouse on these pages. Most difficult of all is the use of models as perfect substitutes for the real thing, which for any number of reasons may not be accessible. At a certain point in the planning, it may make more sense to do digital compositing instead, but models retain a certain innate appeal.

Although scale model construction can be a highly specialized skill, doing it solely for still photography is easier and less exacting than usual. In most cases, the model is only intended to be viewed from one position, and provided that the camera angle is worked out beforehand, only the camera-facing side need be built, rather like street frontages on movie lots. Another time-saving advantage is that models for photography hardly ever need to be permanent, so solid construction is not necessary.

▲▲▶ Imitating a full perspective scene

To create this fictional moonscape, fine-textured material and false perspective were employed. With a board measuring 125 by 100 centimetres as a base, the shooting angle was chosen, and the camera locked down in position. The area covered by the lens was drawn on the base, as was the compressed distance scale, from infinity at the other side of the base to about three metres nearest the camera. The landscape was then modelled in high alumina cement from a sculptors' supply shop. This is ideal because it can be given different textures by spraying or mixing with water. The view was constantly checked through the camera to make sure that the illusion of perspective remained accurate. Black velvet was hung for the background, and the earth and stars were added later digitally. The lens was stopped right down to its minimum, *f*22, for maximum depth of field, and a small flash gun was used to give hard shadow.

Simple materials

Simple, inexpensive materials can be just as effective as custom-made kits and parts. To illustrate a magazine article on the subject of hoarding, white beans were used to symbolise a mouse hoarding a pile of food. The basic shape of the mouse was made in modelling clay, and the beans were placed one by one to cover the surface. The whole model took about an hour to make.

Forcing perspective

To make an ordinary brick seem the size of a large building, a wide-angle lens was used from a very short distance and angled upwards to give a deliberate convergence of verticals. However, if it had been set up against a real landscape, the depth of field would have been insufficient to keep the whole scene sharp. Instead, a twilight setting was used, and a false horizon cut out of black card with the recognisable outlines of a church and house to make it obvious. This was laid on a thick sheet of translucent Perspex/plexiglass and backlit. A small portable flash unit was used to light the brick at a grazing angle to emphasise texture. This helped the illusion of a large scale, because the small flash tube cast very detailed, hard shadows. In addition, being aimed from such an acute angle, the lighting did not include the horizon or 'sky'. For a realistic evening sky, two sheets of transparent coloured acetate were taped under the Perspex/plexiglass – blue for the upper sky and plum-coloured for the area close to the horizon. By shaping them so that they fell away in the middle of the picture area, the transition was smooth and natural. To help the illusion further, one last refinement was to add the moon digitally from another photograph.

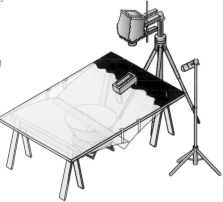

Building symbols

The complex theme for this shot was international finance in the construction industry. To convert this non-visual idea into a simple image, model bricks were built into a wall in the shape of pound sterling and dollar signs. Construction time was ten hours.

Coins and stamps

Specialized collections call for accurate documentation, and if the image database will be added to later, lighting and viewpoint need to be consistent.

The usual reason for photographing coins from a collection is to document them, meaning straight-on, clearly and cleanly lit (and both obverse and reverse, in most cases). If the coin is in mint condition, as it's likely to be, it may be highly reflective, depending on the kind of metal, and this brings special lighting needs. The normal approach is as with any shiny surface – use a diffused light from an angle that covers the full face of the coin. However, there is an extra problem with coins in that most are circular, and a circle is a strong memory shape. If you shoot at a slight angle for the light, the coin will appear slightly misshapen, but if you shoot straight down, the light cannot be fully reflected in the surface. Without a shift lens, the solution is to use a long lens to reduce the angle, and then correct in image-editing with the perspective tool. An alternative lighting method that gets around this is side-lighting – from at least two sides – so that the relief is highlighted but the base is dark.

Half-silvered mirror or thin, plain glass

Diffused

45°

Coin

Brightfield axial lighting

In one sense, a straightforward coin photograph is a copyshot. The film back should be parallel with the coin so that it appears truly circular. In addition, however, many coins have all the problems of reflective objects. To combine bright reflected lighting with perfect alignment, use axial illumination. This is light that appears to come from the position of the camera, along the lens axis. With a special box, using a half-silvered mirror, or even very thin plain glass, any lamp can be made to produce axial lighting. The lens axis and light axis are set at right angles to each other, and the glass at 45°. Part of the light is lost, passing straight through the glass, but part is also redirected down to the coin, where it is reflected straight back up to the camera. The inside of the box should be matt (flat) black to reduce unwanted reflection from the top of the glass, and the lamp should be diffused.

Low-angled darkfield lighting

An alternative lighting method, which works best with proof coins that have a mirror-like finish, picks out only the relief details, leaving the main surface area black. The principle is a glancing light from the side that reflects only from the raised areas. Black paper taped to the front of the camera bellows allows only the lens to show, so that nothing bright can reflect in the flat surface of the coin. A reflector, in this case gold foil, opposite the light balances the lighting.

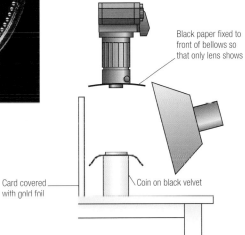

Black paper fixed to front of bellows so that only lens shows

Card covered with gold foil

Coin on black velvet

Postage stamps

Stamp collections also call for a documentary approach, with the additional requirement of colour accuracy (as with copyshots). Also consider including, as in this example, the edge of a ruler for exact dimensions. If you later want to arrange the images in sets, this will be essential if shots were taken at different times with inevitable small differences in scale. The background against which stamps are displayed in real life is a matter of taste, but a dark background makes it easier to select stamps for cutting out. An alternative to all of this is to scan stamps, but check to make sure that there are no reflections from coatings and metallic inks.

Correcting the angle

This group of coins (an extremely rare set) posed a special problem of angle, because in order to have the diffused area light reflected in all of them, the camera axis had to be at a slight angle. This created some distortion, which was corrected using the Perspective tool at the image-editing stage. A pre-drawn perfect circle in an overlying layer was used as a reference for the correction.

Case study: **out of the studio**

Sometimes the studio, for all its facilities and possibilities of control, is not the most effective setting for a still life. It certainly scores on efficiency, particularly of lighting, but there may be other, more important qualities needed. Most still-life photographers, once they have established a way of working in familiar indoor surroundings, with an assembly of lighting and other equipment, tend to tackle each project as one to be solved in a studio manner, building up everything from scratch. It's worth remembering, however, that there are no rules about this, and sometimes an outdoor location can be perfectly relevant. Just as unplanned still-life scenes can be found anywhere (*see pages 30–31*), they can also be constructed. This was the case here, with a set of small ceramic pieces that the artist, Yukako Shibata, had conceived as being partly organic in form. After a straight studio shot, we looked for other treatments.

▲ **Studio**
The first approach had been to concentrate on the pieces' physical qualities: their shape, variations in size, and the subtleties of their glazed off-white surfaces. A sheet of black Perspex/plexiglass was selected as a background. This would provide a strong, definite contrast, while the delicate reflections that would be visible from a low shooting angle would add interest. A broad area light was suspended low over the grouping in order to light them evenly while giving a suggestion of the glaze through its large reflection.

▼ **Grass**
There was something mushroom-like about these little domes, so we decided to treat them as organic entities, and took them to a woodland location. Special care was taken so that blades of grass appeared to be growing around the pieces.

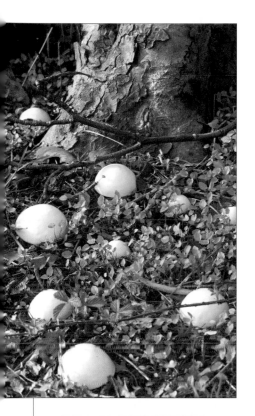

◀ Tree roots
Even more successful as a location, once we thought about it, were the roots of a tree, partly because they added the suggestion of an enclosing frame, and partly because in nature this is a likely habitat for mushrooms. Lighting control was sacrificed, but the weather was good, with hazy sunlight in the late afternoon. This brought gentle specular highlights that helped to define the glaze on the ceramics.

▶ Pond
Finally, another small work by the same artist, featuring a subtly painted sphere sitting in the centre of a square mirror, was shot in the same general location. To make the most of the reflective surface, we chose an area with taller clumps of grass, shooting towards the sun for contrast. The suggestion here is of a small pond.

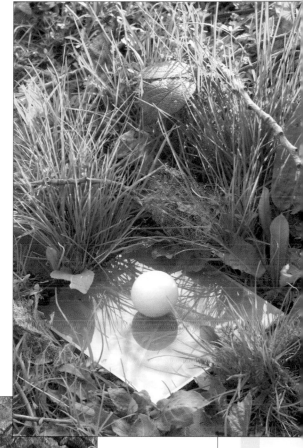

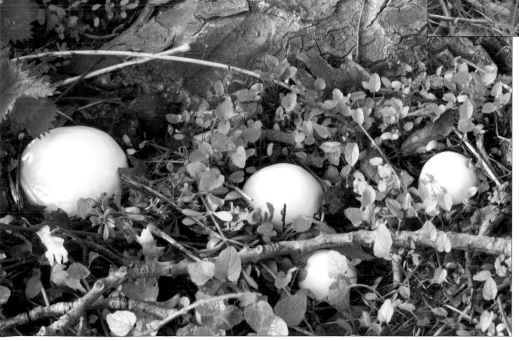

Copyshots

Photographing flat images such as paintings and illustrations demands precision and technique, the three most important considerations being alignment, fidelity and lighting.

Copying can be used to record documents or illustrations, or as part of other photographic techniques such as photomontage. There is absolutely nothing creative in this, but there is considerable technique, and when it's necessary it saves a great deal of time and frustration if you follow a few simple procedures, as follows.

Daguerreotype
Originals with reflective surfaces need special care. This daguerreotype had a silvery, mirror-like finish that is typical of this old photographic process. To avoid the camera from appearing recognisably in the portrait, the following precautions were taken: a long lens was used so that the camera position could be far back away from the lighting; black cloth was draped around the shiny parts of the camera; and a wide aperture was used so that the depth of field would be shallow and the camera well out of focus.

Alignment

The two most convenient positions for taking copyshots are horizontally on the floor or a table, and vertically against a wall. With small originals, the horizontal position is usually easier, but with large paintings it may be necessary to photograph them while they are hanging in place. A custom copying stand is useful if you do this type of work frequently, or you can adapt an enlarger. Otherwise, you can use a regular tripod for vertical copying against a wall or a tripod with an extended horizontal arm for copying horizontal originals.

Vertical copying
One straightforward way of keeping the illustration flat and level is to place it on the floor and photograph it from above. An extended horizontal arm will keep the camera clear of the tripod. A plumb line or sprit level can be used to centre the camera vertically above the picture.

Copy stand
If copying is likely to be a regular exercise, a standardised set-up of camera and lights may be convenient. A copy stand can be adapted from an old enlarger — one way of recycling pre-digital equipment!

Alignment is a critical procedure, and even a slight error can cause the effect known as 'key-stoning', which will turn the rectangular borders of a painting into a trapezoid and can even throw part of the image out of focus. There are four basic methods of aligning the original to the film plane:

1. Use a spirit level to check that both the camera back and the original are precisely horizontal or vertical.

2. Where the original has to remain at an angle (a hanging painting, for example), measure this angle with a clinometer or a plumb-line and protractor, and then adjust the camera back to the same angle.

3. Use a grid focusing screen (some digital cameras have this as a menu option) and compare the edges of the artwork with the etched lines. Occasionally, however, the original itself may not be exactly rectangular.

4. Place a small mirror flat against the surface in the centre of the original, focus the reflection of the camera manually sharply in the viewfinder or the LCD screen, and move either the original or the camera until the reflection of the lens is dead-centre. Remember to reset the focus before shooting. This is a very accurate method.

Fidelity

As in duplicating, completely accurate reproduction is not possible and some colour may be distorted by certain types of film. As an independent check, place a Colour Target or Separation Guide alongside the original. This is an accepted standard, and if the shot is intended for reproduction, the printer can then correct colours and tones without viewing the original illustration. Also, you can measure the known values on the target in an image-editing program, and use them to correct the image. Contrast is often a problem; if your camera allows it, experiment with tone compensation. For the best results, eliminate flare by placing the original against a dark background, such as black velvet, and use naked lamps unless the painting or its frame may show reflected highlights, in which case you will need to diffuse the lights (*see the following pages*).

▲ Colour patches and greyscale

Several manufacturers, including Kodak, make standard colour patches and greyscales. Use them when copying painting or illustrations where accurate reproduction of colours and tones is important. Place these within the frame of the photograph and shoot them beside the original illustration as an extra measure of colour and brightness accuracy. They can be measured digitally during image-editing.

▲ Mirror alignment

Place a regular hand mirror flat against the artwork (if you can), and focus on the reflected image of the camera. Adjust the positioning until the image of the lens is exactly in the centre of the viewfinder or LCD.

Lighting flat artwork

In total contrast to the lighting of objects, the ideal illumination for a copyshot has no character, but is simply efficient, covering the subject evenly, without shadows or reflections.

The first principle in lighting for a copyshot is to get the entire area completely even, with no fall-off in any direction. The most even lighting is equally from all sides, and the ideal lighting arrangement uses four identical lamps positioned at the corners and equidistant. To avoid a hot-spot in the centre, aim each light towards the opposite corner. A simpler arrangement, which is usually effective enough, uses just two lights. Again, aim each at the opposite edge of the original, but position them at a greater distance than with four lamps. Even a single lamp, or daylight from a window, can be used provided it is diffused and a reflector is placed at the opposite side.

To measure the evenness of the lighting from more than one lamp, place a plain card against the original and hold a pencil perpendicular to it. The shadows cast by each lamp should be equal in length and density. Alternatively, use a light meter with the white plastic receptor for incident readings. Hold it facing the camera right next to the artwork and take several readings from different positions, including the corners. Each measurement should be identical. Also hold it in the centre, aiming it in turn at each light while shading it from the other(s). Again, the readings should all be equal. Always flag off the lights from the camera with pieces of card attached to stands, or use a professional lens shade.

Reflective surface
Pictures covered with glass or with a varnished surface can be a particular problem. To cut down unwanted reflection, place black card or velvet in front of the camera, with a hole for the lens.

Two lamps
A good result can also be achieved with two light sources placed at either side. They should be aimed at opposite sides of the illustration.

All-round lighting
The best lighting arrangement for a completely even spread uses four identical lights, one at each corner. Direct each lamp at the opposite corner to avoid a strongly lit centre.

Reflections can be unexpectedly troublesome. They are at their most obvious with varnished oil paintings, but can also appear almost imperceptibly with other textured surfaces, such as paper used for prints and for photographs. Even apparently matt surfaces can suffer, causing colours to appear less saturated. To avoid reflections, position whatever lights you are using at about 45 degrees to the original. A position closer to the camera will cause reflections and a shallower angle will show texture. There is even less risk of reflections if the camera is positioned farther back, with a moderately long-focus lens. For absolute control of reflections, cover the lights with polarizing sheets and the lens with a polarizing filter. Rotate the filter until the reflections are reduced, but beware of small violet highlights from very bright reflections. Because the light has to pass through two polarizing screens, an extra three stops exposure is needed. When the original is behind glass that cannot be removed, use the same techniques but in addition hang a sheet of black velvet or black paper in front of the camera with a small hole cut for the lens.

Checking the lighting
If more than one light source is being used, hold a pencil vertically at the centre of the illustration. The shadows cast by each lamp should be of equal length.

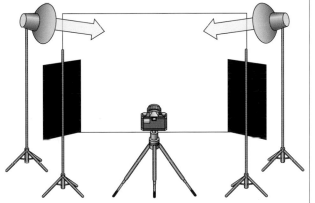

Shading the lens
Because it is particularly important to avoid flare to reproduce the full contrast in the subject, the lights should be flagged from the camera with pieces of dark card.

Gold
Avoiding too much reflection in the gold leaf is achieved using the black card method shown opposite. Even then, however, it is important to ensure that reflected light is not too strong.

Nature in Detail

Nature means detail. In one of the companion books in this series, *Landscape and Outdoors*, one of the themes is the wider context of the natural world, the landscape, where not only is the scale large, but the various components are seen fitting together – mountains rising above plains, rivers connecting them, vegetation covering them from foreground to distance. Here, however, we make a selection from the natural world. By closing in and framing with care, the camera can be made to isolate parts from the surroundings.

The American photographer Eliot Porter (1901–90) did more to refine the aesthetics of the close considered view of nature than anyone else. He believed nature photography to be of two types, either 'centripetal' or 'centrifugal'. In centripetal photography, all the elements work to converge on a centre of interest, drawing the attention inwards, away from the context of the wider surroundings. In centrifugal photography, the composition is more dynamic, drawing the eye towards the edges, encouraging the viewer to think about what lies outside and why the photographer excluded it.

It is perhaps the centrifugal approach that draws more strongly on the art of photography. A photograph of a beetle, for example, demands very little in the way of composition. We simply want to see it, which means large in the frame and clearly. There are subtle, efficient improvements that can be made, such as making sure that the background is not unnecessarily confusing, or placing the creature slightly off-centre if it is moving so that a larger area of background is ahead of it, but

essentially the design of the image does not really call for surprises. But when it comes to choosing a part of an interlocking view, whether of grasses, trees or rock, with their interplay of colour, shadow, and shapes, the image frame then becomes a creative tool of real importance. Design in photography always relies heavily on how you crop the image, but it matters more in nature photography, where the act of closing in is central.

There are two main purposes in nature photography: documentary and aesthetic. In one, the subject takes priority, while in the other its visual qualities are the starting point. In the following pages, I've tried to look at nature from both points of view, in the hope of showing that an informative image can be visually stimulating, and that a photograph that sets out to explore the purely visual can also add to our sense of nature. Porter, though knowledgeable as a naturalist, wrote, 'I do not photograph for ulterior purposes. I photograph for the thing itself – for the photograph – without consideration of how it may be used.' However, he was happy for his work to be used for environmental awareness.

In this section, we turn from the constructed and controlled still-life image to the detail that occurs outdoors naturally, much of it unexpected. One of the inspiring qualities of nature photography is that, on this small scale, nature always delivers visual surprises. The subject matter is wide-ranging: not just the plant and animal kingdoms, but minerals and rocks, from the texture of a limestone cliff to precious gems. The field is vast, and appears even larger when looked at closely.

Colour and pattern

Nature is the source of an amazing range of graphic material from which you can create images that are both abstract and minimalist.

Just as some nature photographs turn inwards while others draw attention to what might be outside the frame (*see pages 118–119*), there is also a subtle distinction between those close-up images that document the natural world and those that are mainly an artist's exploration of it. The documentary approach is more concerned with the facts – what a particular species looks like; its identifying characteristics; how it behaves or where it grows. This in no way prevents the photograph from also having an aesthetic appeal, but a clear, legible view is the first priority. The other approach starts from a different point of view – that there is much beauty to be found within the natural world. It may be beauty of colour, of line, or of form, and even though it has a role to play in the survival of the plant or animal, this is secondary to the picture.

To a botanist, the colour of a flower may mean one thing, as the function of a snake's repetitive pattern might to a herpetologist. They play a part in natural selection. But quite divorced from this they also make very appealing images in themselves. Nature provides the material for abstract imagery, and it reveals itself above all in colour and pattern. In a sense, of course, nature is the source of all colour, shape and line that appears in art. Artists' pigments

◢ Cracked
This outpouring from a mud volcano had baked under the tropical sun. To fill the frame with as large an area as possible, a 20mm efl lens was fitted and the camera tilted down.

◀ Azalea in bloom
A large and spectacular azalea tree, more than two centuries old, blooms a rich red in the summer. Shooting from very close – almost inside the tree – with a wide-angle lens captures the maximum number of flowers while excluding the surroundings.

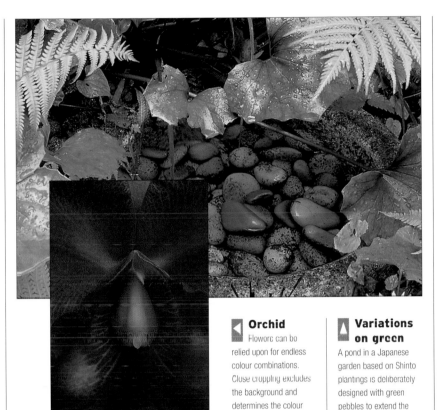

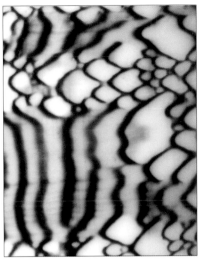

Cone shell
Like flowers, shells are a guaranteed source of close and unusual detail. This painterly pattern is from a cone shell, an image of the full shell appears on page 149.

Orchid
Flowers can be relied upon for endless colour combinations. Close cropping excludes the background and determines the colour arrangement.

Variations on green
A pond in a Japanese garden based on Shinto plantings is deliberately designed with green pebbles to extend the theme of natural green.

are extracted from such sources as rocks and insects. But the nature photographer has a much wider palette at his or her disposal than does a painter, because the full, complex range is there growing in the natural world.

Looking at nature from the position of photographer rather than naturalist, the act of closing in with the camera becomes an essential tool of photography. This is the way in which you can select from a plant or a small grouping, or from an animal, just the graphic elements that you want to record. The examples shown here have in common a framing that has cut right in on a scene to show just one of these visual features. Defining the element is completely up to the photographer, of course, and might mean a single hue or a small range of hues; a pattern that appears to cover a large area; or just a few components of the pattern. All of this is a matter of closing in to exclude the other elements. Compare, for instance, the red-saturated image here of azalea leaves with the photograph of the entire tree on page 129. This tree is a remarkable specimen of its type, and there is more than one way of photographing it.

Snakeskin
At this scale, cropping in close so that they are disassociated from the animal or plant of which they are a part, many patterns appear new and unusual. This snakeskin posed no depth of field difficulties as it could be stretched flat and photographed with the camera pointing vertically down. The light chosen was a naked flash aimed from one side, with a white card reflector opposite to even the illumination. The naked lamp helped reveal the texture of individual scales.

Flowers and fungi

These are the staples of close-up nature photography; they are relatively easy to find, static, and always beautiful at some degree of magnification.

Photographically, flowers, mushrooms and toadstools are similar subjects, in that their size and location calls for a similar approach. Individual portraits fall within the range of close-up photography, and need the techniques described on pages 90-101, but being relatively static subjects they are, on the whole, easier than insects. Rather than photograph the first specimen you find, look for others that may be in better condition or in more attractive settings. Most plants that flower do so seasonally, and this varies from species to species, not only in the dates of first flowering, but also in duration. Other than just keeping your eyes open on a trip, it helps to know which

▲ Stinkhorn

Fungi, such as this Stinkhorn mushroom, generally appear suddenly (sometimes overnight) and deteriorate rapidly. The window of opportunity for shooting is small, and they need to be photographed as soon as found.

◄ Pitcher plant

A pitcher plant (*Nepenthes villosa*) growing close to the ground on the slopes of Mount Kinabalu, Sabah, Malaysia. The bizarre shape with its lid-like covering of a leaf has evolved for trapping insects and dissolving them for sustenance in the liquid at the bottom of the pitcher. Some plants, like these, which grow at an altitude of around 2,750 metres (9,000ft), have a very narrow range of habitat. This concentration makes them fairly easy to find.

blooms to expect in particular months, and there are many wild-flower guides that give this information.

Woodland is especially rich in plant life. With so much vertical growth and with a seasonal leaf fall, the soil receives ample nutrients from the decomposed litter. In clearings and around the forest edges where sunlight can penetrate, ground plants are common, and open woodland often has a profusion of flowers in the spring and summer. Even more characteristic of the forest floor are fungi, which feed on decaying organic matter, breaking it down into simpler chemicals that plants can use for nutrients. Some of the largest and most spectacular fungi are woodland species specializing in breaking down lignin from rotting wood. The best time to find fungi is autumn, when there is most dead organic matter on the ground. In tropical forests, most flowers are at higher levels, and are epiphytic – clinging to stems and branches. The most spectacular of these are the orchids. Their flowering times depend on the species rather than the month as there are no distinct seasons in true rainforest. Use a long-focus lens and tripod for high-level epiphytic plants. In the habitat that contrasts the most with these lush forests – desert – flowers are rare, typically appearing after rains and in the spring, but they are highly visible when they do appear.

Generally, flowers and fungi can be photographed at three different scales: as standard portraits, nearly filling the frame; in extreme close-up, concentrating on details, or as components in a small landscape, shot from a distance. The viewpoint chosen depends on the species, but a low camera position is often useful. Intervening blades of grass and debris can be cleared or bent back out of view. Backgrounds are usually best when simplest, and the further they are behind the subject, the less sharp and distracting they will appear. A long-focus lens enhances this effect. Small alterations to the camera position can change the background radically.

Iris
One way of simplifying the view of a single flower is to find a specimen that is separated from its background, and use a wide aperture for a shallow depth of field, as in the case of this Yellow Iris (*Iris pseudacorus*) in the rain. Use the LCD screen to preview the effect of different apertures on blurring the background.

Marsh orchid
Wetlands are excellent locations for plant photography, with species such as this European Northern Marsh Orchid. Most flowers grow below the level of sedges and grasses, which easily make a solid green background. In the case of this flower, the colour contrast was a welcome element.

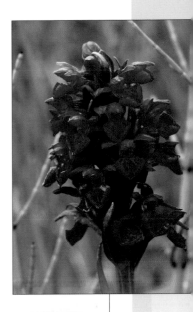
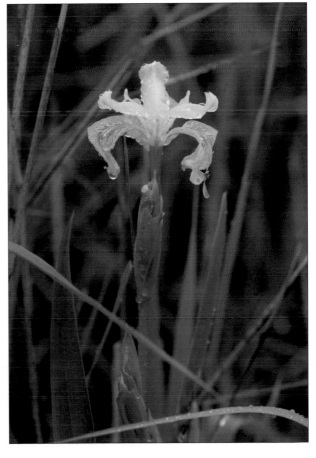

Plants in situ

Photographing flowers where they grow calls for a range of techniques in managing the surroundings, depth of field and lighting.

For a clear documentary portrait, a relatively small aperture is essential, and this, in natural light, will mean a slow shutter speed. A low tripod position or an alternative ground-level support is then virtually mandatory. If the background and foreground also appear sharp, the picture may appear confused; an unobstructed foreground and distant background help to isolate the image (*see pages 18–19 and 22–23*). The shape of most flower heads is deep, and at very close range complete sharpness may not be possible. In this case, move back and re-compose. At slow shutter speeds even a slight breeze will cause blurring, so use a piece of card, a jacket or your body as a windbreak. An alternative, impressionistic, approach is to use a wide aperture for shallow depth of field and an image that relies on a blurred mixing of out-of-focus colour (*see pages 20–21*).

If the background is totally unsuitable, you can, with a little effort, provide one yourself. Use a plain sheet of material, in either a neutral or natural colour. Velvet is best, as it shows creases less than ordinary cloth or paper. Black is the most acceptable colour in most cases. Erect the sheet as far behind the flower as possible, to minimize the danger of the material's texture showing. This distance affects the size of the sheet that you need, as does the lens focal length and size of the flower. A one-metre-square sheet is satisfactory for most situations. Two small, collapsible stands make good supports, although it may be necessary to use tent pegs to secure them against movement. Attach the sheet with clips.

Judge the lighting needs on the merits of each situation. Your camera's range of sensitivity settings means that you can usually shoot in natural light, particularly if you use a tripod – and for ground plants, a small pocket tripod is ideal. Both shade and shafts of direct sunlight can be attractive natural lighting effects. One of the special advantages of shade is that the low contrast simplifies the image and gives good colour saturation – although be careful to judge the white balance, particularly if much of the light is reflected from a blue sky and has a pronounced colour cast. If necessary, use a card to shade the flower. Also, a white card or piece of silver foil can be used in sunshine to fill in shadows.

Barrel cactus
Most cacti flower sparingly, which increases the difficulty of catching them in bloom, although this is offset by the ease of spotting the bright flashes of colour at a distance in a desert landscape. This barrel cactus was found in Arizona, near Sedona.

If the natural light seems insufficient or not very interesting, experiment with flash. Flash lighting is often most successful when it imitates direct sunlight. To do this, hold the flash over the subject rather than mounting it on the camera. For extra realism, calculate the exposure so that some of the background, in daylight, is also recorded (to be safe, bracket exposures). A sheet of tracing paper, white cloth or a diffusing umbrella (the kind used in studio photography) can be used to diffuse the light from the flash unit for a gentler, less intense, effect.

▼ Bluebells

Spring is the season for bluebells, which in some years can form great carpets of colour in woodland. This beautiful scene in an old forest on the borders of Wales and England gave the opportunity for three distinct scales of image, shown here and below. I captured this overall view using a medium telephoto on a tripod at minimum aperture for maximum depth of field.

▶ Portraits

◀ I photographed individual plants at a wide aperture (right). In between these two scales of full-view and portrait was a medium-scale arrangement that took in the gnarled roots of the forest (left).

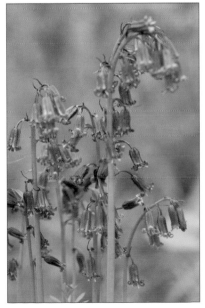

Flowers in the studio

Bringing flowers into the controlled conditions of a studio allows you to light and arrange them elegantly, for a quite different, considered type of image.

An interesting alternative to photographing flowers in their natural settings is to bring them into the studio. Here you can select whatever background you need to complement the flower, and there is no risk of a breeze moving it during a long exposure. Moreover, much of the appeal of flowers lies in their form and colour, and the graphic compositions that they offer are more easily worked out in the controlled environment of the studio.

It is usually best to have a background that isolates the flower and makes it as prominent as possible. Most flowers, particularly those with light tones, stand out more clearly against a dark background. For the darkest of backgrounds use black velvet, which absorbs light more efficiently than practically any other surface. If you need colour, consider coloured velvet rather than paper, which frequently shows creases and wrinkles. A second method of providing an isolating background is to use a colour that contrasts with that of the flower. So, a blue background for a yellow rose or a green background for a red hibiscus will give the greatest contrast of colours, at the risk of looking garish. An alternative and more subtle approach is to add overall back-lighting with a second lamp and diffusing sheet behind. This, as shown here, gives a clean, elegant setting. Flare is always a problem with this kind of lighting, as a large percentage of the image area is bright. Always

Back-lighting

To photograph these orchids in uncluttered close-up, a studio setting was chosen. The graphic, luminous effect was achieved by balancing back-lighting and top-lighting. The back-light – an evenly illuminated sheet of thick opal Perspex – was used to provide a shadowless background, but also to reveal something of the inner structure of the translucent petals. Exposure and lighting were set so there was just a hint of tone in the background. Any brighter, and flare would have degraded the image. The top-light provided modelling and sparkle to the highlights.

Optimizing for flare and saturation

Degraded saturation is a common feature of back-lit shots with large areas of white. Setting the black point and white point, done here with a third-party colour correction plug-in, helps to restore the image qualities.

Complementing colour
It's easy to overdo this approach, but occasionally using the background actively can help make an interesting addition to a shot. Here, art paper was chosen to match the hues of this tulip, and torn into shapes that play with and extend the colour references.

Bluebells
Compare this studio shot of bluebells with the sequence on page 125. There, in situ, the flowers are a part of nature, embedded in their surroundings. Here, they are treated as organized objects. This is not a question of which is better; the aims are quite different. The same back lighting set up was used as for the orchids. A fine spray of water contributed to the highlights, and also had the practical value of keeping the flowers fresh under the studio lights.

mask down the camera lens (such as with a lens shade and/or black card) to cut out any stray light.

As for the light source, flash has an advantage over tungsten because it is cooler. The heat output of a tungsten lamp is enough to wilt a flower in a very few minutes. Even with a studio flash unit, you should dim the modelling light. The quality of lighting makes an important difference to the final image. Diffused lighting, such as from a window reflector, has a soft and natural quality to it. There are no hard edges to the internal shadows from petals. If the flower is very small, however, this diffusion of light may eliminate shadows too efficiently, to the point where there is almost no modelling. Hard, direct lighting mimics strong sunlight, but produces an inevitable harshness and sometimes causes unpleasant highlights. Remember that the most saturated colours are achieved with diffused light – grass is at its greenest on a cloudy, overcast day. The angle of the light can emphasize certain parts of flowers, and can also add atmosphere to the shot. A light placed behind the flower and to one side, out of the camera's view, can be adjusted to give a bright edge to the petals and stamen. In this case, use white card or silver foil reflectors in front of the flower to lighten the shadows. One technical issue is the great depth of field needed to bring every part of the bloom into sharp focus. But by increasing the amount of light or by taking longer exposures, it is possible in the studio to stop the lens down to its smallest aperture – usually f22 or f32. For larger flowers, this should render every part sharp.

Recording colours faithfully
A flower's colour is one of its most important qualities, and you should take as much care as possible to render it accurately. Consider including a colour target in one shot (*see page 115*). Even so, there are occasions when faithful colour reproduction may still be very difficult. Some flowers reflect light in wavelengths to which the eye has poor sensitivity. For this reason, some blue morning glory and ageratum blooms, for example, can show colour shifts in an image – that is, they appear different from the way we see them in real life. Digitally, this is entirely correctable, provided that you check the image on the computer at the time of shooting. Compare the on-screen image with the actual specimen, and use a correction procedure such as the HSB sliders, Curves or Levels.

Trees

Trees are an inevitable component of many landscapes, but photographing them as individuals takes more effort, both in finding specimens and in choosing the light.

As components of a landscape, trees can be treated decoratively, but as subjects in their own right they generally need to be photographed clearly and distinctively. This is by no means always simple, as most have complex shapes and normally grow in settings that are, to the eye, confused. Images of trees can be simplified first by finding specimens that are distinct and preferably isolated, and then by shooting at a time of day and in weather that gives the most suitable lighting. Alternatively, you can photograph large stands of trees, emphasizing the patterns and textures of massed tree trunks and foliage, or concentrate on details of roots, branches, leaves and so on.

For a clear, isolated view of a single tree, first look for the best specimen – meaning one that is a good example of the species, and also is in a setting from which it stands out, such as a single palm tree in a hardwood rainforest, or one maple that has turned to its autumn colours before its neighbours. Some species, such as elm and acacia, tend to grow more or less singly, scattered over open ground. However, even among species that grow in stands, occasional individuals can be found just beyond the edge of a woodland or forest. There's no guarantee that you will find a good example, and there's no shortcut to avoid an on-the-ground search.

There are certain conditions that can help, however, particularly when it comes to the background. A steep hillside, for example, by arranging the

▼ When the view comes first

Quite often, surrounding trees and vegetation make it difficult to get a clear view of a particular specimen, and the choice of tree may be determined simply by its location. In this forest in the northern Everglades, a long walk produced only two possible views of the cabbage palm typical of the habitat. The clearing in front of this small stand was just large enough to shoot with a moderately wide-angled lens. The shot was improved by using surrounding leaves as a frame and by waiting until late in the afternoon when these palms alone were sunlit.

▶ Panorama of detail

This old, moss-covered oak tree was the most spectacular of many in a small forested South Wales valley. While there were only cluttered, confused views of the entire tree, the lower spreading branches made an interesting image in their own right when treated as a panorama from close. Seven overlapping frames were later joined seamlessly using Stitcher software.

vegetation more vertically, tends to isolate individual trees, and can provide a continuous background. Water, from a high viewpoint, also provides a simple background. Look for trees near the edge of lakes, rivers, or the sea, and photograph them with a long-focus lens from higher up the slope. The sky forms a very clear backdrop, although it is at its least interesting with continuous cloud cover, which gives little more than a plain silhouette of a tree. Look for skyline views, on the tops of hills and low rises. As for weather, mist and fog can isolate trees very effectively, even in a forest, by muting distant tones and colour, and by separating a scene into distinct planes. Clouds in mountains have the same effect. The best focal length of lens depends on the viewpoint you choose, and as this is often limited, a zoom lens is useful for refining the composition. More often than not, a long focal length helps simplify the image by making the background appear larger in proportion to the tree.

Lighting makes a major difference, though it is not easy to predict. When the sun is low, it casts longer shadows, and depending on where these fall, shafts of light will sometimes pick out one tree among many. You are more likely just to come across this than to be able to plan for it. Early morning and late afternoon are, therefore, potentially good times of the day, although in mountainous country the middle of the day may be better, depending on the angle of slope. Another condition that gives a pattern of light and shade is when there is broken cloud and a wind. When the shadows of individual clouds are moving across the landscape, it's usually worth waiting for one tree to be in sunlight while its background is in shadow.

Lighting contrast
Even when surrounding woodland makes it difficult to distinguish individual trees, shifting light and shade can be used to highlight one at a time. This was a day of mixed clouds and sunshine, and, after waiting several minutes, the pattern of cloud shadows was just right to separate this tree from its neighbours.

Full bloom
For trees that flower spectacularly, timing is everything. This exceptional azalea (the same tree as in the detail on page 120) was at its peak in a Japanese garden in late April.

Life in miniature

By far the majority of the world's creatures are tiny, and while most escape our attention unless they interfere with our enjoyment, the living macro world is endlessly rich in subjects to photograph.

Small-scale wildlife is everywhere, although largely adept at avoiding large creatures like ourselves, principally through concealment and camouflage and, when that fails, by speed and agility. Finding insects, spiders and other invertebrates is often no more complicated than squatting down to ground level and looking with macro-attuned eyes – which is to say, carefully and focused on small objects. Familiarity with nature on a small scale soon brings a sense of likely places to find creatures – on the undersides of leaves, under stones, in crevices in fallen trees, at the margins of ponds. Each niche has its own inhabitants.

Woodland is especially full of niche habitats. In particular, the heavy forest litter on the ground – leaves, branches, fallen fruit and dead trees – is a major source of food and shelter and is, on the whole, the most rewarding place to search. Ants, beetles and wingless insects make up most of this

Slug
This slug crawling over a bed of rain-soaked moss was in one sense easy to photograph – the colour contrast between it and the greenery made an attractive composition, and, because it moved slowly, there was sufficient time to compose the shot at close distance. Its reaction to a close approach, however, was to withdraw its eye-stalks and stay still, and it took several minutes before it felt safe enough to set out once more.

population. For bees, butterflies and other insects that help in pollination, the heads of nectar-bearing flowers like snapdragon and honeysuckle are good sites to investigate. In temperate climates, the greatest abundance of insects is in high summer, and most are active during the heat of the day. Keeping sufficient depth of field for a sharp image of the entire insect is probably the main technical problem, and the usual answer is to use a portable flash unit.

Occasionally, however, there are situations where you can work by daylight alone. These opportunities are not to be missed as they provide a chance for a variety of naturally lit shots that can make a welcome change from the conventional and predictable character of flash lighting. One such opportunity is very early in the morning, when insects are sluggish and can

be photographed with a slow shutter speed. If the air is still, it is even possible to fit the camera to a tripod and make exposures of around one second. Of course, the very inactivity may be a little dull.

Another opportunity is to create silhouettes of the subject against the sun or its reflections. This can be particularly successful with a spider on its web, or with any insect that is clearly outlined on a leaf or stem. In either case – slow shutter speed or back-lighting – the larger the insect, the less magnification is needed and the less of a problem depth of field is. With most insects, you can make the most of whatever depth of field you have by shooting side-on to its body.

For most insects, a thorough search among forest litter, in cool damp places under rocks and wood, on bark, and on the undersides of leaves is as successful a technique as any. Butterflies, however, are not very approachable and baiting may be better, using a 'sugar' mixture painted on, say, a tree trunk. This is likely to yield better results in clearings and at the edges of woodland than in dense forest.

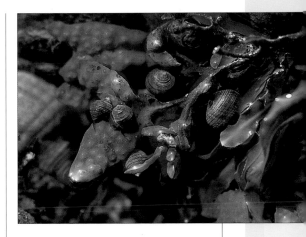

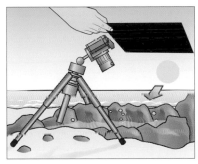

Webs
In morning light and into the sun, these strands glistened, making this a good angle from which to shoot. Having taken the photograph under natural conditions, I decided to enhance the strands by spraying them with a fine mist of water.

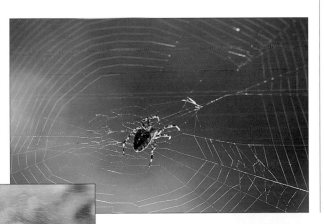

Rock pools
The small pools left behind by the tide are an outdoor and readymade version of an aquarium. Anemones and a hermit crab in an abandoned shell are the main inhabitants of this temporary rock pool, a marine microcosm that survives the twice-daily retreat of the tide with just a few centimetres of water. Using the method shown above, with the sun low in the sky and a dark card used to cut down reflections from the surface, it is a straightforward matter to photograph tidal pools like this.

A new background
The mist spray on the web resembled early morning dew, and helped to define the individual strands. To make this even more definite, a sheet of black cloth was held behind the web, but without blocking the sunlight.

Tropical macro

Heat, light and moisture in abundance make tropical forests the most spectacular of all habitats for finding small-scale life.

In tropical rainforest, insects and other invertebrates exist in such profusion and variety that even on a casual walk there is no difficulty in finding many species. As in temperate woodland, the prime places to look are around rotting wood and among other debris on the forest floor, and on the leaves of shrubs. The high temperatures and abundance of food make ideal conditions for insects, and this, together with the large number of separate niches, has led to the evolution of some very specialized and distinctive forms, including the most spectacular, even bizarre, adaptations on the planet. Camouflage and mimicry are two of the most extreme kinds of adaptation, and are more highly developed and striking here than in any other kinds of habitat. Look for mantids, katydids and stick insects that imitate vegetation, and also for insects that use strident colours and patterns (orange and red are common) as a warning that they are poisonous or unpalatable. Many non-poisonous species gain protection through having evolved to resemble some of these harmful species – often so well that you may not realise it yourself.

While flowers and fungi can be photographed in natural light with long exposures, insects usually need flash. The height of the principal trees, which form a largely unbroken canopy of leaves at the top – typically 30 metres above the ground – block much of the light, and very little filters down to the forest floor. Direct sunlight rarely penetrates to ground level, and even though midday tropical sunlight is extremely bright, as little as a thousandth of it may reach the ground – a difference of 12 f-stops.

Baits can be used if you find it easier to photograph insects after a field trip under more controlled conditions. Sugar, salt, rotting meat and overripe fruits all work as bait. For moths and other nocturnal insects, a white sheet draped around a lamp or powerful torch (flashlight) is a strong lure; the insects can be pulled off the sheet by hand.

The heat and humidity are not ideal conditions for camera equipment. Expect up to 100% humidity down among the undergrowth, where low plants and rotting vegetation trap moisture. You may also face the likelihood of daily rain. Moisture can short-circuit electrical connections, and over a period of

▲ Shadowless ring-lighting
The profuse insect life of the Amazon offers a rich choice of subject matter, for which one of the most convenient lighting set-ups was a ring-light, surrounding the front of the lens (*see also page 135*). The advantage of this is that it casts virtually no shadows, making it ideal for pushing the lens into small cavities between leaves and branches. A potential drawback is the ring-shaped reflections from shiny surfaces, but in the case of the yellow and black carapace of this bug, the effect is not intrusive.

◁ Stick insect

This almost geometrically precise stick insect, also in the Amazon, was found on the underside of a leaf. Turning leaves over carefully becomes second nature to insect photographers. As in the image opposite, a fixed ringflash set-up was used, so that shots could be taken immediately without adjusting settings.

▽ Trilobite beetle

The bizarre and the colourful are, if not exactly commonplace, at least not unexpected in the rainforest. This heavily armoured beetle, named appropriately enough after the well-known segmented marine fossil, is an inhabitant of the middle slopes of Mount Kinabalu in northern Borneo.

time (maybe only a few weeks) fungus will grow in some unlikely places, even on the lens. As much as possible, keep equipment sealed until you need to shoot. Use dry cloths and towels for wiping down and wrapping around kit. A gasket-sealed camera case is ideal, or failing that, an insulated picnic cool-box. Plastic bags sealed with rubber bands are useful for protecting individual items, as is a plastic sheet to spread on the ground when you are shooting, both to kneel on and to lay out bits and pieces. Use a desiccant such as silica gel crystals, kept in small containers with perforated lids (you can regenerate its drying power by heating in an oven). Uncooked rice is an alternative, though less effective.

Special flash set-ups

Active subjects, such as insects and small animals, call for flash, but at close distances the built-in camera flash unit has serious drawbacks.

For most photographs of insects and small animals in the field, flash is essential. To achieve sufficient depth of field for most of the image to be sharp, the lens must nearly always be stopped down close to its smallest aperture. With natural light, even on the brightest day, the shutter speed would then have to be quite slow at a normal (around ISO 100 to 200) sensitivity to prevent camera shake without a tripod, and in any case too slow to freeze the movements of an active subject. And, for the many small creatures that are nocturnal, there is no alternative to flash.

The major problem with built-in flash is that it is positioned on top of the camera body to aim at normal shooting distances, and so creates a parallax-related effect. At close range, the centre of the beam is likely to be too high. Not only this, but with a normal lens focal length, the lens housing itself can obstruct the lower edge of the beam and cast a shadow over the insect. One solution with SLR cameras is to use a longer focal length of macro lens, which reduces both problems. Nevertheless, an ideal lighting set-up would avoid this flat, on-axis illumination, and also provide some shadow fill. If your camera allows synchronization with separate flash units (not all of them do),

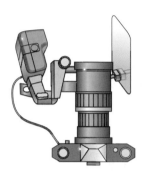

Single flash with reflector

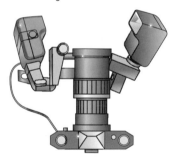

Two flash heads

SLR flash set-up for close-up fieldwork
Single flash with reflector

This is a basic configuration of a single head aimed at the subject from about 45º, with a small reflecting mirror on the opposite side to fill in the shadows. The lighting is more natural if the head is elevated slightly as well. Keep the flash close to the lens to minimize shadow areas.

Two flash heads

A second, smaller flash unit, aimed from the other side of the lens, is a more effective fill-in than a reflector. Synchronization with a slave cell is safer than a sync junction because it places a smaller load on the camera's sync contact.

▷ **Off-camera flash**

This cricket was photographed in a Thai forested national park at night. The small flash unit was extended on a bracket, as in the illustrations shown left, and aimed from one side. Although this can enlarge the shadow, it also provides a more normal-looking lighting arrangement.

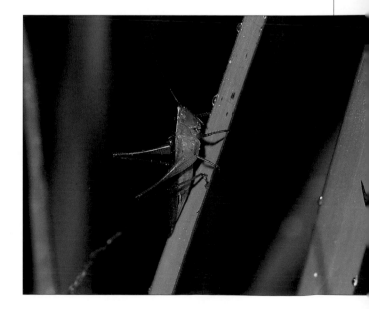

you'll find that it avoids wasting time and missing opportunities to have a fixed, standard arrangement of flash units.

One of the simplest is shown here, with two variations – single flash with reflector and double flash. The method of attaching the units to the camera is not so important, provided that the units are adjustable and can be locked into position. Provided that your camera can sync with any type of flash unit, small, simple ones have the advantages of being cheap and uncomplicated. Once you have tested the set-up, there is no real need for automatic exposure – simply note the aperture setting that works at any given distance, and use that in manual mode. This kind of set-up is especially useful at night, when fiddling about with adjustments is inconvenient, to say the least. As maximum depth of field is usually the ideal with this kind of close-up, it is better in most situations to decide first on the aperture and then adjust the flash output or distance.

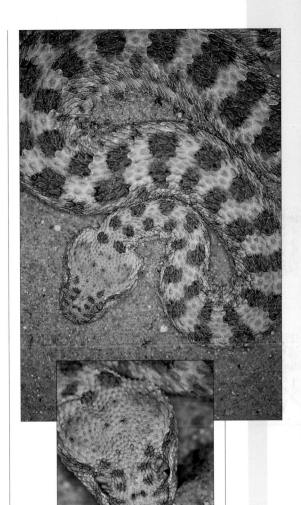

Close-ups with ringflash
A ringflash is, as its name suggests, a circular tube, and is designed to fit around the front of the lens to give shadowless, frontal lighting. Although the results can look monotonous if used frequently, it gives extremely consistent results, and is particularly useful in crevices and other cramped spaces. Because the flash is in a fixed position in relation to the lens, the only exposure adjustments possible are aperture setting and power output. At high magnifications, the flash is so close to the subject that a small aperture and great depth of field are possible, but at small magnifications the flash distance is likely to be too great for a satisfactory depth of field.

▶ **Macro flash**
A macro flash is similar to a ringflash but is simpler in construction, with two lamps on either side of the lens. It casts very slight shadows right and left.

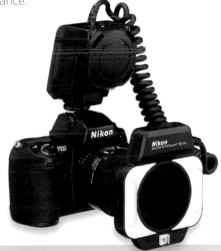

Aperture settings

As a way of calculating the settings, trial and error is fairly painless with a digital camera because of the instant feedback. Nevertheless, if you have a flash meter, use it, making allowance for lens extension. Alternatively, you can use this formula:

Flash to subject distance [divided by] guide number = aperture x (magnification + 1)

The result is in feet or metres, depending on which guide number you use. For example, with a guide number of 60 (in feet) and a 50mm lens extended by 75mm (a magnification of 1.5x), then to use an aperture of f22 the flash distance will be:

60 / 22x (1.5 +1) = 60 / 22 x 2.5 = 1.1 feet, or 13 inches

Zoos

Small creatures in zoos are normally in indoor displays and frequently behind glass, but digital cameras are well-equipped to deal with imperfect lighting conditions.

The opportunities for shooting close-up in a zoo are usually fewer than with the larger animals, because of limited access and less than ideal lighting, and much depends on whether a particular creature is in a visible position at the time you want to photograph it. Fish, reptiles, amphibia, tiny mammals and insects are usually kept indoors, and the usual setting is either an aquarium or vivarium. Being indoors, the lighting may often be difficult to work with, generally being set at quite a low level. Indeed, because many small mammals are nocturnal, the light levels may be extremely low – perhaps only just enough to see by. There are often restrictions on using flash photography in these situations because it can disturb the animals, so check first whether this is an option. If not, select a suitably high ISO sensitivity.

Shooting without flash is much easier with digital cameras than with film because you can choose the sensitivity and the white-balance settings on demand, changing them from subject to subject. As a rule, choose the lowest sensitivity at which you can handhold the camera without camera shake appearing in the pictures. In aquaria and vivaria, it's possible to use shutter

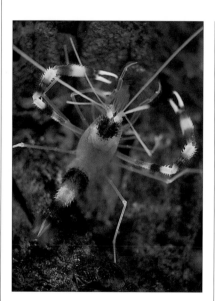

Shrimp
With subjects that keep relatively still, such as this shrimp or spider, it may be possible to use the available lighting. The light levels are nearly always low, so that at a sensitivity of ISO 100, shutter speeds of between about 1/2 sec and 1/15 sec are necessary, depending on the maximum aperture of the lens. Always position the camera at a slight angle to the glass to avoid catching the camera's reflection, and be careful to watch for reflections of other illuminated tanks. Without a tripod, place the camera against the glass as a support.

Flash past glass
Lighting levels in the indoor sections of zoos are usually too low for shooting, and this makes flash essential, if allowed by the zoo (ask first as it is often forbidden). Aim the flash from an angle to avoid reflections on the glass, and check the result on the LCD screen.

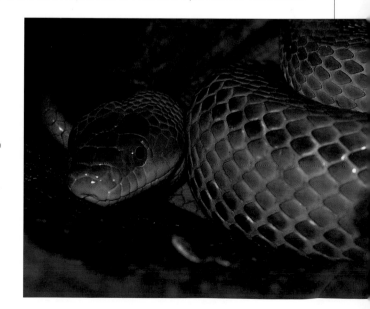

Tree snake
In zoo photography, you have no control over animal behaviour and a very limited choice of viewpoint. You must rely totally on what is available, and make several return visits in case anything has changed. In the case of this Emerald Boa, its choice of resting place was serendipitous.

speeds as slow as 1/4 sec without using a tripod (they are normally not allowed) by pressing the lens up against the glass to steady it. This only works, of course, with slow-moving animals or ones that are resting, but such opportunities are surprisingly frequent. Another good reason for shooting with the lens against the glass is to minimize the effects of marks on the glass. Very high sensitivity settings, above ISO 1000, cause appreciable noise in the image. The auto white-balance setting will often cope with the available lighting, but, if you have time, check the lighting type and choose that setting in the camera menu. Tungsten is normal.

If flash photography is allowed (or at least, not forbidden), consider using it for any moving creature, particularly in water. The main precaution to take is to avoid reflections of the flash in the glass front of the aquarium or vivarium. Make sure that you shoot at an angle to the glass – shooting full-on will bounce the flash output straight back into the lens.

Camera angle and flash angle are such that there will not be reflection back into the lens. As the light passes twice through the glass on its way to the sensor, some will be lost, particularly if the glass is thick, although TTL flash metering automatically compensates for this.

Tarantula
A red-kneed tarantula, behind glass as in all the pictures on these pages, obligingly positioned itself on a rock close to the front of the case. The flash was held off-camera and aimed from the right.

Indoor sets

The professional nature photographer's way to guarantee images of small creatures is to construct a special captive set that you can then design and light perfectly.

An alternative to photographing insects in the wild is to collect them and photograph them later in controlled conditions, such as in a studio or at home. Use a net to catch flying insects and to sweep vegetation, or hold a cloth tray underneath leaves and branches and beat them with a stick. Take any appropriate vegetation back with you if you intend to reconstruct the creature's habitat realistically.

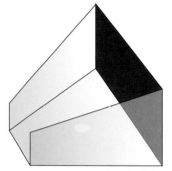

Vivarium shaped to match the angle of view of the lens.

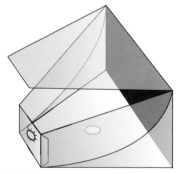

Shaped vivarium with angled 'scoop' and lid.

A flexible collar prevents animal from escaping.

Adaptable sets

Consider a set design that can be adapted. If you plan the shape to fit the angle of view of the lens you use most frequently, there will be no wasted space and, more importantly, no hidden corners.

There are two kinds of enclosed sets for photographing wildlife in the studio: those for terrestrial animals (vivaria) and those for water dwellers (aquaria). They have different requirements of construction and management, and they also demand different photographic techniques. Dry sets can be used for small mammals, such as field mice and voles, a variety of lizards and other reptiles, and some insects (wet sets are dealt with on pages 142–143). Although the habits of many creatures call for custom-built tanks or containers, a single basic design can be adapted for most.

One method is to build a large vivarium, well stocked with the appropriate vegetation or other suitable material, and wait for the animal to settle into a routine. Then you will just have to wait for the animal to be in the right position for you to photograph it. You will almost inevitably have to shoot from a high position, and this kind of set is really only suited to creatures that will not attempt to climb or jump over the sides.

Designing a set

Much more control can be achieved by building a set that serves the camera. By angling the side walls towards the camera, a set can be constructed that covers exactly the angle of view of a chosen lens, no less and no more. Barring focusing problems, the animal will always be in the field of view. A simple housing to suit docile subjects can easily be built from plywood, board or Perspex. Decide on the focal length of lens you will use – for example, a 50mm efl macro – and measure out the field of view on the uncut material that will form the base. This can then be cut to shape, forming the foundation for the remainder of the construction. A slightly more elaborate version has a hinged perspex or glass lid and so can be made escape-proof. In this case,

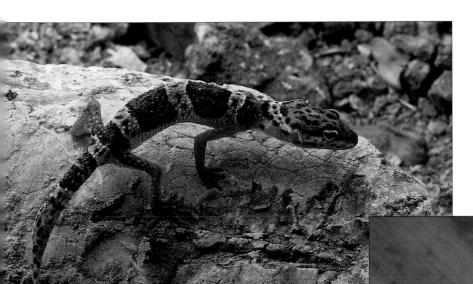

Soft lighting

One of the simplest and most useful lighting arrangements is a single overhead light source, diffused through a window-like attachment (a box fronted with translucent plastic or cloth). Shadows are soft and there are no hard, bright highlights. In this photograph of a Leopard Gecko, the area of the light is many times the size of the subject, imitating the effect of a hazy sun.

to avoid degrading the image quality by shooting through a glass front panel, a flexible sleeve puts the lens inside the vivarium, yet still provides a good seal. An additional sophistication is a scooped background, so no obviously artificial horizon line will appear in the shot.

Studio photography allows a great deal of control, including the opportunity to arrange the setting for the subjects and even to design the whole picture. One approach is to imitate the natural habitat as closely as possible, but this is by no means the only one. How you choose to present an animal is only partly influenced by its behaviour; the rest is up to the photographer. There may be one particular aspect that you want to highlight, such as the way a gecko grips a vertical surface. You may decide to treat this in a detached, scientific way, or treat the photograph as a studio portrait, with no pretensions to naturalism. Natural backgrounds are the most demanding, simply because they need to appear accurate. A good knowledge of the real habitat is essential. If in any doubt, carefully examine photographs of similar environments. Once you have assembled the correct vegetation, rocks and other elements, start laying out the set, but avoid 'over-designing'. Being too neat is tempting, but the result will look artificial. Deliberate untidiness will help to give more naturalism to the picture.

Simple settings

When you simply need a clear, straightforward portrait, look for an uncomplicated yet relevant and natural background. This leaf, sloping diagonally down, is both an unobtrusive setting for this tiny arrow-poison frog, and demonstrates the creature's size.

Lighting and welfare

One major advantage of building an indoor set is that you can light it as carefully as you would a still life, for clarity and saturation.

There are no rigid rules for lighting, as no single quality or direction of light is 'correct'. Essentially, good lighting is that which gives an aesthetically pleasing effect, and this can be very subjective. Nevertheless, naturalism calls for a general spread of diffused light in imitation of daylight. However, if the animal is very small in relation to the light source, the diffusion may appear too soft. With small lizards, for example, a one-metre-square diffused area light may cast very little shadow, producing almost no modelling. In this instance, a harder and more direct light may look better. Think about the balance between diffusion and modelling.

A single, well-diffused light source has many attractive qualities, and can be used as a basic form of lighting for most studio wildlife subjects. The shadows are relatively soft, without hard edges, and the overall effect is rounded and even. Used well, there is often no need for secondary lights, which nearly always create an artificial impression. Reflectors, such as hand mirrors, crumpled silver foil and pieces of white card, can be used to fill in the shadowed areas. If the diffused light is suspended directly over the set, pointing downwards, the result created will be a good impression of hazy sunlight.

The most manageable design of diffuser is a box attached to the light head, fronted with opal Perspex (plexiglass) or some other translucent material. With a studio flash unit placed close to the subject, use a low-watt domestic bulb as a modelling light in the same position. This will have no effect on the flash output, but it will prevent overheating of the vivarium. Even so, take care that the lighting does

Life sciences
In contrast to the image of the arrow-poison frog on the previous page, this entirely contrived arrangement with the same animal was designed for the wrap-around cover of a dictionary of life sciences. The butterfly was a preserved specimen, but the frog was very much alive and prone to jumping. A very short time was available for taking the shot (all the other elements were in place and the camera on a tripod), as it would have caused stress to the frog to keep catching and repositioning it.

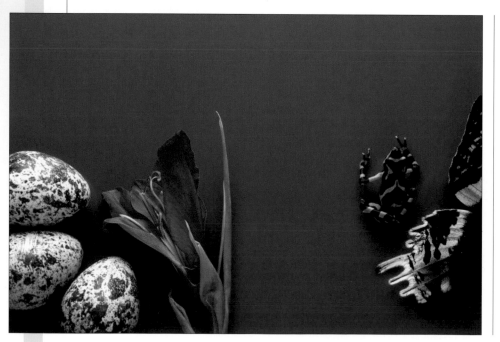

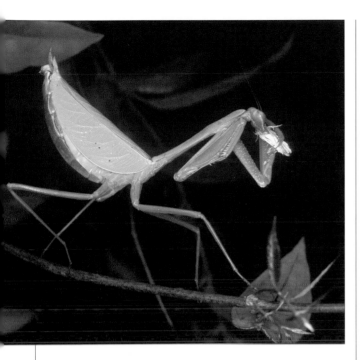

Animal welfare in the studio

Looking after animals is an important and difficult skill, and providing permanent accommodation for animals is almost a form of zoo-keeping, and is not to be undertaken lightly. With some protected or dangerous species, you will need a licence. Even if animals are brought into the studio for a day or two only for a photographic session, check beforehand that you can provide the necessary facilities. These conditions vary greatly from species to species, but consider the following general points:

General environmental needs
Provide sufficient space and cover, including areas for retreat, feeding and nest building.

Temperature
Domestic tungsten lighting may be sufficient but if the animals prefer darkness, an infrared lamp may be necessary. A thermostat is useful for critical temperature control.

Lighting
Some animals are unaffected by ambient light, but others, such as nocturnal species, have exacting demands. Many small mammals are most active at night, but it is possible, over a long period, gradually to alter the diurnal schedule so that the animal's night falls during the working day. This is usually more convenient.

Humidity
A humidifier provides the most accurate control, but even a bowl of water or a wet sponge can be useful.

Ultraviolet light
To stay healthy, many reptiles need the ultraviolet light that they would normally receive by basking in the sun. Fluorescent ultraviolet lamps can be used as a substitute.

Oxygen
In aquaria, the oxygen content of the water can be critical. Aeration, through a small pump, is often necessary.

Minerals
The chemical composition of water in aquaria is usually important, particularly for marine creatures. Even for freshwater aquaria, beware of chlorinated tap water.

Food and water
Ensure that you have the recommended diet, and know how and when to feed.

not make the subjects uncomfortable. Lizards or snakes that are accustomed to desert heat will thrive in the warm, dry conditions of studio lighting, but animals that need high humidity may need extra moisture in the set.

▲ **Feeding**
One reliable method of encouraging animals to adopt natural attitudes, while inducing some action, is to provide food. Here, a South American mantis eagerly accepts a small moth.

Also, some animals will not behave normally under continuous bright light. In these cases, it may be better to switch the modelling lamp off altogether, working in semi-darkness and using the flash illumination above.

In many cases, the animals, despite all the preparations of a carefully designed set, will not adopt exactly the pose you were expecting, and you may need to encourage them into different positions. How much you can interfere with the animal depends on the species. Be careful not to confine the animal excessively or move it around too much. Beyond a certain point you will induce stress, and you will only photograph a display of fear, aggression or other extreme behaviour.

Wet sets

Aquatic creatures occupy a three-dimensional world with great possibilities for interesting pictures, and an aquarium designed for photography makes this manageable.

Aquaria pose a special set of problems for the photographer, but they have one distinct advantage – they offer a great range of camera viewpoints. Remember at the outset, however, that conditions such as temperature, chemical composition of the water and oxygen content are generally critical, and monitoring is often even more important than with dry sets.

Converting aquaria for photography

Commercial aquarium supplies are usually the most convenient starting point. It is nearly always easier to adapt an existing tank for photography than to build one from scratch. Even in a fairly small tank, the water pressure near the base is high, and it can be surprisingly difficult to make an efficient seal. Water and electricity are dangerous companions, so electrical cables and components must be well insulated. It is also a good idea to raise cables off the floor, where spilled water will collect. Most aquarium photographs are inevitably taken through glass, so check that the sides of the tank are free from defects. For the very best optical conditions, it may be worth replacing

Marking the field of view
Mark the field of view so that you can predict when a fish will be in frame whilst guiding it, without having to look through the viewfinder. With the camera in position, check the limits of view on the front and back sheets of glass, marking them with tape.

the front sheet with plate glass. To do this yourself, you will need fresh rubber sealant for the new glass. Once fixed, fill the tank immediately with water so that the pressure will make the seal watertight.

Not all water-dwelling creatures need aeration; many small freshwater fish, for example, can live happily without it – so it can be turned off temporarily. In some cases, however, a few bubbles can improve the sense of movement in a picture. The most useful aeration system is a simple modular one, with a small pump, plastic tubing,

Shrimps in oil
This shot was meant to recreate shrimps in seawater polluted with oil leaked by a tanker. It is taken using a sample of water with organisms, from a regular collection made by a research college in Maine which studies the effect of oil pollution. The set construction is backlit in the same was as illustrated on page 100.

adjustable valves and a variety of bubble-generating heads. With a system like this, the rate and size of the bubbles can be adjusted to taste. Some species, particularly marine ones, need running water, for which a water pump will be necessary. Seaweed makes a good background for marine photographs, and this also needs flowing water to survive. If you collect water from a natural supply, which is safer than using tap water, which is usually chlorinated, run it through a filter first to remove particles.

Controlling movement

The problem of focus and depth of field are even greater when working with wet sets than with dry sets. Fish in particular have three dimensions in which to move about, and controlling their position in some way is usually necessary. Although it is possible with flash illumination to hold the camera by hand so as to follow movements, it can be frustratingly difficult. A more considered approach is first to fix the camera's viewpoint and then to encourage the subject to move into position.

Arrange the camera position so that the background and reflections are under control. Look carefully to see if the back edges of the tank are visible with the aperture stopped down. Focus on a pre-arranged position for the fish, and then mark off the field of view on the tank front with a grease pencil or adhesive tape. You can then shoot without looking through the viewfinder, freeing you to control events inside the aquarium. To confine the fish to the plane that you have already focused on, hang a sheet of glass inside the tank, close to the front. The fish now has little choice of moving out of focus, and whenever it swims into the area that you have marked off, you can shoot. If you need even greater control, you can block off the whole of the area surrounding the field of view with a Perspex/plexiglass insert. With this method, which virtually creates a small tank within the aquarium, the fish is compelled to stay inside the picture frame. Be careful, however, that this extreme confinement does not place the fish under noticeable stress, which will in any case make its movements unduly agitated. Small aquatic creatures need much closer control. Depth of field at a macroscopic level is very limited, and a normal aquarium is not very satisfactory. A simple miniature tank can be made with no more than two small sheets of glass, a short length of flexible plastic tubing, and clamps. The two sheets are held together with a U-shaped curve of tubing sandwiched between them. The tubing forms the seal, and its diameter determines the thickness of the tank.

Message in a bottle
A magazine cover called for a well-lit bottle on the sea-bed, which meant introducing fish and enough particles to look realistic. White sand was poured into an aquarium, which was then lit by a diffuse overhead studio flash.

Background

In most situations, the background of the aquarium will be out of focus, even when the lens is stopped down to its minimum aperture. Nevertheless, care should be taken to make it appear right. For some subjects, you may choose a clinical, uncluttered setting so as not to interfere with the detailed appearance of the subject. In this case, a plain white background may be best. This can be created with the back-lighting arrangement described above. Otherwise, you can provide a black or coloured setting either by hanging a velvet sheet behind the rear glass or, if there is a danger of reflections, by putting a sheet of black or coloured plastic inside the tank. For a natural-looking background, the habitat of the creature you are photographing will be the deciding factor. Water vegetation is a good, safe choice, but a blurred painted sheet of appropriate colours, such as green and brown, or blue and black, may be all that is necessary to give the right impression of depth.

Lighting aquaria

Overhead lighting is normal, but take special precautions to avoid unwanted reflections in the glass walls of the tank, both the front and internal.

A common problem to deal with aquarium photography is reflections from the glass sides of the tank. With a few commonsense precautions, however, this can be overcome. Any light source that is close to the camera position will be reflected by the glass into the lens and ruin the picture. Frontal lighting is, in any case, rarely the most attractive, and these reflections can easily be eliminated by placing the light or lights further back, at a greater angle to the camera view.

More intractable is the reflection of the camera itself; the chrome trim and the numerals engraved on the lens mount may be particularly noticeable. Shade the lights so that very little spills onto the camera; this is also important for avoiding lens flare. An even more effective, simple solution is to hang a sheet of black paper, or better still black velvet, between the camera and aquarium. Cut a small hole in it sufficient for the lens. With these precautions, you will have a wide choice of lighting positions. An overhead source, similar to that described for dry sets, gives the most natural illumination. If the bottom of the aquarium does not appear in the shot, a white plastic sheet can be weighted down to act as a reflector. Lighting from below, or obliquely from behind, can be dramatic, but also obviously artificial.

A special form of illumination is back-lighting. For this, place an even sheet of diffusing material, such as opal Perspex/plexiglass, behind the tank so that the entire field of view is covered. Put the light behind this, aimed

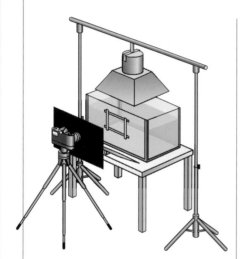

Basic lighting
The choice of lighting positions is limited by the risk of catching reflections in the front sheet of glass. A straightforward arrangement that can be used for most situations uses an overhead, diffused light in much the same way as a dry set. Any secondary reflections from the bright parts of the camera or the room can be eliminated by poking the lens through a piece of black paper, card or velvet. A white card reflector below the lens can be used to balance lighting on the undersides of fish and plants.

Confining the action
This arrangement was used for the sequence of pictures showing the clam. It would be equally suitable for any small creature and has the virtue of great simplicity. For particularly small creatures in close-up, this device can be used to confine the subject to a shallow plane. In this arrangement, a U-shaped length of surgical rubber tubing provides a watertight seal between two sheets of glass clamped together.

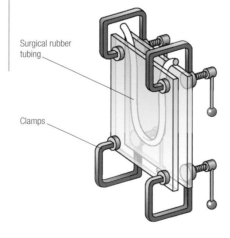

Surgical rubber tubing

Clamps

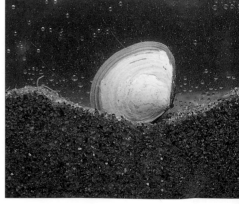

directly towards the camera. Used on its own, the effect will be a silhouette. This can be very effective for animals that are at least partly transparent, but for a more balanced effect, a supplementary top or side light can be used. To avoid flare, mask off the back-light to the edges of the picture frame with black paper or cloth held in place with tape. Flash is essential to arrest motion, and a studio flash unit, as described for terrestrial animals, has sufficient power to allow the small apertures necessary for depth of field even when well diffused.

Some creatures, particularly bottom dwellers, look best when photographed from directly overhead. In many ways, this is easier to manage, as a shallow depth of water automatically keeps the right plane of focus. For small creatures, a laboratory petri dish is ideal. Overhead shots such as these can be backlit by placing the dish directly on top of a diffused light, or lit from the side by placing the dish on a sheet of glass. The background, of whatever colour, is then placed underneath. The position of the light must be low, so as to avoid reflections from the water's surface. The reverse of this position, looking directly upwards through the base of the tank, is awkward for photography, but poses few special difficulties. To keep the subject in focus, keep the water to a fairly low level.

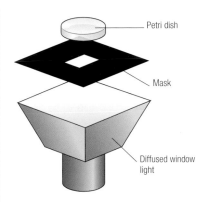

Petri dish

Mask

Diffused window light

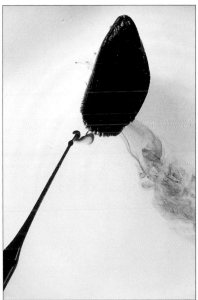

◥ Lighting from beneath
To demonstrate the feeding mechanism of a mussel, which pumps surprisingly large volumes of water through its body, a red food dye was introduced with a pipette. Back-lighting was the ideal way of showing this clearly. The mussel was placed in position in a shallow petri dish with a small piece of Plasticine underneath to hold it in position, and the dish was placed directly on the opal Perspex/plexiglass diffuser of the studio flash. To cut down flare, all the area outside the picture frame was masked off with black paper. To add some modelling to the shell, a second light, a small portable flash, was directed from one side and synchronized with the main flash.

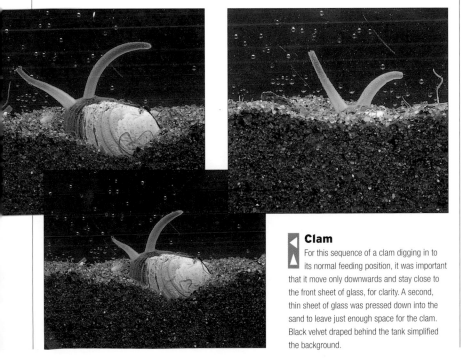

◁ Clam
For this sequence of a clam digging in to its normal feeding position, it was important that it move only downwards and stay close to the front sheet of glass, for clarity. A second, thin sheet of glass was pressed down into the sand to leave just enough space for the clam. Black velvet draped behind the tank simplified the background.

Fossils and bones

Photographing fossils successfully means making the most of the great skill involved in preparing them, which involves extracting and revealing them from their matrix.

Fossils were formed in a number of different ways, but in practically all cases there were two pre-requisites. First, the organism must have had some form of skeleton. The soft parts would have decomposed too quickly to allow the processes of fossilization and even shallow impressions of skin and organs are rarely found. Secondly, the animal or plant must have been quickly covered over with some material, before the skeleton could fall apart or be damaged. This meant a process of deposition, and so almost all fossils are found in sedimentary rocks. As most of these were laid down in water, marine fossils are the most common. The pressure of the overlying sediment and later rock movements often deformed them. To appear at their best, most fossils must be carefully removed from the matrix or rock in which they are embedded. This is not easy to perform, demanding patience, skill and a knowledge of what is yet to be uncovered. Prepared fossils can be easily bought, however. Very rarely, an entire organism is preserved – insects trapped in fossil resin (amber) are well-known examples.

One of the most common ways in which fossils have been formed is through replacement, where the original materials are dissolved away and replaced by minerals. Fossil trees can be found in which even the cells and vessels are faithfully reproduced. This replacement occurs with different minerals, such as silica, calcite, iron pyrites and haematite. In other cases, the

▼ Devonian fish

Many fossils are too delicate to remove entirely from their matrix, and so are commonly displayed in low relief. How best to light fossils in this form depends very much on what you want to show. These Devonian fish provide an interesting test for lighting. While they stand up in low relief from the matrix, they are also darker in tone. Because of this, either the relief or the tone can be displayed. The standard technique for throwing low relief into prominence is to use a direct spotlight from a very shallow angle, throwing long, definite shadows. Conversely, the most effective way of showing tonal differences is to exclude relief by using shadowless lighting. Both methods were used here. For the first shot, a single spotlight was used, from the top left (more conventionally acceptable to a viewer than any other position). The effect is a very strong emphasis of relief, but the light level also falls off towards the bottom right. In the second shot, a white card reflector, positioned on the opposite side of the specimen from the light, balances the light level across the picture without altering the definite shadows. The third and fourth shots were taken with the light increasingly diffused, weakening the shadows and softening their edges. Finally, for completely shadowless lighting, a light tent was built (*see pages 92–93*).

skeleton is dissolved but not replaced, leaving behind a mould that may later be filled with, say, glauconite or flint, producing a perfect cast of the original.

Although fossil animals and plants can sometimes be found naturally exposed, the erosion that brought them to light will also have set to work on the fossils themselves, and it is rare to find them in good condition. Sometimes, like the petrified tree here, good fossils are found in situ. This is the exception, however, and most fossils are specimens best shot in the studio.

The variety of fossil formations call for a range of lighting techniques. A common kind of specimen is one in which the fossil is still partly embedded in the matrix, or rock stratum. The background, therefore, is already provided. These are usually in low relief and the light is better set at a low angle to emphasize detail; raking the surface, the lighting will cast definite shadows. As strongly angled lighting also gives uneven illumination across the surface of the specimen, use a reflector on the opposite side. Concave fossils need a similar lighting treatment. If the depression is deep, move the light to a less acute angle, closer to the camera position. Again, use a stronger reflector to fill in the shadow.

Cave bear

The purpose here was to illustrate a point about the extinction of the cave bear through hunting by man. An ancient human skull was added to the shot. The comparison of the two skulls, and their symmetrical arrangement, made the shot more effective than showing the bear's skull alone. To keep things simple, both skulls were photographed on black. The bear skull looked more dramatic with the jaw open, so this was propped up with a metal rod that was brushed out during image editing.

Petrified tree

Most fossils that are exposed either suffer natural erosion or are quickly removed by collectors. Nevertheless, there are occasions when it is possible to find remains that are in situ and relatively undisturbed. This 200-million-year-old fossilized tree trunk, its original composition replaced cell for cell by silicates from ancient falls of volcanic ash, has been gradually uncovered by wind and occasional rain. It owes its preservation to two conditions: the silica of which it is composed is more able to withstand the mild erosion than the surrounding soft shale and clay, and it lies in Arizona's Petrified Forest National Park, which is protected by law.

Shells

Shells display some of the most elegant forms in nature, and are rewarding subjects to explore in a close-up setting, as pure objects rather than as part of the marine ecology.

When photographing shells, the most important element is lighting. As a general principle, one single main light source, partly diffused, gives good, uncomplicated modelling. Two lights aimed from different directions will, if positioned carelessly, cast conflicting shadows. Not only is this ugly, but it confuses the detail in the shell. With a single light, the shadows can be filled in slightly by placing a white card or silvered reflector. A hand mirror gives the strongest fill-in. Crumpled cooking foil glued to a card is a simple device for selective shadow fill. Shells with shiny surfaces need particular care, as they inevitably reflect the light source. Consider adding an extra sheet of flexible diffusing material and curving it over the shell.

Anything other than a featureless background is usually a distraction with shells. Plain black or plain white backdrops are obvious choices, depending on whether you want to emphasize the outline of the shell or the surface detail. Contrasting backgrounds are good for shape, while similar-toned backgrounds concentrate attention on texture and pattern.

It's usually easiest to photograph shells vertically downwards, with the shell resting on a flat surface, light to one side angled downward, and camera directly overhead. The choice of angle will often depend on the key features of the specimen. Gastropods, for example, are usually positioned to display the aperture. With a black background, you can either lay the shell directly on the velvet or raise the specimen a few centimetres on a vertical rod and adjust the light so that very little illumination spills onto the velvet (support the shell on plasticine or putty). Take care that the camera is pointing absolutely vertically downwards so that the support remains hidden.

If you are shooting against a light background, a plain white surface, such as white card velvet, can be used, but the shadows underneath are likely to be deep. Making a cut-out at the image-editing stage (using Paths) may improve the image, and you could add a digital drop shadow for realism. However, it may be less trouble to back-light the surface on which the shell

▲ Black and white points
This mass of shells contains a wide variety of tone and colour. As photographed (top right), the image seemed perfectly acceptable, but, as the colour-corrected version (main image) illustrates, a more vibrant result was possible. In a standard technique of image editing, using Levels, the white point was set to the highlight of one cowrie, while the black point was set to the shadowed area indicated.

rests, as in the set-up on page 77. This is also very effective with thin shells to show internal features, and with sliced sections of a shell to display the geometry of spiral partitions. The light should be well diffused for an even white background. An alternative background arrangement is a glass shot as on page 76, where the fossil is laid on a horizontal glass sheet, which itself is raised above a white or coloured sheet of card. With careful positioning, the background card can then be lit separately, and no shadows are cast. Here, the effect makes it look as if the shell is floating. The main light must not be so close to the camera position that it is reflected in the glass.

There are also techniques for removing reflections, but use these with discretion as they can radically alter the shell's appearance. Dulling spray is a crude method that leaves a sticky film that is clearly visible in a high-resolution photograph. If you use polarizing filters and sheets be aware that light transmission will be reduced by nearly two stops.

The colour of some shells can be intensified by wetting. One complex variation is to submerge them completely. The lighting must then be positioned very carefully to avoid reflections from the water's surface.

Cone shell
To reduce reflections in the shiny surface, crossed polarizers were uses, as described on page 117. A sheet of polarizing material was placed in front of the light, and a polarizing filter over the lens. One occasional danger with polarizers crossed in this way is a slight violet cast in the reflected highlight, but this can be removed during image editing.

Golden cowrie
This golden cowrie was photographed against black Perspex/plexiglass to enhance its colour. However, the setting's reflective surface posed a problem. Using a main light overhead, the base of the shell was too dark (top left), while adding a mirror reflector (above left) also introduced an unacceptable highlight. The solution was to combine the two versions as layers, partly erasing the lower part of the darker image (above right) to allow the lighter version to show through (right).

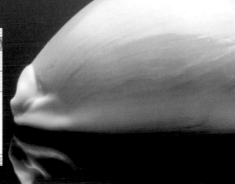

Rocks and stone

Nature's quietest and most enduring subject deserves more exploration in photography than it normally receives. It offers opportunities for pure exercises in composition and lighting.

Rocks are exposed either through erosion – which is why rocky sea-coasts and mountain rivers are good locations for shooting – or because the climate is too dry or windswept or cold for vegetation to take hold. Deserts and high mountains are the places where rock becomes the main component of nature. For nature photographers who think in terms of plants and wildlife, it's easy to dismiss these landscapes as barren, yet the earth's exposed geology is rich in texture and form. Above all, it offers the opportunity to create abstract and minimalist images. And the natural history of rocks is as involved and interesting as that of any life-form. Eliot Porter, master of the nature close-up, was particularly drawn to them. Living in New Mexico, which is largely arid and abounds in exposed rock, Porter was finely attuned to the differences between, say, the black and grey bentonite clay (which reminded him of 'the wrinkled backs of sea monsters') and the black lava, which is matt from one angle and iridescent from another ('in detail irresistibly abstract').

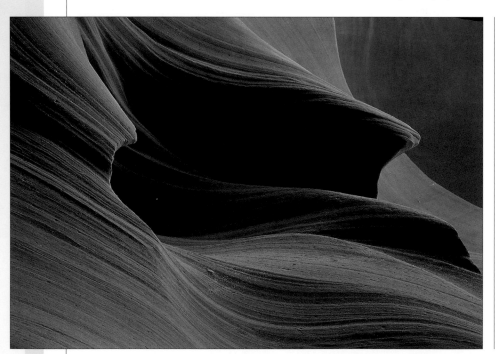

Slot canyon
This image reveals sandstone eroded into a beautiful variety of curves by the combined action of flash floods and wind-blown sand in an Arizona slot canyon. The rock shapes, together with the colour contrast from sunlight and skylight bouncing and reflecting off the canyon walls, made this small and narrow canyon a rich location for abstract compositions.

It's especially difficult to generalize about rock surfaces for photography, because not only do they vary intrinsically so much, but there is always some image to be made whatever the natural light. As very few rocks stand out as individual objects, the subject is usually a section of the surface, so that in any given place, such as a cliff or desert pavement, or a smooth slope carved out by an old glacier and left with striations, there is an enormous choice of framing. It's important to examine rock from different distances, as its texture will vary with the scale. Colour is often muted, which is why the rich reds and

blues of a low desert sun opposite a clear sky are so popular when they briefly light up sandstone – as in the picture here of an Arizona slot canyon. Nevertheless, the non-colours of many rocks can be subtly rewarding. Henry David Thoreau wrote in his journal for 1852, 'It seems natural that rocks which have lain under the heavens so long should be gray, as it were an intermediate color between the heavens and the earth.'

There are three groups of rock: igneous, formed directly from molten lave; sedimentary, deposited by water or wind; and metamorphic, formed by the alteration of existing rocks under heat and pressure. Here, the important properties to convey are composition, texture and structure. How visible the composition of a rock is depends on the grain size of the individual minerals, and on how similar they are to each other. Granite displays its composition very clearly, as not only are the grains large and obvious, but the three minerals – quartz, mica and feldspar – that it contains have distinctively different colours and tones. The surface texture of the rock may also be very distinctive, from the fine smoothness of marble to the roughness of limestone. Its structure, on the other hand, is often on too large a scale to be seen in a small specimen, although some rocks, such as ropy lava and folded schists, show structural characteristics clearly.

Fingal's Cave

This shot was taken on the island of Staffa in the Scottish Hebrides. Where rock structure is distinctive, a close-up may be more effective than distance. A wide-angle lens and a view angled strongly up emphasizes the graphic arrangement of these volcanic basalt rocks.

Detail with a polarizer

Desert varnish is a highly reflective oxide coating that grows on certain smooth rock surfaces long exposed to sun and wind. It can conceal texture and pattern – the perfect time for a polarizing filter. Here, the surface of the rock carrying these old petroglyphs in Arizona was so shiny that it provided one of the strongest contrasts I have seen between polarized and unpolarized. The filter was rotated 90° between shots.

Minerals

The properties of geological specimens vary greatly, and each needs to be treated on its own merits, with the lighting adjusted to show off its essential and unique qualities.

Just as plants and animals can be collected and brought into the controlled conditions of studio lighting for a different, more analytical kind of photography, so can rocks and minerals. Minerals are basic constituents of the earth's crust, each with a precise chemical composition, while rocks are accumulations of minerals, with much greater variety of form and appearance. Try to choose good specimens of their type – crystals of feldspar, for example, are often found twinned (that is, interlocked), and it is worth hunting for an example where this property is clearly visible. The same general lighting conditions apply to minerals and rocks as to shells and fossils, and many of the same techniques can be used.

When minerals are allowed to solidify out of solution freely, they form crystals, with characteristic shapes and flat faces. Understandable, perfectly formed crystals are rare, and most minerals grow as aggregates of crystals, where the individual crystal shape is submerged in the form of a larger mass. These forms are also characteristic and enable the mineral to be identified. Mica, for example, frequently occurs in flat, flaky sheets; haematite is often found in gently rounded shapes known as a mammilated form; and native copper is commonly found in a dendritic form, branched like a fern. The way in which individual minerals break is another property. When the break is irregular, it is called a fracture; some minerals fracture very distinctively, such as the curved surface of obsidian. Other minerals more frequently exhibit cleavage; this is a break that is closely related to the structure, usually close to where a crystal face would have been formed.

The optical properties of minerals can include transparency, colour and lustre. Of these, lustre is usually the most challenging problem for photography, as it is

Simple set-up for specimens

This is an uncomplicated set-up for small cut specimens that can be moved around easily.

When arranging the lighting, there are four considerations:

1. Intensity. This should be sufficient to allow a small aperture for depth of field.
2. Direction. Conventionally, the main light is normally aimed from the top left or top of the picture. Other lights can be added for fill.
3. Diffusion. Less diffusion reveals fine textural detail; more diffusion is better for overall shape and for tone.
4. Reflection. Use white card, silver foil or mirrors on the opposite side from the main light to fill shadows.

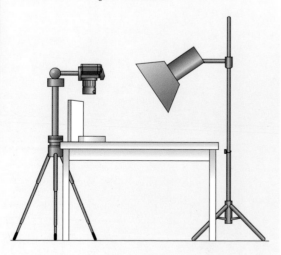

essentially a subtle quality – the way in which a mineral's surface reflects light. Descriptions such as metallic, resinous, greasy, silky or pearly lustre are quite easy to understand and also easy to see when a specimen is turned in the hand to vary the play of light across it. In a still photograph, however, to make such refined differences obvious you will have to experiment with different lighting positions and diffusion. Knowing the essential properties of a particular specimen will help you to decide on the style of lighting. If a mineral has an interesting lustre, for example, such as the greasy or waxy look of chalcedony, then a well-diffused light will reveal this most clearly. On the other hand, the same lighting would do nothing to display the compact, powdery texture of loess, a clay deposited by wind, which would appear better with a hard, direct light. A low-angled light reveals surface interpretation most clearly, but if the texture is unimportant in a specimen, try more frontal illumination.

Crystals are probably the most difficult of all minerals to photograph, because of the interplay of reflections from the various faces – and refractions if the crystal is transparent. We deal with these under gemstones on the following pages.

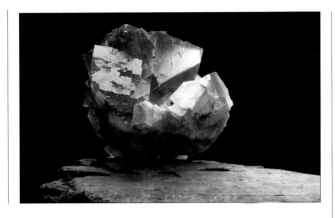

Form and structure
This is the amethyst block from page 23. Here I was interested in showing its form, and the interpenetration of the individual crystals, and chose monochrome to avoid the distraction of the strong colour. The lighting, partly diffuse, is overhead and just behind, to catch reflections in some surfaces and refractions through others.

Thin and colourful
Translucent minerals present another opportunity for photography – by cutting a thin section and back-lighting it, as with this yellow onyx. Back-lighting can often bring out greater colour saturation, and this can be adjusted later during colour correction.

Scanning cut sections
A common way of presenting rock specimens is in cut sections, such as this small slab of ruin marble (so-called because of its supposed resemblance to a painting of ruined walls and columns). If the texture is important, then the lighting can be directional, but here, where the section has been polished to heighten tonal contrast, even illumination is called for. One alternative is to light diffusely, but if the specimen has been cut along a perfect plane, as here, a desk-top flat-bed scanner may be simpler. Make a low-resolution test first, and check for unwanted reflections and specular highlights.

Gemstones

By their nature, gemstones are defined by and valued for their appearance, and this makes them among the most challenging and rewarding of all possible close-up subjects.

The majority of gems are hard, transparent stones (such as diamonds, topaz, zircon, emerald, and so on), and so typically combine two important qualities for photography – reflection and refraction. In their natural state, many are rough or rounded, and quite unlike their final presentation in jewellery (*see page 96–97*), but cutting and faceting, an essential part of the business, enhances both of these visual qualities. Reflection, from the different faces of the crystals, helps to define the outer surface. Refraction not only reveals inner details, but gives the essential sparkle. Capturing both in a photograph requires very careful positioning, both of the gem in relation to the camera, and the light in relation to both. The ideal is to display as many of the faces as possible and to keep the general appearance simple. The best way of achieving this is to vary the illumination on each face. As a starting procedure, look for a viewpoint that shows several faces and adjust the lighting so that each reflects slightly differently. Try to catch the reflections of a large diffused light source in at least two major planes, then use reflectors of different strengths, such as foil and white card, carefully placed around the gem to give different intensities of reflection in each plane.

Not all gems are faceted, and this largely reflects fashion and the tastes of different cultures, as well as the decorative possibilities of certain gems,

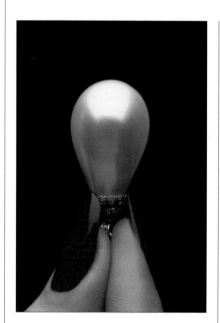

Surface texture
This pearl (the specimen is actually the largest known gem-quality pearl) needed soft lighting for its highly reflective surface, but not so even that the curved form and characteristic sheen were lost. A square softbox was chosen as the solution, fitted to a flash head and suspended overhead, with two pieces of white card on either side as reflectors. Flash was essential to freeze the movement of the model's hand.

Emerald
This is the 17th Century Indian emperor Shah Jahan's 'Taj Mahal' Emerald from the collection of the Sackler Gallery in Washington DC. Engraving was a popular technique of the period, and the lighting had to show both this (through angling the light to reflect in the surface of the stone) and the stone's colour (by placing aluminium foil cut exactly to shape under the emerald).

like the carved Elizabethan ruby on page 29. In Southeast Asia, for example, where rubies and sapphires are important gemstones, the taste is for rounded cabochons. The term 'gems' also embraces objects other than hard stones, most notably pearls, which are a natural accretion found inside an oyster, deposited in layers around foreign matter such as grit as a protection by the animal. Pearls have their own special visual qualities, in particular a nacreous lustre and play of colour, created by the outer translucent layers and slight interference patterns.

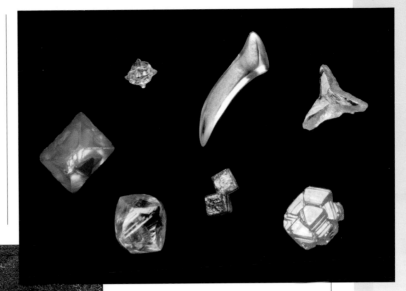

Odd-shaped diamonds

For this group shot of unusually shaped diamonds, a single, well-diffused light was used. A black background was chosen to enhance the refraction by contrast. The area light provided one bright tone for reflection, while a medium tone for other crystal faces came from a white card reflector. The light also displayed refraction. The key to success in a shot like this is the precise angle at which the stones sit. Plasticine cannot be used to prop up transparent stones, as it would show, and the answer in this case was to use small diamond chips, which are unnoticeable amid the play of light and colour. The arrangement is inevitably painstaking.

Sapphire

A 202-karat star sapphire from the famous mines at Mogok. The star effect is only obvious under a pinpoint light.

Jade

High-quality Imperial jade rivals emerald in its gem like qualities. For this shot, I was interested in contrasting the polished cabochon with the raw boulder from which it is cut. These river-washed stones acquire a brown skin, and for trading purposes a grindstone is used to cut a 'window' to give some clue as to the quality of jade inside.

Jade backlit

Another way of showing gem-quality jade was to back-light it for maximum colour intensity. To add interest to the composition, the slot from which this carved piece was cut was included.

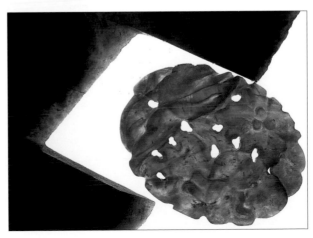

Glossary

aberration The flaws in a lens that distort, however slightly, the image.

aperture The opening behind the camera lens through which light passes on its way to the CCD.

artefact A flaw in a digital image.

back-lighting The result of shooting with a light source, natural or artificial, behind the subject to create a silhouette or rim-lighting effect.

bit (binary digit) The smallest data unit of binary computing, being a single 1 or 0. Eight bits make up one byte.

bit-depth The number of bits of colour data for each pixel in a digital image. A photographic-quality image needs eight bits for each of the red, green and blue RGB colour channels, making for an overall bit-depth of 24.

bracketing A method of ensuring a correctly exposed photograph by taking three shots; one with the supposed correct exposure, one slightly underexposed, and one slightly overexposed.

brightness The level of light intensity. One of the three dimensions of colour in the HSB colour system. See also hue and saturation.

buffer Temporary storage space in a digital camera where a sequence of shots, taken in rapid succession, can be held before transfer to the memory card.

calibration The process of adjusting a device, such as a monitor, so that it works consistently with others, such as a scanners or printer.

CCD (Charge-Coupled Device) A tiny photocell used to convert light into an electronic signal. Used in densely packed arrays, CCDs are the recording medium in most digital cameras.

clipping path The line used by desk top publishing software to cut an image from its background.

channel Part of an image as stored in the computer; similar to a layer. Commonly, a colour image will have a channel allocated to each primary colour (e.g. RGB) and sometimes one or more for a masks or other effects.

CMOS (Complementary Metal-Oxide Semiconductor) An alternative sensor technology to the CCD, CMOS chips are used in ultra-high resolution cameras from Canon and Kodak.

colour temperature A way of describing the colour differences in light, measured in kelvins and using a scale that ranges from dull red (1900K), through orange, to yellow, white and blue (10,000K).

compression Technique for reducing the amount of space that a file occupies, by removing redundant data.

conjugate The distance between the centre of the lens and either the subject or the sensor (depending which side).

contrast The range of tones across an image from bright highlights to dark shadows.

cropping The process of removing unwanted areas of an image, leaving behind the most significant elements.

depth of field The distance in front of and behind the point of focus in a photograph in which the scene remains in an acceptable sharp focus.

diffusion The scattering of light by a material, resulting in a softening of the light and of any shadows cast. Diffusion occurs in nature through mist and cloud-cover, and can also be simulated using diffusion sheets and soft-boxes.

edge lighting Light that hits the subject from behind and slightly to once side, creating flare or a bright 'rim lighting' effect around the edges of the subject.

extension rings An adapter that fits into an SLR between the sensor and the lens, allowing focusing on closer objects.

extraction In image editing, the process of creating a cut-out selection from one image for placement in another.

feathering In image editing, the fading of the edge of a digital image or selection.

file format The method of writing and storing information (such as an image) in digital form. Formats commonly used for photographs include TIFF, BMP and JPEG.

filter (1) A thin sheet of transparent material placed over a camera lens or light source to modify the quality or colour of the light passing through. (2) A feature in an image-editing application that alters or transforms selected pixels for some kind of visual effect.

focal length The distance between the optical centre of a lens and its point of focus when the lens is focused on infinity.

focal range The range over which a camera or lens is able to focus on a subject (for example, 0.5m to infinity).

focus The optical state where the light rays converge on the film or CCD to produce the sharpest possible image.

fringe In image editing, an unwanted border effect to a selection, where the pixels combine some of the colours inside the selection and some from the background.

f-stop The calibration of the aperture size of a photographic lens.

graduation The smooth blending of one tone or colour into another, or from transparent to coloured in a tint. A graduated lens filter, for instance, might be dark on one side, fading to clear at the other.

greyscale An image made up of a sequential series of 256 grey tones, covering the entire gamut between black and white.

histogram A map of the distribution of tones in an image, arranged as a graph. The horizontal axis goes from the darkest tones to the lightest, while the vertical axis shows the number of pixels in that range.

hot-shoe An accessory fitting found on most digital and film SLR cameras and some high-end compact models, normally used to control an external flash unit.

HSB (Hue, Saturation and Brightness) The three dimensions of colour, and the standard colour model used to adjust colour in many image-editing applications.

hue The pure colour defined by position on the colour spectrum; what is generally meant by 'colour' in lay terms.

ISO An international standard rating for film speed, with the film getting faster as the rating increases, producing a correct exposure with less light and/or a shorter exposure. However, higher speed film tends to produce more grain in the exposure, too.

lasso In image editing. A tool used to draw an outline around an area of an image for the purposes of selection.

layer In image editing, one level of an image file to which elements from the image can be transferred to allow them to be manipulated separately.

luminosity The brightness of a colour, independent of the hue or saturation.

macro A mode offered by some lenses and cameras that enables the lens or camera to focus in extreme close-up.

mask In image-editing, a greyscale template that hides part of an image. One of the most important tools in editing an image, it is used to limit changes to a particular area or protect part of an image from alteration.

megapixel A rating of resolution for a digital camera, related to the number of pixels forming or output by the CMOS or CCD sensor. The higher the megapixel rating, the higher the resolution of images created by the camera.

midtone The parts of an image that are approximately average in tone, falling midway between the highlights and shadows.

monobloc An all-in-one flash unit with the controls and power supply built-in. Monoblocs can be synchronised together to create more elaborate lighting set-ups.

noise Random pattern of small spots on a digital image that are generally unwanted, caused by non-image-forming electrical signals.

photomicography Taking photographs of microscopic objects.

pixel (PICture ELement) The smallest unit of a digital image – the square screen dots that make up a bitmapped picture. Each pixel carries a specific tone and colour.

plug-in In image editing, Software produced by a third party and intended to supplement a program's features.

ppi (pixels-per-inch) A measure of resolution for a bitmapped image

reflector An object or material used to bounce available light or studio lighting onto the subject, often softening and dispersing the light for a more attractive end result.

resampling Changing the resolution of an image either by removing pixels (lowering resolution) or adding them by interpolation (increasing resolution).

resolution The level of detail in a digial image, measured in pixels (e.g. 1024 by 768 pixels), lines-per-inch (on a monitor) or dots-per-inch (in a half-tone image, e.g. 1200 dpi).

RGB (Red, Green, Blue) The primary colours of the additive model, used in monitors and image-editing programs.

saturation The purity of a colour, going from the lightest tint to the deepest, most saturated tone.

selection In image editing, a part of an on-screen image that is chosen and defined by a border in preparation for manipulation or movement.

shutter The device inside a conventional camera which controls the length of time during which the film is exposed to light. Many digital cameras don't have a shutter, but the term is still used as shorthand to describe the electronic mechanism that controls the length of exposure for the CCD.

shutter speed The time the shutter (or electronic switch) leaves the CCD or film open to light during an exposure.

SLR (Single Lens Reflex) A camera which transmits the same image via a mirror to the film and viewfinder, ensuring that you get exactly what you see in terms of focus and composition.

snoot A tapered barrel attached to a lamp in order to concentrate the light emitted into a spotlight.

soft-box A studio lighting accessory consisting of a flexible box which attaches to a light source at one end and has a diffusion screen at the other, softening the light and any shadows cast by the subject.

spot meter A specialized light meter, or function of the camera light meter, that takes an exposure reading for a precise area of a scene.

telephoto A photographic lens with a long focal length that enables distant objects to be enlarged. The drawbacks include a limited depth of field and angle of view.

TTL (Through The Lens) Describes metering systems that use the light passing through the lens to evaluate exposure details.

white balance A digital camera control used to balance exposure and colour settings for artificial lighting types.

zoom A camera lens with an adjustable focal length giving, in effect, a range of lenses in one. Drawbacks include a smaller maximum aperture and increased distortion over a prime lens (one with a fixed focal length).

Index

Acknowledgements

The Author would like to thank the following for all their assistance in the creation of this title:

Bowens International

Calumet Photo

Lastolite Limited

Nikon UK

Mark Simmons

Photon Beard Ltd

Redwing

Zero Halliburton

Useful Addresses

Adobe (Photoshop, Illustrator)
www.adobe.com

Agfa www.agfa.com

Alien Skin (Photoshop Plug-ins)
www.alienskin.com

Apple Computer www.apple.com

Association of Photographers (UK)
www.the-aop.org

British Journal of Photography
www.bjphoto.co.uk

Brunel Microscopes
www.brunelmicroscopes.co.uk

Calumet
www.calumetphoto.com

Corel (Photo-Paint, Draw, Linux)
www.corel.com

Digital camera information
www.photo.askey.net

Epson www.epson.co.uk www.epson.com

Extensis www.extensis.com

Formac www.formac.com

Fractal www.fractal.com

Fujifilm www.fujifilm.com

Hasselblad www.hasselblad.se

Hewlett-Packard www.hp.com

Iomega www.iomega.com

Kodak www.kodak.com

LaCie www.lacie.com

Lexmark www.lexmark.co.uk

Linotype www.linotype.org

Luminos (paper and processes)
www.luminos.com

Nikon www.nikon.com

Nixvue www.nixvue.com

Olympus
www.olympus.co.uk
www.olympusamerica.com

Paintshop Pro www.jasc.com

Pantone www.pantone.com

Philips www.philips.com

Photographic information site
www.ephotozine.com

Photoshop tutorial sites
www.planetphotoshop.com
www.ultimate-photoshop.com

Polaroid www.polaroid.com

Qimage Pro
www.ddisoftware.com/qimage/

Ricoh www.ricoh-europe.com

Samsung www.samsung.com

Shutterfly (Digital Prints via the web)
www.shutterfly.com

Sony www.sony.com

Umax www.umax.com

Wacom (graphics tablets)
www.wacom.com